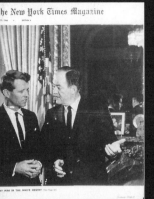

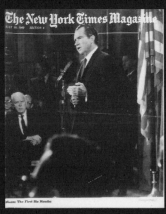

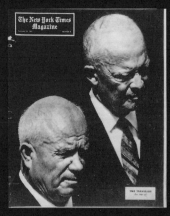

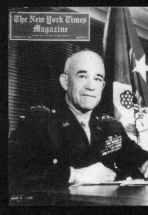

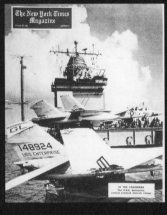

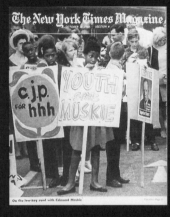

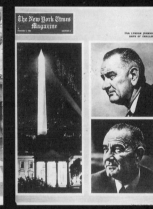

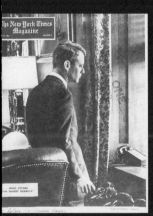

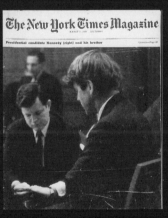

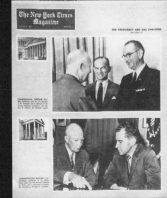

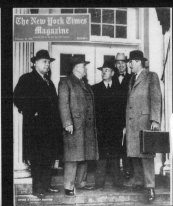

Gunnison June, 1997
(Hamilton's)

EYE ON WASHINGTON

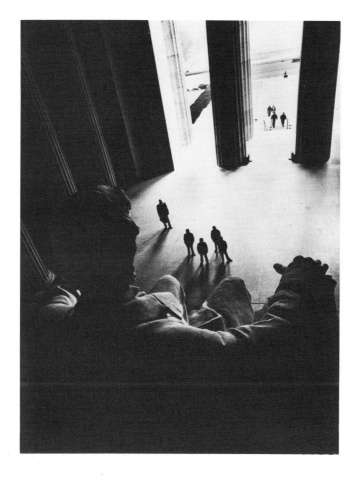

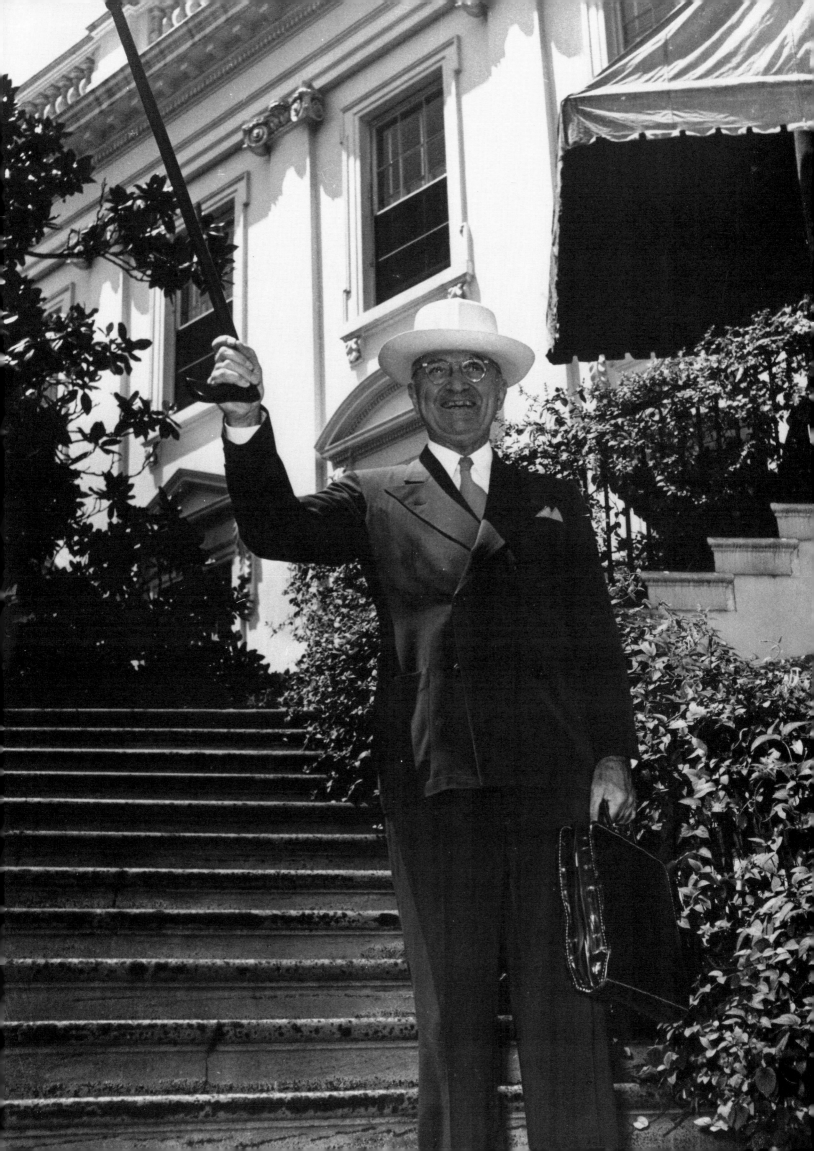

EYE ON WASHINGTON

The Presidents Who've Known Me

GEORGE
TAMES

HarperCollinsPublishers

To Frances,
A loving wife and partner of forty-four years,
mother of Chris, Pamela, Kathryn, Stephanie, and Michael

PAGE 1

"In reverence": Lincoln Memorial, 1960.

PAGE 2

President Truman on the South Portico steps of the White House.

PAGE 6

Washington Monument in the fog, spring 1972.

PAGES 8–9

Snow scene, Capitol Hill, winter 1980.

PAGE 160

Vietnam War protester mounts the General Grant statue at the Capitol during a demonstration.

Photo Credits: Photographs in Roosevelt and Bush chapters copyright © George Tames. Photographs in Truman, Eisenhower, Kennedy, Johnson, Nixon, Ford, Carter, and Reagan chapters copyright © George Tames/The New York Times. Prologue photographs #1, 7 and 9 copyright © George Tames; all other photographs in Prologue copyright © George Tames/The New York Times.

FIRST EDITION

DESIGNED BY JOEL AVIROM

Library of Congress Cataloging-in-Publication Data

Tames, George, 1919–
 Eye on Washington: the Presidents who've known me/ George Tames.
 —1st ed.
 p. cm.
 ISBN 0–06–016031–4
 1. Presidents—United States—Pictorial works.
2. United States—Politics and government—1933–1945
—Pictorial works. 3. United States—Politics and
government—1945– —Pictorial works. 4. Tames,
George, 1919– . 5. News photographers—Washing-
ton (D.C.)—Biography. I. Title.
E176.5.T36 1990
973.9′092′2—dc20 89–45069

90 91 92 93 94 DT/MPC 10 9 8 7 6 5 4 3 2 1

CONTENTS

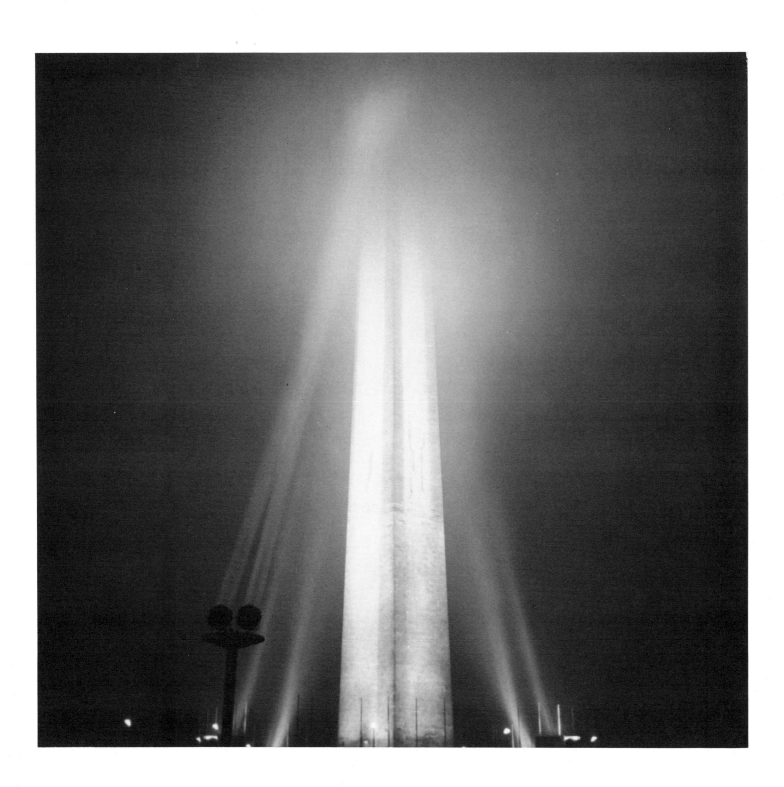

ACKNOWLEDGMENTS

I owe lasting gratitude to many people for their generous support—whether for text, photo editing, or a timely laugh. Their contributions saw me through.

Especially, to my daughter Kathryn Ann Tames-Walton for her two years of service—typing, correcting the text, and choosing the final pictures.

To photographer Susan Raines, who first made sense of my photo files and urged me to write my memoirs. Without her prodding this book would not have happened.

To *New York Times* picture editor Mark Bussell for his uncommon sensitivity in helping me select the photographs.

To *New York Times* assistant managing editor Carolyn Lee for her unwavering support, suggestions, and editing of my entire original manuscript. She was a true inspiration.

To HarperCollins senior editor Craig Nelson for his high professional excellence. His perseverance made the difference.

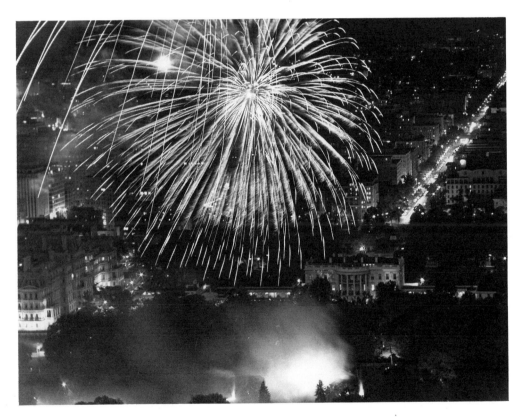

Fireworks over the White House. Mrs. Kennedy and the president, entertaining foreign guests, decided to have a fireworks display near the White House. Picture made from the top of the Washington Monument during this occasion. This is the only time that fireworks have ever been set off this close to the White House.

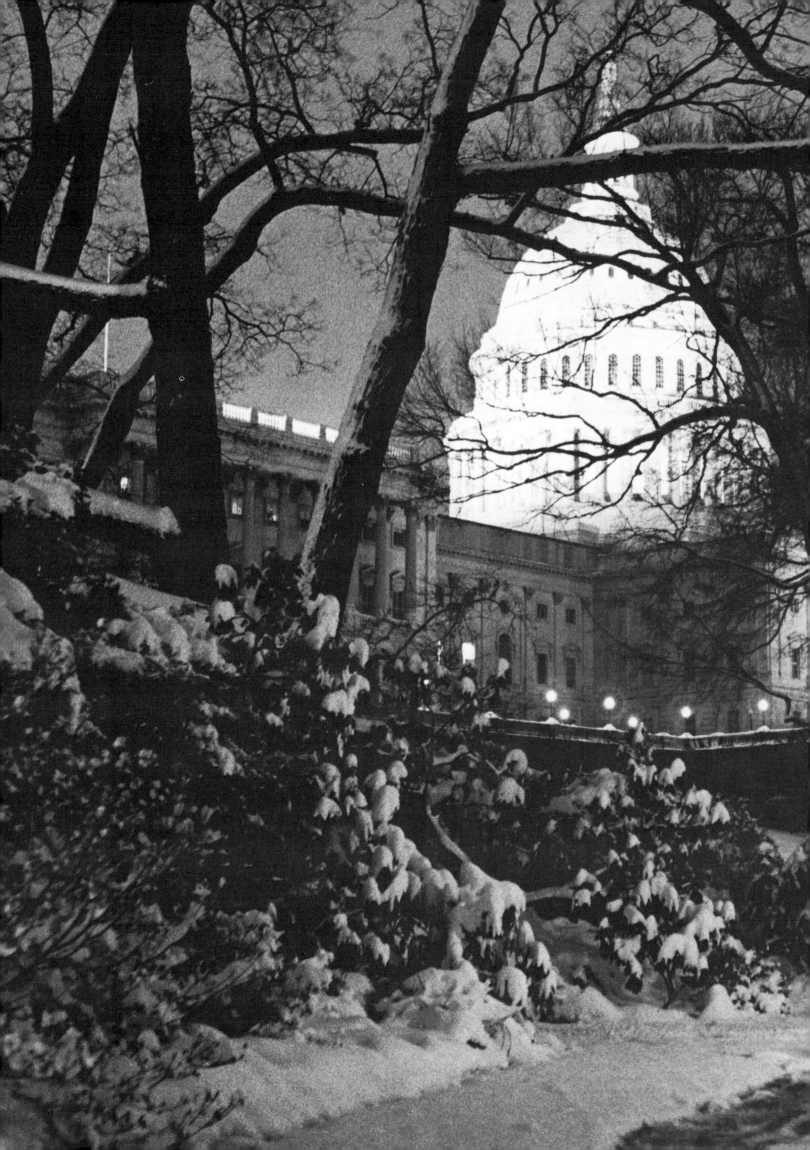

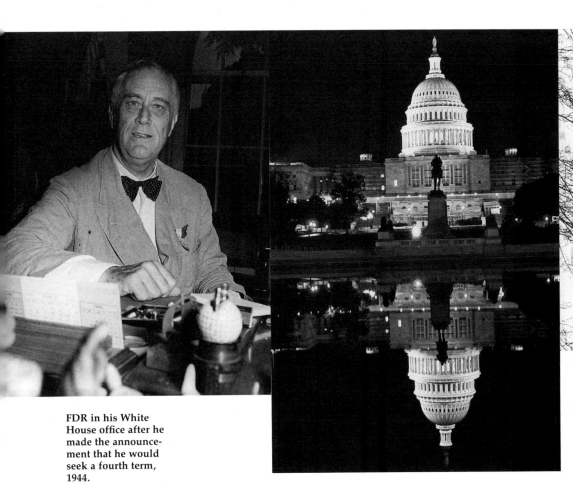

FDR in his White
House office after he
made the announce-
ment that he would
seek a fourth term,
1944.

Capitol reflections.

"Widows Walk,"
Arlington Cemetery.
Snow scene, 1968.

PROLOGUE

I was born in 1919 within sight of the United States Capitol and lived the first twenty years of my life at its feet and the next fifty as a news photographer within its sandstone walls.

Washington was a beautiful place to be born, still a sleepy southern town brave with United States flags, museums, and monuments, a town of quaint charm and grace with visible pockets of history everywhere and with friendly neighbors who never locked their doors.

It would move into its central role in the world much later, and I would watch from a privileged position, behind the viewfinder of a camera.

In sharing with you memories from a career that spans the administrations of ten presidents, I have tried to concentrate on the human traits of those who governed, those who hoped to govern, and those who surrounded them, stressing especially the humor that reveals so much about character.

All people are shaped by their heritage and environment, then honed by subsequent events. The words and actions of politicians should be viewed with this in mind. So should those of photographers, which is why I want to share my own background with you.

My childhood home was a small cold-water flat on the second story of a carriage house in John Marshall Alley, an ethnic ghetto of about twenty im-

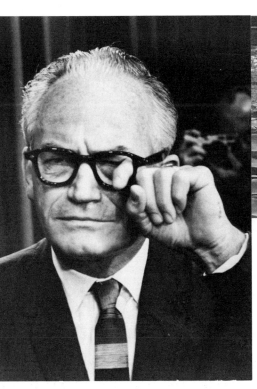

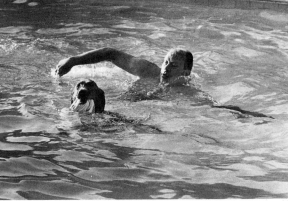

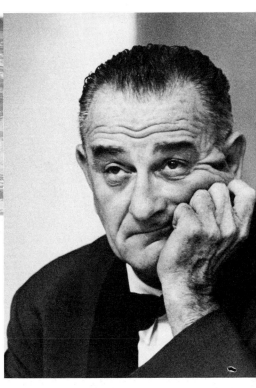

LEFT

Senator Barry Goldwater back in Washington, D.C., posing for campaign portrait after his nomination as the Republican presidential candidate for 1964. To avoid reflection from heavy glasses, he wore them without any lenses and after the session playfully stuck one of his fingers through the hole.

ABOVE

Minority Leader Gerald Ford in the heated pool of his Alexandria, Virginia, home, taking a swim at 6:45 A.M. with the family dog. This was a ritual for the president while he lived in Alexandria, and he maintained it later in the outdoor pool at the White House.

RIGHT

President Johnson in his office after announcing his decision not to seek reelection, 1968.

migrant families with numerous children who all spoke Greek and had only limited command of the English language. I shared a bedroom with my brother Steve and my immigrant parents, Chris and Athena.

When I was first registered for school, somehow my last name was spelled "Tamis." Then later, when I transferred to another school, the *i* was changed to an *e* and I became Tames. The six brothers and sisters who followed me all assumed that name too, but I later discovered to my great surprise that the name appearing on my father's immigration papers was actually "Damis."

I remember our alley, about three blocks from the west front of the Capitol, as a noisy playground overshadowed by a great dome that was somehow suspended to loom over our shacks. And I can remember my great surprise when my mother took me for a walk one day past the Capitol and I was able to observe that it actually had a base. Somehow, I had always thought of the dome as just hanging there, even in the night sky I saw through my bedroom window.

Most of the neighborhood fathers earned a living as pushcart peddlers of fruit, and the alley echoed with the sounds of their comings and goings. The majority had built their own carts, and the different weights rolling over the cobblestones produced a distinctive sound easily recognized by children, who would run to greet Papa.

On summer nights, with the Mall only a block away, we were invaded by fireflies that dodged and blinked while being chased and captured by joyously screaming children. One night while chasing fireflies, I heard my father returning and I rushed to greet him. I could see sparks flying from his cart's steel-rimmed wheels as they rolled over the uneven cobblestones.

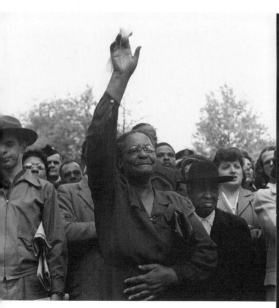

Mourners along Pennsylvania Avenue, the route of President Roosevelt's funeral.

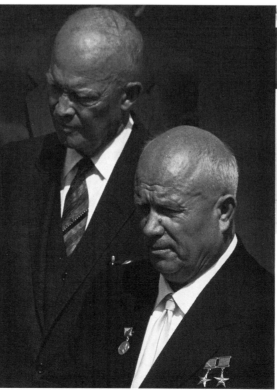

LEFT

Ike and Khrushchev at Andrews Air Force Base ceremony when the premier of the Soviet Union arrived in Washington.

ABOVE

"The Wall," Vietnam War Memorial. Vietnam vet mourns fallen comrade.

"Papa," I yelled with delight, "you are making fireflies!"

Those homes in John Marshall Alley, on what is now the site of the Federal District Court Building, were exceptionally hot in summer. Air did not circulate in the small, cramped rooms that had once been stables or, above them, in the living quarters for Irish immigrants who worked for the gentry residing on John Marshall Place and Pennsylvania Avenue.

Because of the heat and high humidity, the lingering odor of the horses was very noticeable. In fact, it penetrated our clothes. I recall that my father, in a very jovial mood, one day remarked that we had "finally arrived": We all smelled like the previous occupants, full of horse shit and gin.

Often, trying to cope with the intense heat of summer, whole families would pack up pillows and bedding and walk the short distance to the Mall to sleep. From the Capitol to the Washington Monument and farther, the lawns might be carpeted with hundreds of people, most of the older ones staying up all night while the children slept. The muggy night air would blend the scent of magnolias with the pungent odors from nearby horse stalls.

Shortly after dawn there would be a great stirring and mingling as people awakened, picked up their bedding, and started home. Many a morning I crossed Pennsylvania Avenue clutching my pillow and my blanket.

As our family grew, we moved from home to home, but none of them was more than ten blocks from the Capitol. It was when we lived in Linworth Place, S.W., facing a city block that had been cleared of homes and prepared for a new building, that I witnessed an event which was to have a major impact on me: the Bonus March on Washington.

The year was 1932, and veterans of World War I had gathered in the capital to demand payment that had been promised but not given to them.

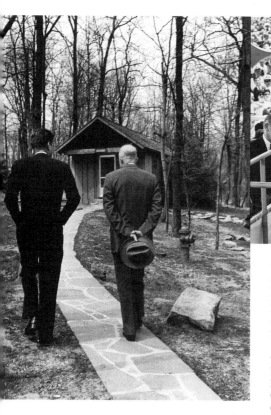

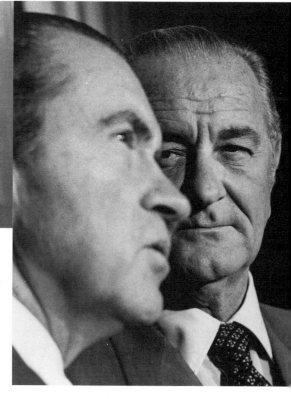

LEFT

President Kennedy and former president Eisenhower at Camp David after the Bay of Pigs fiasco.

RIGHT

"Nose to Nose": President Lyndon B. Johnson and President-Elect Richard M. Nixon in the White House News Room.

ABOVE

Launching of the John F. Kennedy flattop: Caroline breaks bottle of champagne on bow, with John-John behind, Mrs. Kennedy in center, and President Johnson at extreme left. Newport News, Virginia.

1 3

Within a month of their arrival, one group of Bonus Marchers had set up a city of shacks in the vacant lot directly across from us.

From the time the first shack was constructed until the last one was burned, I spent every day with the Bonus Marchers. I ran errands and messages, went with the veterans to beg food from the produce markets and the slaughterhouses, and sat with them around their campfires in the evenings, listening to stories of war.

I was the first to bring the news to this unit when the main group of Bonus Marchers clashed with the local police near the Capitol, and the first to bring the rumors that the army was being dispatched by President Hoover.

Our camp decided not to resist, and the evacuation was ordered for the women's and children's division, about a block away. Carrying all their belongings, they gathered in the street four abreast, then marched to the corner of 12th and D, where the men fell in, also four abreast, front and back. The long line of the Bonus Army stood for a couple of hours, waiting until the first trucks of U.S. troops and tanks arrived.

A signal was given, and the veterans and their dependents, led by a flag bearer with the Stars and Stripes, began a peaceful march west on D Street to 14th Street, left and across the 14th Street Bridge into Virginia and away.

I marched with them four blocks, then turned back to the camp area. The troops had started to burn the shacks, watched by about ten Bonus Marchers led by a man in uniform jacket with captain's bars. When a torch was put to the huge U.S. flag stretched across the camp's main street, he called for a hand salute until the flag was completely burned. Then to his small group he said, "Dismissed! Go your way. As for me, I will never serve under that flag again."

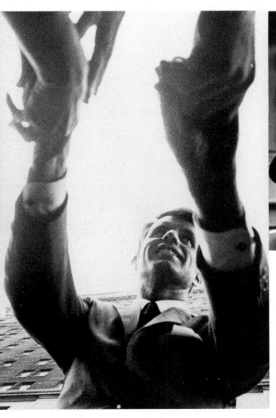

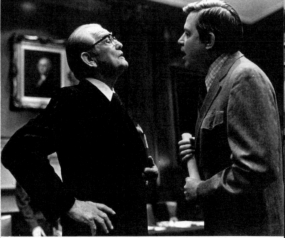

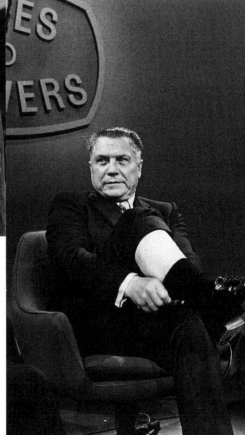

LEFT

Senator Bobby Kennedy in New York City campaigning against LBJ for the Democratic nomination.

ABOVE

Senators John Stennis and Frank Church: "The Confrontation."

RIGHT

Teamsters president Jimmy Hoffa returns to his Detroit local after winning presidency of national union.

I was born into the Democratic party just as I was born into the Greek Orthodox church, receiving the basic principles of both along with my mother's milk, and my religious and political faiths both taught that civilized nations are judged on how they treat their unfortunate citizens and that government has a duty to help those who cannot take care of themselves.

After I was old enough to think for myself, I never found reason to question that principle or change either of my alliances.

As an eight-year-old starting my *Washington Post* paper route at dawn, I always made it a point to stop at 3rd and B Streets, SW (now Independence Avenue, where the Hubert H. Humphrey Building stands) to look at the Capitol and see how it changed during the seasons and how the sun played on its surface. I loved the Capitol in the rain, and I particularly loved it in the snow years later when, as a news photographer, I strove to capture on film these visions of childhood joy.

But until I was twenty years old, my love for this old building was purely an exterior one. Then in 1939, as a copyboy for *Time* magazine, I was sent up to the Hill to pick up a bill from the document room just off the old House chamber of the Capitol. I became so fascinated with the building and what was going on that I stayed there all day, went up into the dome, attended a couple of hearings, sat in on sessions of the Senate and House, and didn't get back to the office until about five o'clock. Harold Horan, the bureau chief, told me in no uncertain terms that if I ever did that again, I would be fired. But every chance I got—Saturdays, Sundays, holidays—I spent time in and around the Capitol.

What an eerie feeling it had been, climbing those long spiral stairs for the first time and realizing I was inside the cast-iron skin of the dome that

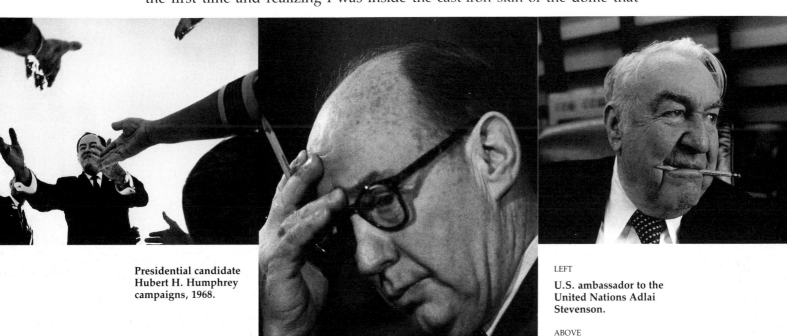

Presidential candidate Hubert H. Humphrey campaigns, 1968.

LEFT

U.S. ambassador to the United Nations Adlai Stevenson.

ABOVE

Senator Sam Ervin.

used to fill my young eyes from John Marshall Alley. To my delight, the voices of visitors far below had been deflected and echoed about me. Then, reaching the top, I stepped out onto the platform that circled the base of the Statue of Freedom and looked over the city laid so beautifully at my feet. Such was my affection for this discovery, in fact, that when I first met and started courting Marine Sergeant Frances Faye Owens, I made a point of driving past on our first date.

World War II had ended, and the lights on the city's monuments were being turned on after four years of being blacked out. I drove to the marine barracks in Arlington, picked up Frances, and drove back in a roundabout way so we could approach from East Capitol Street. I wanted her to come upon the Capitol suddenly and dramatically. It was spectacular, and she was very much impressed. In fact, she cried.

She has been my constant companion—my wife and the mother of our five beautiful children—in the forty-four years since then.

The Capitol and the White House, their inhabitants and would-be inhabitants, have been my subjects for a half-century, four decades of which I spent as a staff photographer for the *New York Times* and for which I now work as a photographer emeritus.

In those years, ten presidents have occupied and left the Oval Office, and hundreds of members of Congress come and gone. I knew every U.S. senator by sight and, in the House, all the leadership and every chairman of a major committee. Some I thought of as friends as well as subjects. All of them I came to know well, for the same camera lens that flatters also reveals.

The spontaneous nature of the photographs I made of presidents can never be repeated because of White House security restrictions. When I first began taking pictures at the White House, I was sometimes in the Oval Office

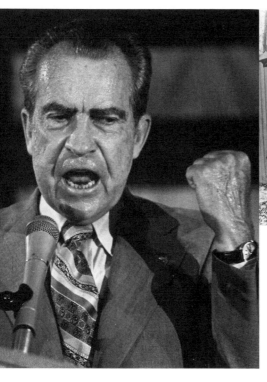

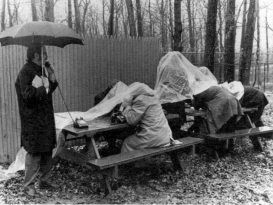

LEFT

Former president Nixon defends his administration during speech at dedication of gym in his name. Hyden, Kentucky.

RIGHT

"The Lobbyist," Statuary Hall, U.S. Capitol.

ABOVE

During President Nixon's administration, reporters at Camp David filing their reports during a rainstorm. Facilities for the media that were always minimal are now nonexistent.

alone with a president for as much as an hour. Today this would be impossible.

One point on my quotations of presidents' words: In some cases, I have recalled conversations that took place as long as forty years ago. At the time, I had no notion of ever writing about these conversations, so I kept no records of them. Therefore, while I have tried my best to recall them, the actual words may not be exactly as they were spoken. However, I have repeated the stories many times over the years, and they certainly reflect each president's views and are the best that I can reconstruct.

I hope in the following pages you will come to see a few of them as I did: mostly hardworking, thoughtful, and fair-minded, sometimes witty and humorous, but always, before anything else, human beings.

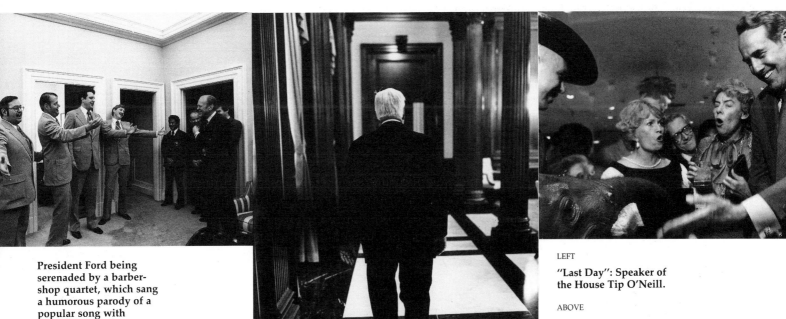

President Ford being serenaded by a barber-shop quartet, which sang a humorous parody of a popular song with references to Ford. He enjoyed it.

LEFT

"Last Day": Speaker of the House Tip O'Neill.

ABOVE

Reception at the 1984 Republican National Convention, Dallas, Texas. Health and Human Services Secretary Margaret Heckler, U.N. ambassador Jeane Kirkpatrick, and Senator Bob Dole after being goosed by baby elephant.

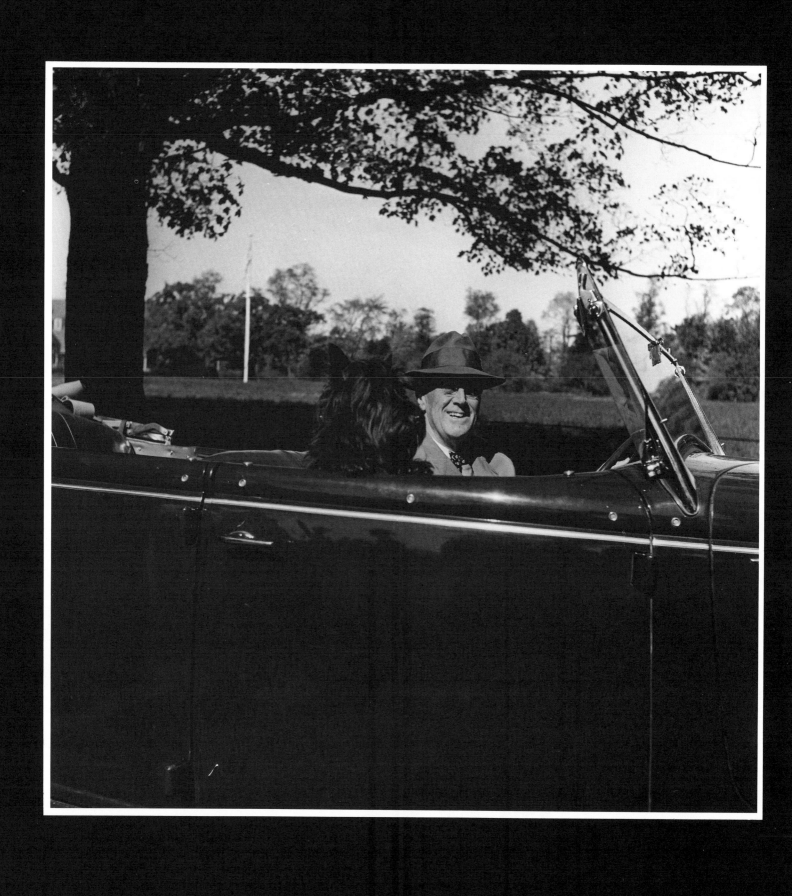

THE ROOSEVELT ERA

In my mother's house, Franklin Delano Roosevelt was considered a saint and was entitled to the respect and reverence that goes with the title.

His photograph, clipped from a newspaper, was in the holy corner on the east wall of her bedroom, in line with the Virgin and Child and with saints John, George, and Luke. It was in that place, in 1932, when I was thirteen and it was my turn to light the wick, that I first met FDR. His image was to become as familiar to me as his name, intoned by my mother in her prayers.

Eight years later in the Oval Office, while acting as an assistant press photographer, I first came face to face with FDR. I didn't know whether to light a candle, kiss his ring, or chant the Kyrie Eleison.

I first photographed FDR during his 1941 inaugural parade and photographed him last when his flag-draped casket returned to Washington from Warm Springs, Georgia, in April of 1945.

I viewed him then as larger than life, and I do so to this very day.

As president, he dominated world events and was elected to an unprecedented four terms while bound to a wheelchair by paralytic polio. It took great control to pull it off, to create an illusion of being able-bodied while being seated. But he was determined not to be seen in a wheelchair and not to be lifted in view of the public.

I have heard that only two pictures were made of Roosevelt being carried, even though about 150 photographers shot him in and around the White House, and about twenty-five photographers from the agencies were regularly assigned there during Roosevelt's twelve and a half years as president. Neither of the two photographs ever ran—because of the extreme pressure exerted by the White House, which minimized the opportunities for such pictures, and because of an unwritten rule against making any such picture.

I asked once to see a copy of the rule and was informed by one of the older hands that if I wanted to be a wiseass who didn't follow rules, then

President Franklin D. Roosevelt and his dog Fala at his Hyde Park, New York, home. He is driving the specially modified Ford convertible, which was operated with hand controls. 1943–44.

they would see that I never made a picture around the White House again.

My first assignment at the White House was in 1940, at the beginning of President Roosevelt's third term. We were escorted into the empty Oval Office and told to set up our cameras on tripods, get focused, set the lights, get ready, and then leave the room.

We did so.

In about fifteen minutes we came back to find the president seated behind his desk and prepared for us. While we fiddled with our cameras, he threw his head back in that familiar exaggerated gesture—cigarette holder at an angle and that big, wide, wide grin—and looked at us sideways with those eyes sparkling and said, "Do your damnedest, boys."

But the moment we were ready, he broke that mood and assumed whichever of the presidential poses he wanted to project at that moment.

It was ever so. He was always theatrical and entertaining. Wherever he was seated was center stage.

So overpowering were his personality and presence that I could never perceive him as being completely disabled, and thus I became part of that great conspiracy to conceal from the general public the true physical condition of the president of the United States.

In 1933, when Roosevelt first came into the White House, Steve Early, his press secretary, called in all the regular photographers for a conference, a number in the neighborhood of twenty-five. He told them that he had a request from the president of the United States. If the president's friends, the photographers, would refrain from photographing him while he was being carried or in any other situation that showed how incapacitated he was, Early said, then Roosevelt in turn would make himself available for picture taking more than any other president in the history of the United States.

The deal was struck, and the conspiracy of silence began, but of course it turned out to be a one-sided deal. Roosevelt became less and less available, and every time in a very controlled situation. Still, the photographers kept their end of the bargain and, however tempted, made no pictures of him being carried or wheeled in his chair. The president's request was now the rule.

By the time I was one of this small group of photographers, there was no question in my mind that President Roosevelt was dying. Poor attempts at makeup for photo sessions ended up being more revealing than concealing. This was especially true the last year of his life. He was obviously losing a lot of weight, his once-massive upper torso visibly shrinking.

In late 1944, while covering a small meeting at the White House, I looked through my long lens and observed that the president appeared very enfeebled. At a point when one of the other speakers was holding the stage, his mind seemed to drift off and his jaw slackened a bit. I came back to my office shocked by what I had observed.

Of course, there were several occasions during the campaign of 1944 when the president seemed to be his old self—kicking the hell out of the Republicans (particularly presidential candidate Thomas E. Dewey), displaying his old relish for the game, because he loved politics, he loved campaigning, and he loved being president.

I was at the Mayflower Hotel in Washington when he gave his famous speech castigating the Republicans and complaining that they were now attacking not only him but his little dog, Fala. As Roosevelt emphasized the untruth of the allegation that he had sent a destroyer to pick up Fala in the Aleutians when the pet supposedly was forgotten after a rest stop, I was impressed with his great timing. He spoke of his old political enemies, Martin, Barton, and Fish, and his cadence was such that the audience picked up and anticipated the refrain at the end of each paragraph and would repeat after him: Martin, Barton, and Fish.

The campaign of 1944, short as it was, took a terrible toll on the president's physical and mental condition. Campaigning in the rain in New York was exhausting to this young photographer, and must have been far more so to the president, traveling in an open touring car and becoming soaked to the skin.

The Secret Service and the staff had arranged for certain stops along the way where the president's car could be pulled into a garage. There they immediately helped him change his clothes and gave him an opportunity to relieve himself. Later I questioned an agent about an unscheduled stop under a viaduct and was informed that this was also a rest stop. A portable potty was always in the touring car during the campaign. Everything possible was done to minimize the president's need to leave the car.

I was amazed at how President Roosevelt was able to control any rally or situation while resting in the back of that car. A special seat hoisted him up a little higher so he could be seen plainly by the crowd when he arrived at a rally, and a bank of microphones would be placed across the back of the car on a special platform to make his voice heard.

It is my understanding that the president preferred to campaign without wearing his leg braces, as they were very uncomfortable, very heavy, and caused much pain. However, when absolutely necessary, or to counter rumors of his failing health, the president would wear his braces and have them locked in place. At a dramatic moment, he would reach forward, grasp the special railings in front of the car, and hoist himself up to the cheers of his audience. This would be followed by a theatrical flip of the cape from around his shoulders, and then he would throw his head back to that familiar jaunty angle, thrust out his jaw, grin, and, with another dramatic gesture, insert the cigarette holder in the side of the mouth at its own outrageous angle.

A typical example of the extent to which the president would go to appear natural, also from the 1944 campaign: He was scheduled to address a rally in the main ballroom of the Mayflower Hotel. He was to walk the approximately forty feet from the entrance to his seat, making two stops along the way at tables selected by the White House staff. Only personal friends of the president were seated at these two tables.

Walking was very hard work for FDR, and it showed in a clumsy gait. He walked like an old sailor, a sort of rolling movement, holding fast by one arm to one of his aides. But no one really got a look at the president's walk, because the moment he stepped through the door and the band struck up "Hail to the Chief," everyone stood except designated "sitters" at the two tables, and the president was engulfed. He acknowledged friends right and left until he could grasp the back of a chair and greet the person seated there

as a long lost friend. His aide immediately backed about five feet away so the president was supporting himself on the chair, talking and creating quite a commotion.

When signaled, the aide casually walked over and the president straightened up, grabbed his arm, and walked to the next table. And always there was that cigarette holder. He used it, gesturing, sticking it back in his mouth, always moving, just like a good magician on stage distracting the audience, so that their eyes followed the holder instead of the effort it took for him to walk that forty feet to the dais.

I will never forget December 8, 1941, the day after Pearl Harbor, when the president came to the Hill to ask Congress for a Declaration of War against Japan and Germany.

The joint session that day was extraordinary. Members gathered in little knots, whispering to each other the latest rumors about the real extent of the damage at Pearl Harbor. The galleries were filled with reporters, photographers, staff, and members of congressional families. Everyone wore a grim, determined look, and the House chamber smelled of tension, like the locker room of a high school basketball team just before the big game of the season.

The president arrived and was wheeled to the back of the House chamber, where he was assisted to his feet and his leg braces were snapped in place. Holding on to the arm of his son James, he walked up the special ramp to address the House, projecting the very image of a vigorous, forceful, determined leader.

I photographed Roosevelt only 100 to 120 times during the five-year span before his death. Most of these negatives were lost, but one that survives is of Harry Truman and Roosevelt under the Jackson magnolia tree in the backyard of the White House on the day that they formally opened their campaign for the 1944 presidential election.

They were having lunch and at the same time talking to the photographers and reporters. The president was in a sort of so-so mood, but Harry Truman was animated and very, very articulate. He seemed to enjoy the session much more than the president.

I was using a Rolleicord with flash off the camera and with some surplus number 50 bulbs that we had lying around the office. These were huge and filled with a type of aluminum foil. When fired, they would give off a terrific light with a little sound like a *kwapp,* and the two men reacted as if they had been hit in the face. President Roosevelt seemed a little annoyed at that, but Truman just laughed out loud, as you can see in the resulting photo.

I was still classified as an assistant photographer at that time, so I was basically working the fringes and letting the regulars make all the shots they wanted, occasionally sticking my camera through to make one myself.

As a result, I only made about seven exposures for the whole session, which lasted, I guess, approximately fifteen minutes. To the best of my recollection there weren't more than about twenty photographers and reporters out back for this announcement of the opening of the campaign of 1944, unlike the tremendous number that would cover such an event today.

I remember another session, in the East Room of the White House, with Sir Winston Churchill and President Roosevelt. Churchill had come to the States and was spending about a week in the White House with the president. When photographers arrived for a small informal press conference, for which we were to make our pictures and then withdraw, the two wartime leaders were trying to upstage one another, telling bigger and better stories—or larger and larger lies, whichever.

A mighty roar arose at a remark by Churchill. I asked one of the reporters what had happened, and he said that one of the White House staff had offered Churchill some scotch and asked politely if he wanted water with it. The prime minister responded, "Water! Do you know what happens in water? Fish fuck in water!"

Also I was told that at this session, Churchill was making some comments about the amount of scotch that he could drink in one day. He told the president and the others with a mischievous little grin, "I estimate that I consume ten double scotches a day, and in my lifetime I bet I have drunk this whole room."

Well, the president challenged him on that. So Churchill turned to one of his aides and asked him, "If I drank ten double scotches a day, how long would it take me to drink this room?" His aide whipped out a pencil, made some calculations, looked around, and finally said, "Mr. Prime Minister, you'd have to live to be 240 years old." He responded, "So much to do and so little time." And with that, the room erupted again in laughter.

My photo opportunities with Eleanor Roosevelt were very limited. I estimate that in five years, I only photographed her about twenty-five times, always in social situations or at public events like the March of Dimes rallies.

She was warm and gracious to me always, but one particular incident sticks in my mind. I was covering a youth rally in the interdepartmental auditorium on Constitution Avenue. "The Grapes of Wrath" was being shown, and Mrs. Roosevelt would be the featured speaker afterward.

She finished her talk and got off the stage and was working the crowd while I took down my gear and headed for the front door. We both exited on Constitution Avenue, and I greeted her for the first time in my life.

I asked her where she was going, and she said she was walking back to the White House. I asked her where was her Secret Service escort. She said she didn't have any and she preferred not to have any, that they only got in the way. However, she said, if I thought that she needed an escort, she would consider it an honor if I were to walk her back to the southwest gate of the White House.

That four-block walk was a delight, but I must confess I don't remember much about what I said to keep up my end of the conversation. I do know that she was completely gracious to a twenty-one-year-old stranger.

The announcement of President Roosevelt's death hit this nation with devastating effect, not to be matched until the outpouring of grief over the assassination of President Kennedy. In FDR I lost a saint who nurtured and

directed my young political soul. In John F. Kennedy I lost a friend who gave me hope that our own generation and its president could make a better and different world.

A great clanging of the Teletype machines in our office at *Time* and *Life* signaled Roosevelt's death. Karsh, the famous Canadian portrait photographer, was in town shooting a portfolio of Washington's wartime leaders for *Life*. He had finished a session with Harry Truman just the day before and was at that moment photographing Dean Acheson, under secretary of state, at the old State, War, and Navy building, and I ran over to tell Karsh that the president was dead and that *Life* wanted the picture of Truman for its cover.

I rushed to Acheson's office, burst through the door, and shouted at his secretary, "Roosevelt is dead! Where is Karsh?"

She said, "Oh my God, he is in there with the secretary."

I burst through the door. There was Dean Acheson, with one foot up on a chair, leaning over looking very solemn while Karsh was behind that huge 8 by 10 camera of his.

I yelled, "Roosevelt is dead!" Acheson said, "Oh my God!" and he put his foot down.

Karsh came flying up from underneath the cloth hood that he had over the camera, looked at me, and said, "You have ruined my picture!"

It struck me that the news of the president's death was already fifteen minutes old, yet the under secretary of state had not gotten the word.

I ran immediately over to the White House and went into the Press Room. The lobby of the West Wing was open to the press then, and it was crowded with reporters, officials, and staff coming and going. Bewilderment, shock, and apprehension were very evident on the faces of many of the staff, but as I recall, there was very little noise, very few voices. Big, burly Bill Simmons, the ex-Secret Service agent who acted as President Truman's official greeter, was openly crying.

I don't know how to describe the feeling there. Above all was this question, "President Harry Truman: Who in the hell is he?"

Just hanging around, I could see that there wasn't much to photograph. The swearing in of the new president was a pool job. So I decided to go back to my office in the Bowen building at 15th and K. The news was about an hour old as I crossed from the White House gate directly into Lafayette Park, and already several hundred people had gathered there in little clusters, looking over toward the White House and whispering, or sort of reverently looking over not saying anything, just looking. Later, I was to learn that some of them actually spent the night sitting on the benches, just looking, just wanting to be a part of it, or just feeling lost.

The emotional display was to come when the president's body returned to Washington from Warm Springs. I walked the entire distance from Union Station to the White House Portico photographing all the way. It was a very moving scene, again not to be matched until the death of JFK.

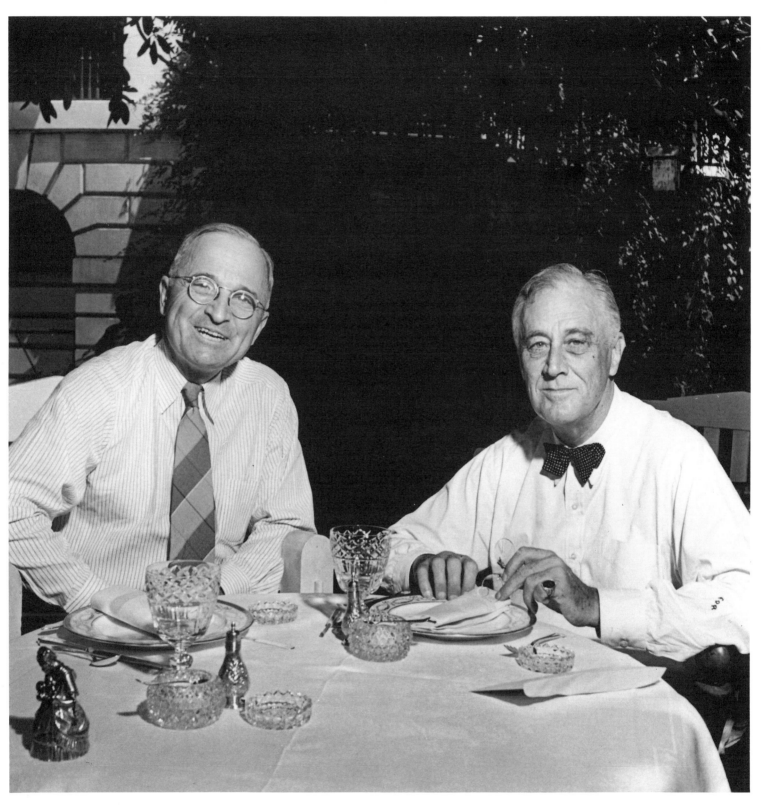

Vice presidential nominee Harry S Truman and President FDR under the Jackson magnolia tree on the South Lawn of the White House after they returned from Chicago, where he picked Truman as his running mate. This was their first joint press conference and also the announcement of the beginning of the campaign, 1944.

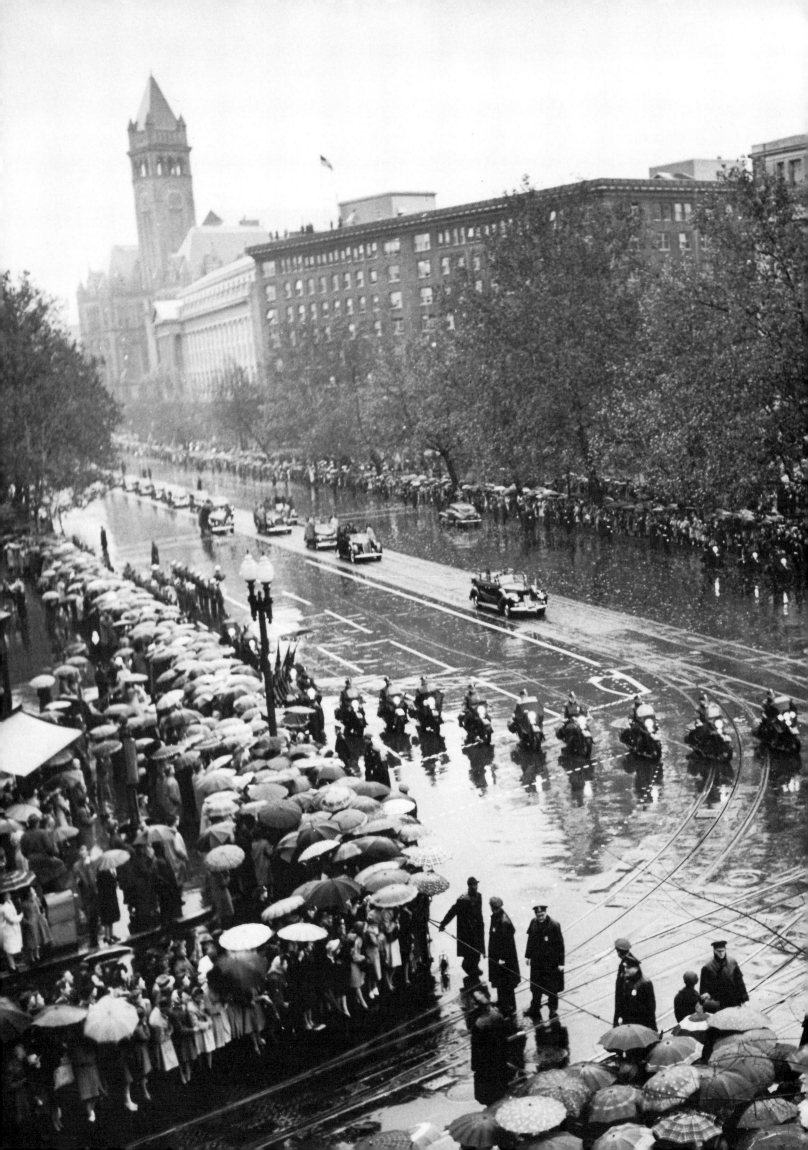

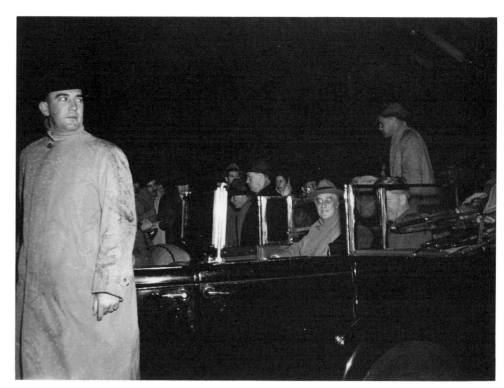

OPPOSITE AND ABOVE

FDR returning to Washington, D.C., on November 10 after his 1944 victory. Picture made from the roof of the Willard Hotel at 14th Street and Pennsylvania Avenue, NW. Above, Roosevelt rides with Harry Truman, the newly elected vice president, and on the right Henry Wallace, the outgoing vice president. He was dropped from the presidential ticket in 1944.

BELOW

FDR's last inaugural address. South Portico of the White House, January 1945.

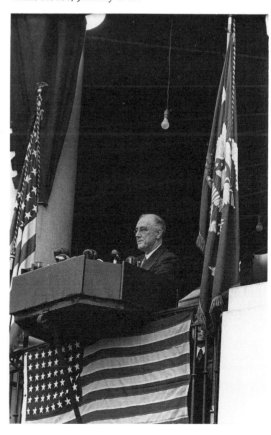

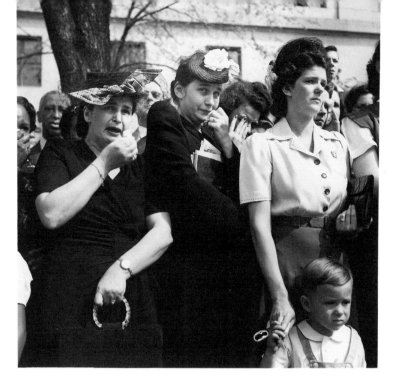

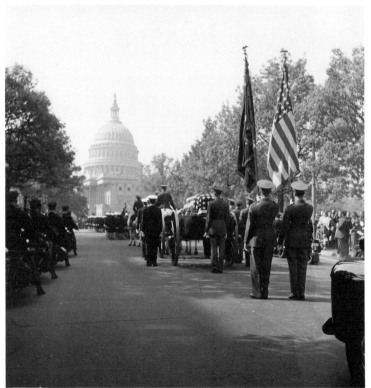

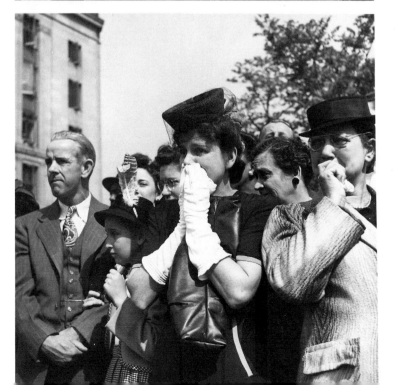

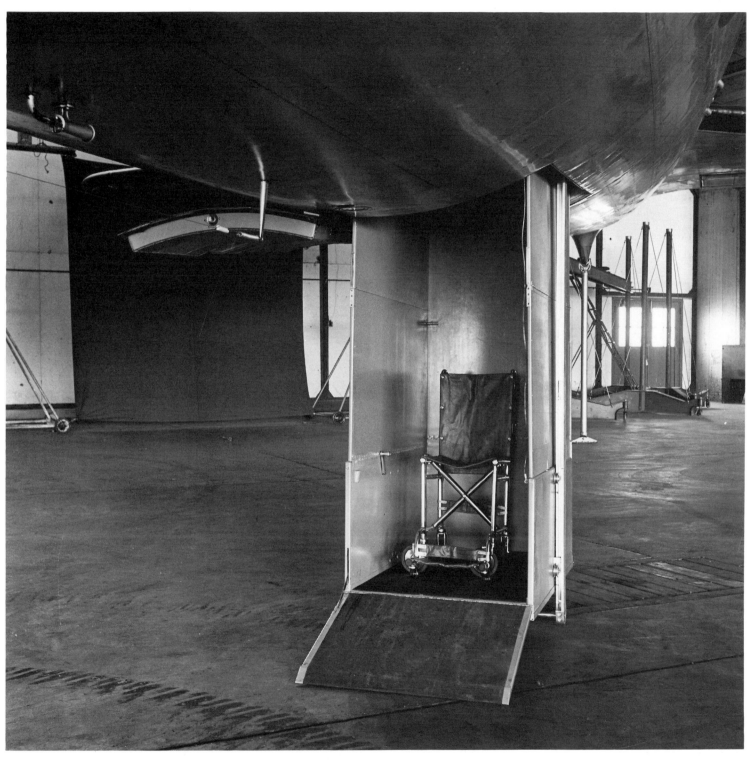

OPPOSITE

Reaction of crowds during the procession bringing the president's body back to the White House.

ABOVE

Rare photograph of the ''sacred cow,'' the military plane for the president. Shown are the special elevator and wheelchair in the plane's belly.

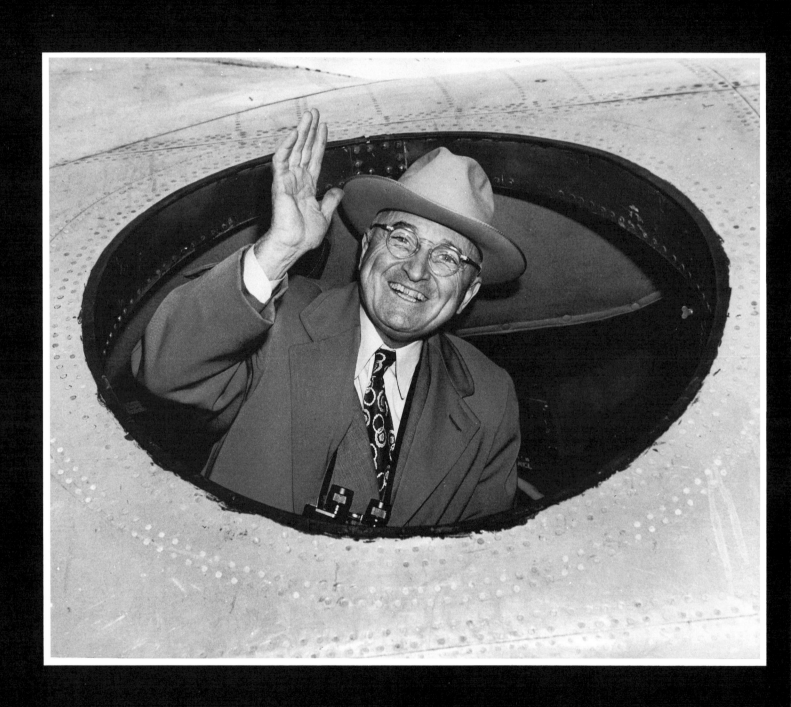

THE TRUMAN YEARS

President Truman made White House photographers first-class citizens. Before his presidency, we were not allowed into the West Wing of the White House or the small press room within it. This ban was placed upon us by the White House correspondents' association, which had jurisdiction over it. During the FDR years we were given a small room just to the left of the West Wing entrance that we referred to as the "Dog House." This room, six feet wide and about twenty feet long, had been assigned to the White House florist and gardener, who kept cuttings and made up bouquets for special events. Their operation was then moved to another spot, in the basement.

Dog house or no, we photographers thought this was a great improvement in status from the days before the Roosevelt administration, when we had to stand out on West Executive Avenue because we weren't even allowed onto the White House grounds, much less given quarters in the building.

About one month into President Truman's first administration, he made an inspection tour of the West Wing and, visiting the Press Room, inquired, "Where are the photographers?"

"Oh," replied Merriman Smith, UPI correspondent, dean of the White House press corps, and no fan of photographers, "they're in the dog house. We never allow them in here."

"Well," said the president, "I want them in here on an equal basis, with all the privileges that the writers have."

I think that was one of the reasons we photographers had such great affection for Truman, who returned the feeling so that a strong, warm bond developed. We photographers organized the "One More Club" and made Harry S Truman our first and only president. (The club was dissolved when he left office.)

During the 1948 campaign, when things were toughest for Truman, when it seemed the battle was lost, he confided to friends that at least his

The president leans from hatch of 1947 *Flying Wing* bomber.

photographers were "thinking with their hearts." Every newspaper he picked up, he told friends from San Francisco to Washington, D.C., showed excellent pictures of the nation's number one subject, and he appreciated it.

In a sense the president was right, for the photographers all liked him personally, but we were also faithfully portraying this president in action. If Truman, instead of smiling and exuding confidence, had looked beaten, the cameras would have been the first to tell it to the people.

This president was the first to take an interest in our technical and personal problems. His soft, dry, nasal voice and slow, unhurried actions and poses tended to put the photographers at ease, which was a neat switch. We worked with a knowledge that this man would go out of his way to make sure that we got our picture.

Once during a photo opportunity in the Oval Office, I ran out of film. Dropping to my knees behind the other photographers, I began loading my Rollie only to sense the presence of a squatting president. Observing my frantic motions, he gently asked, "What in the hell are you doing? Take it easy—we can wait." And he did.

On one of his flights to Missouri, I was late arriving at the airport and found a line of people filing into the plane. "Missed him," I told one of the Secret Service men as I ran up. Just then, the president caught sight of me from the top of the ramp and laughingly said, "Tames is always late." He good-naturedly came back down the ramp to pose again. I lifted my camera and was about to shoot when the president stopped me. "You forgot to put a bulb in," he reminded me gently and laughed as I finally made the picture.

President Truman relaxed easily, smiled easily, lived easily in front of a camera. He was himself, friendly, chatty, but aware. If a shutter failed to click, he noticed it as quickly as did the photographer. I saw him assist photographers in getting the names of people in a group shot for the traditional left to right identification, and I heard him tell members of a group to remember the order in which they stood so as to help out with the caption.

When visitors would come to the White House and the president would greet them formally under the North Portico, he would turn them around so the photographers could get a good picture. He would tell them, "This is how you do it. You just stand right here and we're going to shake hands and you look over there and we follow whatever instructions they yell at us, because I am president of the United States and commander in chief of the most powerful nation in the world, and I take orders from no one except the photographers."

He would laugh and the guests would follow along, some very reluctantly or apprehensively, not certain whether the president actually meant what he was saying.

One birthday, the photographers decided that maybe President Truman would like to have a cake. So they sent word through Bill Simmons, who was his assistant and official greeter at that time, and back came the response that he'd love to have a cake. He'd love to observe his birthday, in fact, and if the photographers would buy him a cake, he'd let us make a picture of him blowing out the candles. We did and he did, and I still have that picture.

No reporters ever went in with photographers during a photo opportu-

nity with Truman, so when we returned to the Press Room we were always besieged and battered by reporters' questions, even though the custom at that time was that photographers lose their hearing and not repeat any conversations heard in the Oval Office.

On this occasion we told the reporters only that we had taken a picture of the president blowing out the candles on his birthday cake. But in fact the president had made a special occasion of it. He had ordered coffee, and the mess orderlies served it in presidential china as Truman cut the cake and served it around, saving slices for "The Boss" (his wife Bess), and for his daughter, Margaret. Many jokes were made during that half-hour social about birthdays past and present, and the problems associated with advancing age. Most of the jokes were in a vein the president referred to as "noncoeducational."

One comment the president made was that he didn't care how many birthdays he had as long as "Mama" still looked good to him.

We were rapidly becoming a visually communicative society. President Truman was very aware of this and told me so.

On the anniversary of the president's first year in office, Arthur Krock, Washington bureau chief for the *New York Times*, received an exclusive interview with the president, and I was sent over afterward for a photograph to go with the article.

My appointment was for 10 A.M., and I arrived at 9:30 and walked into Charlie Ross's office. Ross, the president's press secretary, said "OK, let's go into the president's office." We went out a back door, through the Cabinet Room, through the office of the president's personal secretary, and into the Oval Office. The president was seated behind his desk.

"Mr. President, George is here to make your picture to go with Mr. Krock's article." The president said, "OK, go right ahead."

I was unprepared. I had expected to have half an hour to load my camera, get things ready, set up the light, and so forth. So I proceeded as fast as I could. I was amazed that I was alone with him, no Secret Service, no staff, nobody but us. To make conversation while I was loading my cameras and getting ready, I said, "Mr. President, what do you do in here when you've got nothing to do?"

"Oh well," he sighed wearily, "this, George." He reached down next to his desk, lifted a pile of official portraits of himself, picked up a pen, and started signing them. "This is what I do. I just sit here signing these." (In those days there was no automatic signature machine. If you received a signed Truman picture or letter, you received one that the president had signed personally.)

To keep the conversation going while I was still fiddling with my gear, I said, "Mr. President, I was up at Hunter College yesterday where the UN is meeting."

He interrupted me and said, "Yeah, what the hell is going on up there?"

"Mr. President, I really don't know, but I'll tell you one thing. I saw TV for the first time in my life, and I was very much impressed by that."

The main room in the main hall of Hunter College was not big enough

to hold all the delegations. Some were stashed inside rooms off the hall, where they were observing the proceedings on television. I had gone in and watched.

"You know one thing that struck me, Mr. President?"

"No, what?"

I said, "Well, politicians now have got to learn that they are on camera all the time. Some of these people were disgracing themselves, what with their crotch scratching and nose picking and other personal things they were doing. They didn't realize that all this was going if not on the air at least into the other satellite rooms, and there was also a possibility of it being broadcast."

The president said, "Yes, I've been thinking about TV. You know, it used to be that in order to be a successful politician, you had to have seventy percent ability and be thirty percent actor. I can visualize the time when you are going to have to be seventy percent actor and have thirty percent ability." He had anticipated President Reagan by thirty-five years.

He reclined in his chair and we talked back and forth about various subjects. I made his picture, and then we had a few social minutes while I was packing up my gear. He rocked a bit, looked around, and said, "You know, it's getting to be that we're all really actors like Shakespeare said—all actors on a stage." He fell silent for a moment, thinking. He said, "I wonder what Huey Long could have done with TV?" After another example or two, he said, "Can you imagine what Hitler would have done with TV? Look at the impact he had with theater newsreels! Now with TV a politician can be a guest in every living room in the world.

"TV," he said, "has got to police and watch itself."

Key West was the president's favorite vacation spot. He could count on going there about four times a year.

The area became very familiar to the media. We made friends with the local people, we got to know all the cab drivers, bartenders, and restaurant owners, and in fact sometimes we would even sneak them into the Key West Naval Base so they could meet the president.

Truman loved to fish and to swim in the ocean. Since there was no beach, the navy literally brought over a couple of truckloads or barge loads of sand and just poured it on the base, and Truman had a beach from which he could swim whenever he wanted. Then they set up a couple of little shacks so he could change his clothes.

One night some of the press corps got a few drinks in them at the clubs in Key West and decided they would buy a miniature mule they saw for sale. They brought the mule up to the main gate of the naval base in the backseat of a cab, their legs sort of thrown over it, and were passed right through. They went straight down to the Truman beach and put the mule in Truman's shower.

That mule left plenty of evidence of having been in the shower all night. When the president came the next morning to take a bath and opened that door, the little mule came out and Truman really broke out laughing. He thought it was one of the greatest jokes that had ever been played on him.

The commandant of the base didn't think it was funny at all. He called

the marines who were on guard that night and wanted to find out how that mule got on the base. When we heard, we talked to Charlie Ross, who called the commandant and told him the president thought it was a great joke and to let it go at that. So that's what they did.

Life for the press was slow and easy when the president vacationed. After a press briefing around ten in the morning, the "lid" was on for the rest of the day. Any changes were posted in the Press Room by Charlie Ross. As a joke one day, Truman sat in on a briefing acting as a reporter, taking notes, and asking questions to the amusement of all.

The president would stay in the commandant's house, which you could walk right up to. There were only one or two agents around. Sometimes we'd see the president or Mrs. Truman, or both together out taking a little walk. Or they'd ride down and visit one of the submarines, and we'd hear about it and casually wander down. Sometimes we would photograph it and sometimes we wouldn't. Or he would go out fishing and we'd ask to go with him. There would be no pictures then, just a social thing. It was pretty dull at the base, except for the occasional softball game to which we challenged the Secret Service.

One day, we photogs decided to organize a parade for the president. We lined up all the press—there must have been about seventy of us at that time —and some of the staff, and we got pots and pans, cans, garbage lids, anything we could make a noise with. A couple of people had harmonicas, and we all formed a single-file snake line and came past the Truman residence.

The president and Mrs. Truman came out, and they got a big kick out of it.

We had a feeling of family with Truman that I have never known with any other president. Maybe we were too much like family, but I don't think that it clouded our judgment, and I never regretted it.

One of the photographers, Henry Griffin of the Associated Press, was always going to the Navy Chiefs' Club. One Christmas, or near Christmas, he found out that a couple of the chiefs had time for leave but there was no way to get off Key West. So he went to the president and told him, "There are a couple of GIs here who would love to go home, but there's no way for them to get out. Why can't we get them as far as Washington on the mail shuttle?"

The president said, "I don't see any reason why they couldn't fly them there. Tell the commandant."

So Griff went back and told the commander, "The president says it's OK. He can't see any reason why these two chiefs can't fly as far as Washington on the mail plane." They put them on the plane and they got out that way.

The 1948 campaign on the cross-country Truman train was a very successful swing. Many incidents occurred, both funny and informative, that reflected on the Truman campaign style.

I remember one night when I was sound asleep and was awakened by a pounding on my door. It was the porter saying, "You'd better get up, because the president is on the back of the train in his pajamas and he is talking to the railroad workers!" So we all ran back, and there he was, as described.

One of the funniest incidents that took place was, I believe, in Iowa. We photographers were always looking for some gimmick to establish the location of our presidential shots. I was standing back below the train, under the president, and there I noticed a little girl about two or three years old with her parents. She had an ear of corn in her hand.

I said, "Hello." She said, "Hello."

I said, "Is that for the president, that ear of corn? Do you have something for the president, a present for the president?"

So she looked at me with great big eyes not saying anything. But her father said, "Yes, yes, that's for the president."

I went over and got one of the Secret Service agents and said, "Look, here we are in Iowa, corn country, little girl, ear of corn, gift for the president. What a combination for a picture. Why don't we get her up and give the president the corn, and then we'll get this nice shot?"

He said, "Wait a minute, I'll talk to him." He went up and the president said, "Sure, hand her up."

So we handed her up, and here is a little girl, the corn, the president, and his smile. The president said to her, "Well, I understand you have a gift for me, this ear of corn."

She said, "No sir, I happened to be passing past the pigpen and picked it up." With that he let out a roar and we got a wonderful, wonderful shot.

During the 1948 campaign, the president made a stop at Dexter, Iowa, where they were having the annual plowing contest, a big event at which the president and whoever was running against him usually made their major farm policy speeches. We were going down a long row of airplanes—I've never seen so many airplanes parked on both sides of the road—with farmers sitting either on the wings or on the struts somewhere, watching the president come by. They were very stony-faced. No reaction. Just watching. When the president got out of the car to make his speech, he looked over at me and said, "George, those farmers are not going to vote for Dewey. They're making too much money under me."

The reporters had literally given up on the president's chances of winning the election. And we were making so many stops that they wouldn't go around the back to listen to him anymore. They would just stay in the press car on the train, listening to his speeches as they were being piped in and playing cards.

In Truman's eyes, no group standing by the tracks was too small for a personal presidential greeting. Many were the times the train slowed to a crawl as he leaned out to grasp hands, looking into eager, friendly faces, greeting people warmly, asking for their vote, and blasting the Republicans. All in the space of about thirty seconds.

As I walked back to the press car after one of the stops, I said to the group, "My God, that was a big crowd back there listening to the president this time!" Merriman Smith looked up at me and said, "What were they, high school kids?" He continued to play. He also announced in an offhand way that he was leaving the Truman train in the next two days to pick up the Dewey campaign train, because he wanted to become acquainted with the incoming president.

Well, needless to say, the word got down to Harry Truman and he was very annoyed. He felt betrayed, not so much because Merriman was going off to join the Dewey train but because of his calling Dewey the incoming president.

We didn't see Smith again until after the election. I was outside the Blair-Lee House, home to the Truman family during a White House renovation, waiting for the president to come out and walk across Pennsylvania Avenue to his office. I wanted to make a picture of him as a newly elected president. Smith was also waiting at the curb.

President Truman came walking across the avenue in that familiar brisk military stride. Smith walked halfway across the street to meet him and said, "Congratulations, Mr. President! Congratulations!" The president continued walking, Smith keeping pace (walking crablike sideways), because the president never hesitated. Truman looked up with his great big grin and said, "How's Dewey?" Smith was never able to regain his standing with the president.

When it was announced that the White House was being renovated, Truman took us on a tour to show what needed to be done.

The ceilings were in bad shape. They had placed bars from the roof to the floor of the residential quarters in order to support the ceiling below. The president took us into his private lavatory, where there was a bar leading straight down through the bathroom from the roof to the floor that was the ceiling of the East Room.

The president commented, "Many a time I've come up here during a diplomatic reception and I have flushed this toilet and I always imagined myself landing down there in the East Room. I wonder how the dean of the diplomatic corps would have handled that entrance," he laughed. "Me with my pants down and the toilet flushing 'Hail to the Chief'!"

He also pointed out where he was adding a balcony directly off the family quarters facing the South Lawn of the White House. He said that not only was the balcony needed for the president's relaxation and to afford a beautiful view of the back, but that it would be architecturally correct and would balance the entrance below.

The president took a real beating on this proposal from everyone, but particularly from members of Congress. He was only a short-term president and he was ruining the view and he was desecrating the White House.

During the first year of Eisenhower's term, we were on the South Grounds; he pointed to the Truman Balcony and said, "You know, I gave Harry Truman hell about that balcony, but now that I'm in the White House and I've been using it, it's the best thing he ever did. . . . It's been an improvement both to the appearance of the White House and, in particular, to the presidential quarters. I can sit up there in the evening and enjoy the South Lawn."

One day I had an assignment to photograph Margaret Truman when she was still in college at George Washington University. I made a pretty nice picture of her, a standard shot, and it ran full page in the *New York Times Magazine.* It

showed a very nice smile, and it also revealed her knees. Just barely. I didn't think anything of it.

I was in the Press Room the day after the picture ran, and I got a request to come in and see the president. He wanted to have a talk with me, I was told. I walked into his office not knowing what to expect.

He was behind his desk. When he saw me, he rose with a copy of the *Magazine* in his hand. Pointing to the picture, he asked with mock seriousness, "What are you trying to do, make presidential cheesecake?" and then let out a terrific laugh.

When the attempt on the president's life was made, I was on my way to the next appointment on his schedule, the dedication of the statue of Sir John Dill at Arlington Cemetery, so I missed this event. The picture I made afterward, at Arlington, was the most solemn I ever took of Truman.

During President Truman's term at the White House, I can remember only one incident in which he became really teed off at us photographers. This was during a routine "dog and cat" day, as we would refer to the Wednesday afternoon on the presidential schedule that included all the week's requests by members of Congress for the president to pose with the strawberry queen or the hog-calling champ or the world's largest hot dog.

This particular day we really had quite a list of dogs and cats. Finally, when we thought it was all over, we were informed there was to be one more shot. We decided, no matter what it cost, it would not be worth exposing any film for. We would just go in, fire a couple of bulbs without exposing any film, and come back.

Well it just so happened to be a picture that the president really wanted. One of his old buddies from World War I days had dropped in to see him. When he asked for the picture, nobody had it. We were all called in turn and made some excuse or other, but finally the truth had to be told. We were summoned back and informed that the president wished to see us. All five of us trooped in and stood there like schoolboys.

He was shuffling some papers around on his desk. After about ten seconds of forcing us to stand there, he looked up and said, "Don't ever let it happen again." We trooped out very sheepishly, and I never, ever did that again.

Harry Truman wore heavy bifocal glasses that unnaturally magnified his eyes. When photographing him, I found that if you used a certain angle, he made a weird-looking picture; like fish look in a tank, the top half of his eyes was normal while the bottom half was four times as large. Very strange and unnatural looking.

So we photographers, in sympathy, suggested that he give us one of his old pair of glasses. We would fix it up so that when we photographed him, he would look natural. What we really did was to remove the lenses and place some plain glass in there. We discovered, however, that the change was not sufficient, because we got reflections. So we simply removed the lenses and went in one day and presented him with his frames.

He put them on and we made a few shots and he seemed pretty content. But the following day when he received the prints and looked at them, he said, "This is not me. I will not go Hollywood; I will be myself. I am what I am and these glasses are what I am and from now on, we'll just have to do with what I have."

In the mornings, President Truman used to like to take long walks, and he had a set routine. He'd come out of the Blair-Lee House about six-thirty or seven in the morning and start walking, fast. In those days he had only three Secret Service agents actually striding with him. On his right would be Jim Rowley, who was head of the White House detail. Directly behind him about ten feet would be two other agents, and in the street there would be a Secret Service car following about fifty feet behind.

The president would walk straight down Pennsylvania Avenue to 14th Street; down 14th Street to the Washington Monument; up and around the Washington Monument; and back down 17th Street to the White House. During this time he would greet people. The early morning street sweepers, who would be out there with brooms and hoses cleaning the sidewalk, would call, "Good morning, Mr. President" and would get a "Good morning" in reply.

We photographers had a hard time keeping his pace. There was one AP man who was very overweight, and he'd run and he'd start huffing and stop, and then run and then stop, and run. One day, the president stopped. "I will always wait when I see a fat man run," he said.

It was on these morning walks that the president was likely to drop some of his more personal mail right into the mailboxes, correspondence he didn't want handled through the White House. These were handwritten letters that ripped the critics of Margaret's singing and some of the cartoonists that he didn't particularly care for.

Some of the White House staff would get after the Secret Service and say, "Why did you let him do that?" The agents would respond, "You tell him, not me, you tell him! How am I going to stop him from going to the mailbox?"

But I understand that after a couple of those hot letters got into print, the staff bought him a small personal mailbox with an attachment labeled "incinerator" in the bottom. They made a big thing of presenting it to him, saying, "Now you can write all the letters you want, but just be sure you mail them in this box."

A number of people today would tell you that they predicted Truman was going to win. Well, I was not one of them, though I hoped that he would. When I got back to Washington off the campaign train, I ran into Margaret Truman on Pennsylvania Avenue and she asked me how things looked. I replied, "I don't think they look very good." She sharply said to me, "You have no faith!" With that, she just turned on her heels and walked away.

The people who told me the president would win were few: Harry Truman himself; the "Boss," Mrs. Truman; Margaret Truman; Vice President Barkley; and Les Biffle, the Democrat who was secretary of the Senate. Tony

Leviero, who was covering the president's campaign for the *New York Times* and who was a very good friend of the Trumans, also predicted the outcome right on the nose. About two weeks before the election, when Tony was making one of his rare visits to our office, I told him that I didn't think the president was going to make it. He looked at me and said, "He's going to do it!"

In 1949, during the inaugural parade, the president and vice president seemed really like a couple of kids cavorting around. There they were in the reviewing stand in their high silk hats with their "coffee"—plastic cups with a shot or so of bourbon—in hand. It made a great picture.

When his new term was about a year old, I received the distinct impression around the White House that the president would not run for reelection. Of the many names mentioned for Democratic nominee, the most intriguing was General Dwight D. Eisenhower. Eisenhower had not declared himself as a member or favorite of either party then.

In 1950, while alone photographing the president, I brought up the name of General Eisenhower, to make conversation. The president's head snapped up and his jaw clinched. "I do not favor nor have I ever favored any military man being head of a political party. Eisenhower should stay in the military," he added. "That's where he belongs and that's where he does best."

As I was leaving his office, the president added one more thought: "I believe that in the whole history of the United States, only one military man would have made both a good civilian president as well as being a great military leader, and that person is General George C. Marshall."

Truman's salty contempt for political generals and General Douglas MacArthur's icy and condescending manner toward his civilian boss, ex-Captain Truman, had a great deal to do with the conflicts between those two strong personalities. In the end, of course, Truman prevailed on the question of maintaining civilian control over the military, firing the popular general in an act of great political courage.

But the fired general returned in his own political way, landing on the West Coast and proceeding in slow stages across the United States to the capital, where he had been invited to address a joint session of the Congress.

Publicity for this potential Republican presidential candidate swelled with each stop until he arrived in Washington to a tumultuous welcome and delivered his famous speech, telling us, "Old soldiers never die, they just fade away." The House chamber erupted with cries of "Don't go; we love you!" and "Damn that Truman!" from the Republicans, while the Democrats applauded politely.

Immediately after, Joe Martin, the House minority leader, sort of tiptoed out with his eyes all glistening and grinning from ear to ear. "How did it go?" one reporter asked. "Well, boys," he said, "all I can say is that there wasn't a dry eye on the Democratic side and there wasn't a dry seat on the Republican."

About a week before the end of Harry Truman's term as president, the members of the One More Club held a party for him in the basement of the Carlton

Hotel. Just the working photographers, still and theater newsreels. No bosses, no writers, no editors.

We bought him a watch with a ringing alarm, a real novelty at the time, and we told him now that he didn't have a whole staff of secretaries to keep him on time, maybe he would like to wear this watch. He put it on immediately, thanking us, and headed for the piano. He played, and we all sang "Auld Lang Syne" and a few other tearful half-drunken songs, the president enjoying himself as much as we. The Secret Service joined in also. There were fond farewells and pledges to visit one another, and he turned to leave.

When he got to the door, he hesitated, turned around, and in a loud voice addressing us all said, "You know, many times in my despair at the White House, I've wondered whether the president and the nation and the world would have been much better off if Harry Truman, instead of being president of the United States, had played piano at a bawdy house." Then he turned around and left.

Although he had suggested it would be a nice thing if the photographers asked President-elect Eisenhower to become president of the One More Club, we decided by voice vote at that meeting, in Truman's presence, to disband the club so that he would always remain its president.

One day near the end of his presidency, I softly asked Harry S Truman how he would evaluate his White House years. He replied, "I did my damnedest, and I never lost a night's sleep."

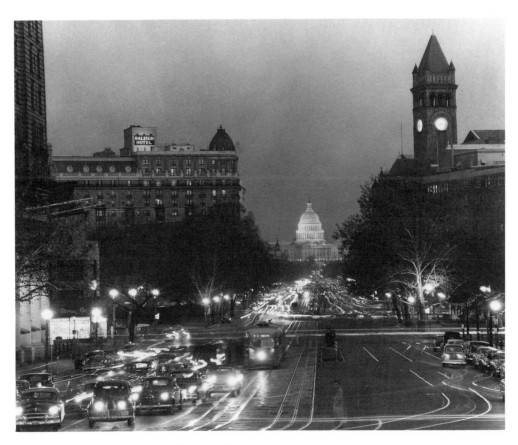

Night shot of Washington, D.C. Truman's Washington from 15th Street to the Capitol.

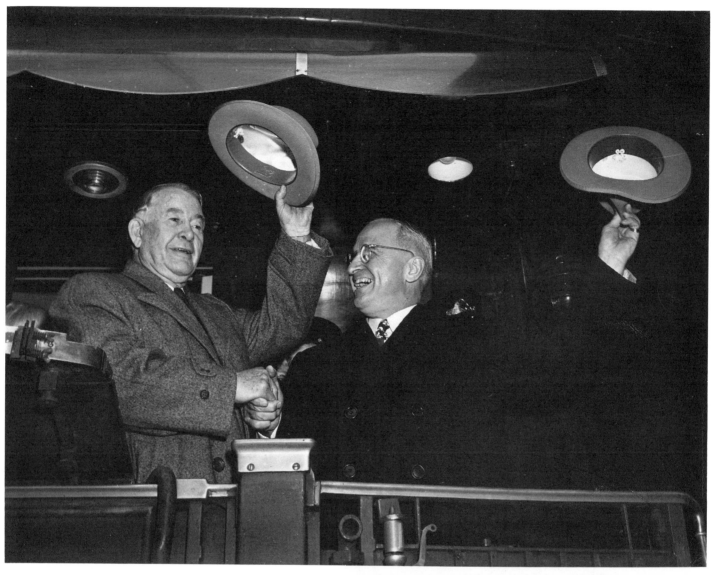

ABOVE

President Truman and Vice President Alben Barkley congratulate each other after election of November 1948.

RIGHT

Inaugural 1949. President Truman and Barkley toast each other with coffee. (And if you believe that, you believe in the tooth fairy.)

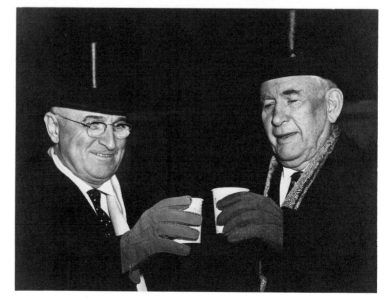

TOP RIGHT

Sir Winston Churchill in Washington, D.C., at Union Station. He was bound for Fulton, Missouri, with the president and made his famous Iron Curtain speech there.

BOTTOM RIGHT

President Truman conferring with former president Hoover.

BOTTOM LEFT

Congressman Richard Nixon (Rep., Cal.) copying part of the "pumpkin papers" buried by Whittaker Chambers during the Alger Hiss hearing.

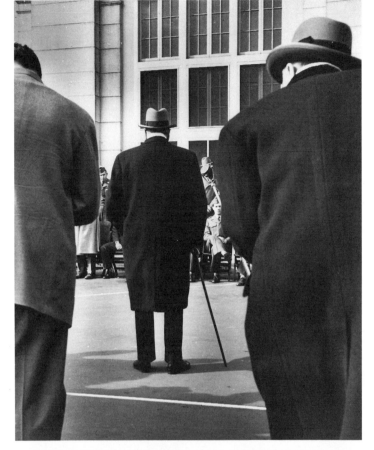

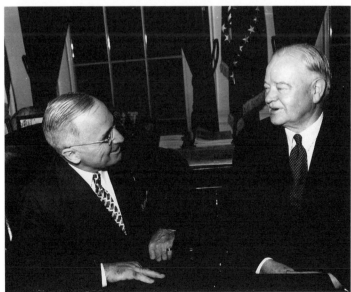

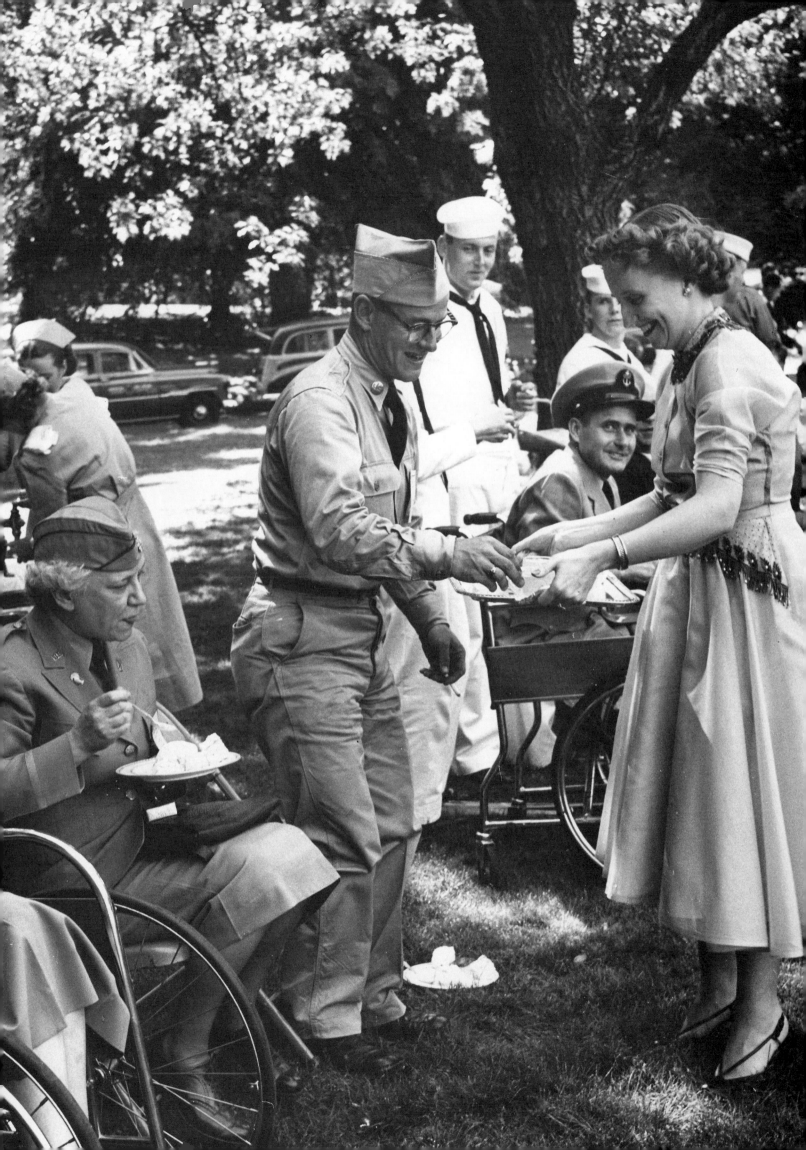

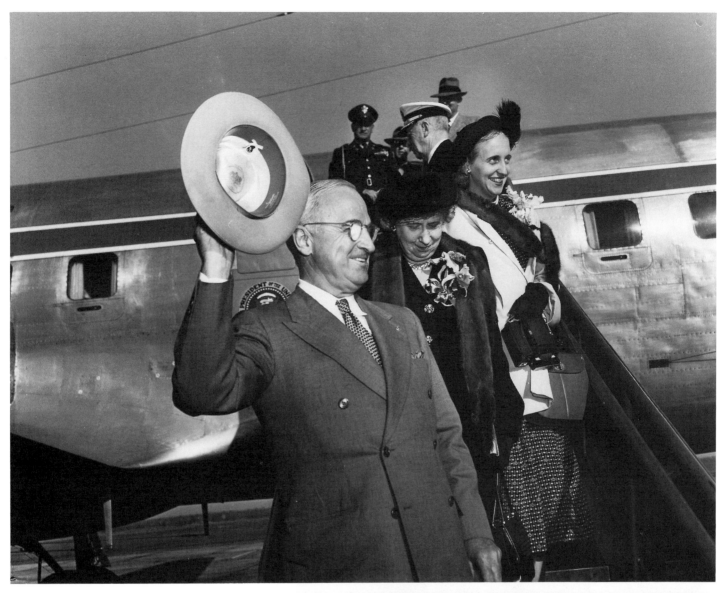

OPPOSITE

Margaret Truman serving refreshments to GIs from Walter Reed Hospital.

ABOVE

President Truman and family return from a visit to Key West, Florida.

RIGHT

Mrs. Roosevelt and President Truman at a Democratic dinner rally at the Mayflower Hotel, 1949.

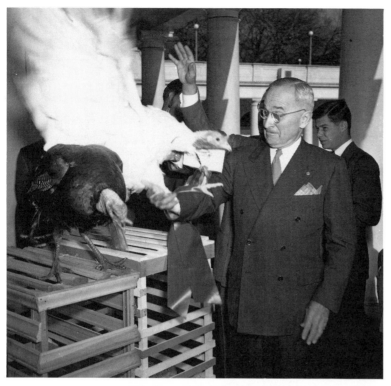

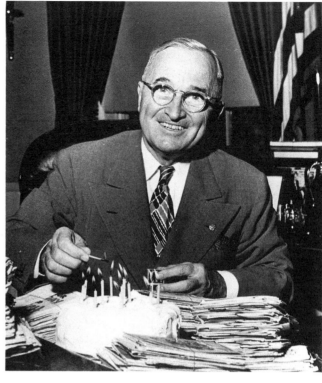

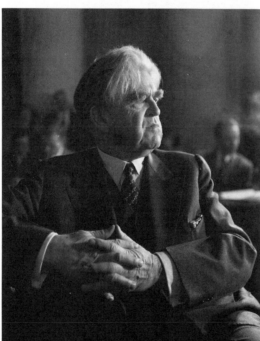

TOP LEFT

The annual "turkey shoot."

TOP RIGHT

President Truman's sixty-third birthday cake, 1947. After he lit the candles he cut the cake up into small pieces and offered them to us. We proceeded to have a little party.

LEFT

AFL-CIO president John L. Lewis during a hearing on Taft-Hartley labor legislation. He is looking at Senator Taft, one of the originators of the bill and a political opponent of Lewis. Senator Taft said at this time, "Mr. Lewis, would you say you were blowing your own horn?" And Lewis in his deep, pontifical voice replied, "Senator, if one doesn't blow one's horn, said horn would never be blown."

BELOW

Secretary of Defense James Forrestal during Senate Foreign Relations Committee hearing.

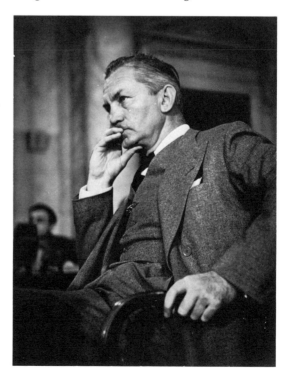

RIGHT

Harry Truman and his military aide, General Harry H. Vaughan, walking from the Blair-Lee House to the White House, with a Secret Service agent on the left.

BELOW

President Truman meets with members of his cabinet on the grounds of the White House after he made an emergency return to Washington following the outbreak of the Korean War.

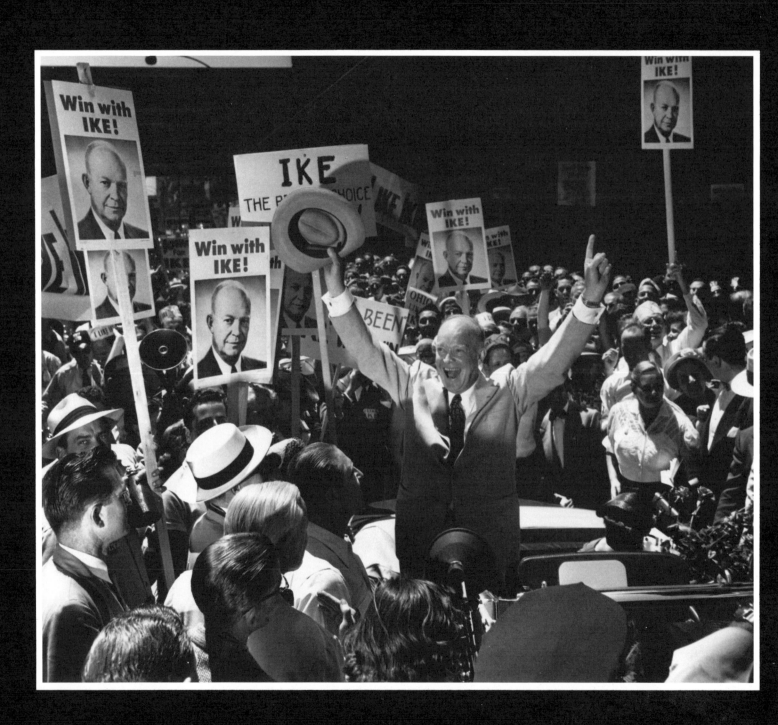

IKE

Eisenhower was a soldier all his adult life, including his presidency. Despite the upstretched arms and wide grin displayed with great effect during the 1952 campaign, Ike was a real shock after the easygoing Truman years. Photographers were no longer family but media troops, ranking no higher than master sergeant and not worthy of cultivating.

In his eight years as president, I know of no photographer and only one reporter who could claim a bond with Eisenhower. That person was Arthur Krock, bureau chief of the *New York Times*.

Truman's successor made one brilliant stroke with the press: He selected Jim Hagerty, former national political correspondent for the *New York Times*, as his press secretary. Jim guarded Eisenhower's door, and the president made few mistakes with the media.

I consider Jim Hagerty the most effective press secretary in the White House during my fifty-year career. He planned the weekly Eisenhower press conferences which supplied so much information to the media that they had very little time to go poking around for themselves. He and other staff members prepared Ike by asking questions on the topic of the day. Then they would analyze the president's answers and suggest changes, a technique still being followed in the White House.

Ike's press conferences were not broadcast live but were captured on newsreel film for use by TV and theaters. All the film was shown in Hagerty's office, and he would censor the shots or the remarks that he wanted cut or modified to prevent any "misstatements." Nor was Eisenhower to be quoted directly unless authorization was issued by Jim Hagerty's office.

If Ike had the answer to a direct question, you would get a direct answer, but if he didn't have the answer, you could always count on his style of double-talk, a profusion of words tumbling out that sounded like English sentences but left you not knowing what the hell he was saying.

He would start by saying, "Well, now" or "Well now, and then I will say . . ." and all the while his mind would be racing as he tried to marshal

Eisenhower during the campaign. This picture was made as he arrived in Chicago for the 1952 Republican convention.

his thoughts. He was not exactly inarticulate, he just worked his mouth, zigzagging along until he'd finally decide what to say, and then he'd say it. Following a laughing Hagerty and Ike from a press conference one day, I heard the president remark that he had really put one over on the boys with his double-talk and stalling.

Under Hagerty's press conference rules, reporters asking questions had to stand, identify themselves and their newspapers, then proceed to the question. This led to some commotion during news conferences as reporters, realizing they might be on TV that night, became even more aggressive.

None was more aggressive than Sara McClendon, a stringer for several Texas newspapers who always managed, no matter how important or at what level the press conference was proceeding, to ask a purely local question involving an area served by one of her papers.

Ike tried to avoid pointing at her, but she was so persistent that his head kept turning toward her as if she were a snake charmer and he the hooded cobra. Finally, he would point to her and she would jump up and ask some off-the-wall question like "Mr. President, my name is Sara McClendon and I represent the *Walhalla Bugle,* a small but powerful voice in west Texas. Now, what about that bridge over the Watchtachi River?"

With that the president would cock his head, give a quizzical look, not knowing what to say, and Jim Hagerty would jump up and whisper into his ear and the president would say, "Well, yes . . . we will let you know later today from the press office; we are looking into that."

The next week she would announce that she was from the *El Paso Times,* and the following week from another one of her papers. After about four or five weeks of this, one day Ike stopped her in the midst of a question and said, "Excuse me, lady, but do you get fired every week?" The room roared.

Ike's press conferences were always relaxed. He was by nature a smiling, genial fellow who enjoyed jokes, even on himself. Though he laughed at mine, I always sensed an invisible wall between us. He was polite and considerate, but unapproachable. Shouts of "One more, Mr. President" did not fall lightly on the ears of this commander in chief, particularly during ceremonial occasions.

Every president from Harry Truman on has received a camera from members of the White House News Photographers Association and has been encouraged to use it in hopes that he would be more aware of our problems and more sympathetic to some of our requests.

Eisenhower became fascinated with instant photos and used the Polaroid we gave him extensively during a trip to the Gettysburg farm that he had just purchased. Before construction had begun on any of the buildings, he photographed the woods and fields and was very pleased with the results. As we were standing there I said, "Mr. President, why don't you make a picture of us photographers?" He did so and gave me the copy. I wired that picture up to the *Times,* which ran it with his credit, and I got word that he was very pleased with his first byline.

While we were at the farm, I noticed a large sign directly across the road. It read FOR SALE, 40 ACRES.

I said, "Mr. President, see that sign over there?"

"Yes."

"I'm going to buy that land."

"Yeah?"

"You know why? Because when you build your house here, there's going to be quite a bit of traffic coming down this road, and I want to put up a hot dog stand over there. I think it would be great. I can just see it now in my mind's eye."

Well, he didn't see the joke. The next day, he bought that forty acres across the road.

Ike loved Gettysburg. His and Mamie's home was a farm on the edge of the famous battlefield. It occupied part of the line of the Confederate right flank, and some of Longstreet's troops rested there. Ike would reenact in his mind the epic battles that took place, putting himself first in the position of General Lee and then in the position of General Meade. He would analyze the actions of the various commanders on that first day's battle, offering criticism and speculating on what he would have done under the same circumstances.

I pride myself on knowing something about the Civil War, and once, when ex-President Eisenhower made a comment about a particular move by one of Lee's lieutenants, I pointed out that he was wrong. I had in my hand a book by Douglas Southall Freedman, which documented that Lee's orders were to the contrary of this modern-day soldier's opinion, and that Lee was correct. I made my remarks with a smile, and he accepted them with a grin.

In 1962, I was assigned to Gettysburg to photograph Ike at work on his memoirs. His office was an old red brick building on the site of Gettysburg College and within the old Confederate lines. He worked very carefully and very extensively with his collaborator, William Bragg Ewald, Jr., and I photographed the two of them together.

I asked Ike if he missed Washington and he said really he did not. Like an old soldier, he could feel ghosts all around him at Gettysburg. For relaxation he loved to take leisurely walks from the college along Seminary Ridge, which was the main Confederate line, and over to his home, which bordered the ridge. Ike said that they helped clear his mind from concentrating on the memoirs. He remarked that when he walked along Seminary Ridge, he felt part and parcel of that epic battle.

I asked him what he would have done if he had commanded instead of Lee. I wanted his judgment to be based not on hindsight but on an estimation of what he himself would have done there under the circumstances.

"I would have retreated after the first day's battle," he said. "Lee's original battle plan was good. I believe I would have followed the same strategy."

This battle site was not critical in Lee's overall invasion strategy. Lee's basic tactic was to smash the strung-out Union forces racing up from Baltimore and Frederick, Maryland, roll them up, and then crunch them into the main Union forces. But Confederate commanders were unable or unwilling to march as fast as ordered, enabling the main Union forces to arrive on the scene and occupy the opposite ridge, Cemetery Ridge, and prepare for battle the next morning.

With the Union army in full force, Ike said, he would have retreated and

saved the bulk of his army. Under cover of demonstrations and loud preparations for battle, units of the Confederate army would have been ordered to retreat rapidly toward Harrisburg, with the bulk of the army to follow during the night. Ike would have picked a site on the outskirts of Harrisburg and repeated the tactics laid down at Gettysburg: Roll back the advancing thin lines of Union troops, force them in on themselves and into the other units, and win the day.

That was the last real conversation I ever had with General Eisenhower. All other contacts until his death were during photo ops, where only a few words were exchanged.

One such occasion was the day the "Ev and Charlie Show" played Gettysburg. Senate Minority Leader Everett Dirksen and House Minority Leader Charles Halleck held a weekly press conference to publicize the efforts of the Republican minority in the Congress. Since this show had very low ratings, they decided to jazz things up by having it in Gettysburg with Eisenhower, figuring the media could not avoid them. They got a pretty good turnout.

During the conference, Dirksen, in that pontifical voice of his, turned to Eisenhower and said, "Mr. President, I understand that people have called the *Washington Post* and complained that when they look at the TV listings, they do not see the 'Ev and Charlie Show' and demand to know why."

Ike laughed and he said, "The *Washington Post*! Why, I wouldn't have that paper around me when I was in the White House. One day there was nothing to read, so they handed me the sports page of the *Washington Post*. But I must admit, Ev, that Shirley Povitch, for a woman, really is a hell of a sportswriter!"

Several of us laughed. Dirksen had a dumbfounded expression on his face. Ike was looking at him blandly, and to this day I just don't know whether the president actually knew that Shirley was a male and was merely pulling a monumental joke on Dirksen.

The Eisenhower years in Washington were orderly, peaceful, and dull. Wednesdays in particular were usually light days at the White House. The president's schedule was cut short so he'd have the whole afternoon free. Everyone knew it and planned accordingly. Ike would go out to Burning Tree to play golf, and the whole city seemed to lie back with a sigh. In later years with other administrations, when crises seemed to come tumbling over one another endlessly, I yearned for those long, lazy, sweet Eisenhower Wednesdays.

Coverage of the president at Burning Tree was simple: We photographed him teeing off, and that was it. Or by prearrangement we met him at the fifth or sixth hole and just stood by photographing as he and his entourage came up the green.

We would watch them putt, make the hole, and then leave. One time I observed what I thought was the secret of Ike's low scores. He missed the putt about six inches. One of the other players kicked the ball and said, "You made it." And Ike took it.

When Ike was army chief of staff assigned to the Pentagon, I was asked to go over and shoot a possible *Magazine* cover and layout on him. I spent about a

week trying to get through and was rebuffed repeatedly, because at this point it was rumored he was going to run for president on the Republican ticket.

In frustration, I was hanging around outside his office when he came out and headed for the men's room. I immediately got into lockstep with him. We stood side by side in the urinal, and while peeing away I made my big pitch about why the *Magazine* needed his picture. Relieved, we immediately turned around and headed right back to his office. Over the next two days, I got everything I wanted.

The White House policy that photographers become deaf while in the president's office was strictly adhered to under Eisenhower. Every word was privileged, including what few exchanges he had with us.

One day, while we were in photographing him with a high official from the German government, Ike spoke long and passionately about what he thought of the Soviet government, the threat and the role to be played by Germany supported by the United States.

Going back to the Press Room, I kept reviewing his conversation in my mind, and I felt so strongly about it that I sat down and typed two pages of remarks between the president and his visitor. I then walked into Jim Hagerty's office and handed over the typewritten pages, saying, "Jim, this is what I heard. This makes the president look real good, and I think I would like to use it. I would like to give it to the *Times*."

Jim took the papers from my hand, read them, nodded, and tore them into four little pieces.

I said, "My God, Jim, what are you doing?"

He answered, "This time Ike's comments are favorable, next time they may not be. I do not want to establish a precedent."

Another example of the lengths to which Hagerty would go to protect the president occurred one day when Eisenhower was heading for Georgia for a golfing vacation. I spotted Hagerty coming out the side door of the White House with a large stack of papers in his hand.

I yelled, "Hey, Jim! What have you got there—the president's extemporaneous remarks?" Jim broke up and almost fell down.

I repeated, "What have you got there?"

Saying nothing, he just brushed off a little dust. I said once more, "Come on, tell me, what have you got there? Let me see."

And he did. He had copies of proclamations, appointments, and various minor announcements that the president made daily. He used to hoard them until he had a great stack and would take them along when the president traveled, passing out a few each day to give the illusion that the president was busy with affairs of state, not spending all his time on the golf course.

This is another Hagerty technique used by every subsequent president to make himself look good when he's on holiday.

When Jim Hagerty announced that the lid was on, you could count on the fact that there would be nothing more out of the temporary White House for the day, and that you would not be scooped on any action by the president.

One day in 1953, when President Eisenhower was visiting his brother, Milton, who was president of Penn State, Hagerty announced the usual lid

after his morning briefing, and everybody went his merry way.

I took a long walk around the campus. When I came back toward Milton Eisenhower's house, the Secret Service car pulled up and out stepped Eisenhower and his brother holding fish. I whipped out my camera and made pictures.

Hagerty heard about it immediately from the Secret Service. He called me in. I told him, "I was there, it was happening in front of me, and so I made it." He replied, "You should not have made it." Some of the other photographers had heard about it, he said, and it put him in an awkward position.

He went into the house and talked to the president and his brother, and they came outside again with the fish. Hagerty in the meantime had called the other photographers, who then took almost the same picture that I had. I cannot imagine any president since Ike who would have done this for the media, just to protect the word of his press secretary.

Eisenhower, the poker player who could have had either party's nomination and been elected, finally declared himself a Republican in 1948 and cast his vote for Thomas Dewey. Four years later he received the party's nomination and was elected president.

Governor Adlai Stevenson of Illinois, who was the Democratic nominee in 1952 and 1956, once told me he thought he was running against everybody's grandfather, and that if Ike wasn't everybody's grandfather, then everybody's grandfather should be like Ike.

Ike wasn't a shoo-in for the nomination in 1952. The conservative Republican party, led by Senator Robert Taft of Ohio (who had presidential ambitions himself), resented the intrusion of this late arrival and his liberal supporters and, more important, his declared liberal leanings. Taft was the regular Republican party's favorite. He had the delegates and he wasn't going to give up easily.

Several days before the opening of the Republican convention in Chicago, Senator Taft made a campaign swing by small plane, stopping at various county and state festivals. I went along with him for this whole swing, coming to know and admire Taft more than any senator I had previously met.

We stayed overnight in Indianapolis and the next morning took an early train for Chicago. I spent that time in Taft's little compartment room, where we discussed the pending Chicago convention. He showed me his charts of the delegates and listed those pledged to him, expressing confidence that he would be nominated on the first ballot. According to his calculations, he had 156 or so more convention delegates than he actually needed.

When we arrived in Chicago, we were met by a hoard of screaming young Ike supporters holding high the signs on which were written their chanted slogan, "Thou must not steal, thou must not steal." The din was unbelievable. This racket over the disputed seating of a southern delegation pledged to Taft was the opening ploy in a campaign that successfully denied the senator the nomination. It came to a floor fight, which Taft lost over the legality of seating the delegation. On the first ballot neither Ike nor Taft received enough votes. On the second ballot, Ike went over. I believe that if

Taft had received the nomination in 1952, Adlai Stevenson would have been elected president.

Stevenson's reply to a reporter asking how it felt to lose the election is a classic: "It hurts too much to laugh and I am too old to cry."

I remember Bob Taft on that little campaign plane opening a copy of the *Washington Post* to the editorial page and seeing a particularly vicious cartoon of him by Herblock. He just sort of grinned and said, "Hmph, I don't really mind, but I do wish he wouldn't make me look so Oriental."

Campaigning with Eisenhower in 1952 was sheer pleasure. The candidate used a large prop plane, into which his staff, the Secret Service, and all the media—a much smaller group than today—could fit. There was free access between the press section and the candidate, so anytime you wanted to say something to Ike, you just strolled up and sat down next to him. I told him once that I had just come from the enemy's camp, that I had been following Adlai Stevenson the whole previous week and that now I was to spend a week with him. "I do not consider that an enemy camp," he told me sharply. "He is my political opponent, and I have great respect and admiration for Mr. Stevenson."

The Eisenhower White House was organized along the military lines with which the new president was most familiar. He believed in logic and order. He was disciplined and realistic, and he admired others who had the same qualities. That is why most of his friends were heads of corporations, managers of large businesses, fellow officials, and leaders in industry.

Eisenhower chose as his chief of staff Sherman Adams, a short, thin, rugged, tough-talking New Englander who gloried in his position to the extent that he referred to himself as "deputy president." On his desk was a large replica of the presidential seal. Other members of Ike's team were given slots according to their individual talents and made responsible for their own actions. The entire staff mirrored Ike's public image: squeaky clean, efficient, hardworking, loyal, and largely middle-of-the-road conservative. And no one reflected these qualities more than Ike's New England friend, Sherman Adams.

For six years Adams served his president with devotion and unprecedented energy. He had Ike's complete confidence and support. A very good organizer, Adams had presidential abilities and almost the same power. He was an asbestos-tough, no-nonsense, do-your-job-and-be-quick alter ego of Ike. Staff and Cabinet were subject to his will, and though he had few friends and many enemies, Adams had the friend who counted most, the one who occupied the Oval Office.

It came as a complete shock when reports emerged that "Mr. Clean" had been bribed to do official favors for New England textile manufacturer Bernard Goldfine. Adams denied the charges. He admitted only to receiving a vicuna coat and an Oriental rug, which were personal gifts from Goldfine, and insisted that he had in no way interceded with any government agency on Goldfine's behalf. Sherman Adams also pointed out that the total value of the gifts was about three hundred dollars, hardly an amount that would

constitute a bribe. But Vice President Alben Barkley's definition of a bribe was cited again and again: "If you can't eat it in one sitting, or drink it in one day, it's a bribe." (Senate Majority Leader Lyndon Johnson opened the Democratic senatorial campaign committee meeting on the Hill one day by announcing, "Well gentlemen, Mr. Clean farted in church.")

Public hearings were held with both Goldfine and Adams as witnesses. A committee report also revealed that Goldfine had paid about three thousand dollars' worth of hotel bills for Adams and, what's more, had deducted that amount from his income taxes. With reluctance, the president forced the resignation of his good friend.

My working relations with Adams had been cordial, dating back to a series of pictures I made of him behind his desk, with the imposing seal of the president hanging in front. I called him up intending to ask permission to photograph him on his last day. He was about to leave and get into his beat-up old Ford convertible on West Executive Avenue and drive away.

"I'd like to get a picture of you on your last day," I said.

"What kind of picture do you want?"

I tried to ease the tension by making a joke. I said, "I would like to have you wear your vicuna coat and stand in the middle of the Oriental rug as Ike bends over and pulls it out from under you."

A moment of silence followed. Then, in his same icy-edged normal voice, without any increase in emotion, he said simply, "Go to hell, you son of a bitch," and hung up.

It was a cruel and unnecessary joke, one that I will always regret. Making light of tragic events sometimes eases the pain, but there are times when a person should keep his mouth shut.

Four official portraits were made of President Eisenhower during his eight years in the White House. Three of the four were mine. The first one, taken in 1953, was also used for the Eisenhower stamp. One of my proudest possessions is a sheet of the original run, which I received during a White House ceremony presided over by President Nixon and Mamie Dodd Eisenhower, and I also affixed my signature.

The picture had been made just before President Eisenhower went on national television to announce the end of the Korean conflict. For years I had watched the president make a familiar gesture while reading. He would be deep in thought, whip off his glasses, and stare off into the distance while thinking. Then he would put on his glasses and continue reading. This would continue off and on. As I was watching him read the text of the speech he was going to give announcing the end of the war in Korea, I eased over near him, and when he made that familiar gesture, I moved around quickly and made one exposure—light held high to give it drama.

The moment the other photographers saw the flash go off and observed what I was doing, they came running over and tried to make the same picture. But, by then, Ike was his same smiling self and the moment was gone. I was the only one who recorded it.

The photo was blown up to 8 x 10 feet and used as a backdrop for the annual White House News Photographers dinner for the president. I was

secretary of the organization at that time and sat near Ike. I kept glancing up at the picture, and then he'd glance up, then I'd glance up again, and then he'd glance up. I kept waiting for him to make some comment.

Finally I offered, "Mr. President, I made that picture."

And he said, "Oh! I like that picture, and do you know why?"

"No, Mr. President, why?"

He replied, "Have you ever seen a smiling picture of Lincoln?" With that I broke up laughing, while he just looked at me straight and serious.

I said, "Mr. President, you know as well as I do that Lincoln was one of the greatest storytellers in the White House, and the only reason we don't have a picture of him smiling is because the film was so slow in those days that one's head had to be clamped and one did not make movement for a full minute. And Mr. President, even you can't hold a smile for one minute."

He laughed and he said, "Well, there goes another of my theories."

Of his three relaxing passions—golf, fishing, and outdoor cooking—golf was far and away Ike's favorite. He kept a favorite driver in his office, and on the spur of the moment he would pick it up, grab a bag of balls, step out to the back of the White House, and drive that bag of balls down toward the southeast end of the White House grounds, where one of the mess orderlies was assigned to pick them up.

And, of course, there is the famous Ike Putting Green in the backyard of the White House. Much as the president loved this green, the White House squirrels loved it more. They would dig into the green, raising little mounds and causing Ike to miss some very easy putts. This led to tension and anger instead of relaxation.

The president consulted the White House grounds keepers, and they came up with a unique solution, which I was told was coded Operation Squirrel Seduction. A small plot of ground next to the putting green was lightly cultivated, smoothed over, and covered with peanuts and other goodies so that the squirrels would take to this area and leave the green alone. Operation Squirrel Seduction was a disaster. The squirrels loved their patch of ground, but they loved Ike's putting green even more.

"The bastards are worse than ever," the president is said to have lamented.

A further conversation with the grounds keepers resulted in a new operation, code name Exodus. Squirrels were trapped and then released about a mile away, in the vicinity of the Lincoln Memorial, where they would find new homes. This worked—for a short period. All of a sudden the squirrels were back at their favorite place, Ike's putting green.

Then they were retrapped and this time taken about five miles away, in the Rock Creek Park neighborhood near Silver Spring, and they never came back. In fact, the White House squirrel population suffered a dramatic decline. However, small traps were to be observed around the putting green for years, and an occasional squirrel was shipped out to increase the population in Silver Spring, which resulted in a more contented president.

Ike wore his golf shoes in the Oval Office and his spikes made pits in the cork floor that edged the rug. After I pointed them out to JFK the first week

of his presidency, he liked to show them off to visitors. They became items of national interest, like dinosaur tracks, something to remind us of our past.

When the Oval Office was renovated and the cork floor removed, I suggested that pieces of it be made into souvenirs and handed out to favorite visitors. This suggestion was adopted, and I have one of those pieces.

Reportedly it was not unusual for Ike to leave a boring meeting or a staff conference that didn't seem to be getting anywhere, instructing the group, "You fellows come to some decision and I'll be back in twenty minutes." He'd go put on his golf shoes and grab his club and a bag of balls. It was a good way to relieve tension and to clear his mind before he went back to the meeting and the decision making.

One day in 1956, the *Times* assigned me to make a picture of the empty Oval Office to illustrate a *Magazine* piece on the presidency. The picture ran half-page, and we received nine letters from around the world from sharp-eyed readers who had spotted the head of Ike's driver hidden behind the TV set in his office.

I never saw it while I was making the picture; never saw it when I was making the print. But readers spotted it and sent letters to the editor asking for an explanation. That's where he kept the driver tucked out of sight, and whenever he wanted to use it, he'd just reach back, grab it, and take off.

I have always harbored the opinion that President Truman's spite toward and unpleasant memories of Ike were largely due to Eisenhower's decision not to join the Democratic party—the party and administration, President Truman felt, that had given the general his chance to become famous.

Ike's undisguised disdain for Truman was unrealistic, and I always thought it ran contrary to this military leader's basic ability to see the viewpoint of others. But that failing may have enabled him to run the nation in spite of a Democratic majority in both houses of Congress. His ability to corral and charm Senate Majority Leader Lyndon Baines Johnson and House Speaker Sam Rayburn was unprecedented. He suffered LBJ's annoying conspiratorial style of politics, though I saw him visibly cringe at the senator's habit of putting his arms around a person and literally breathing into his mouth. If LBJ didn't convince you with his voice, he would numb you by depriving you of oxygen. Ike tried to back away, his grin tight, without giving offense.

Eisenhower's years in the White House were a time of peace and prosperity, but in my view his administration had three glaring faults: (1) the president's stand on civil rights, (2) his inability to fight Senator Joe McCarthy, and (3) his decision to go with a navy satellite, the Vanguard, enabling the Russians to put Sputnik into space first.

On civil rights, the most charitable thing I can say is that he was inactive. And the most damning is that he was reactionary.

Eisenhower's reluctance to use his powerful office and personal prestige to counter the demagogic Senator Joe McCarthy will always be a black mark on his record, and his failure to publicly defend his friend and mentor, General George C. Marshall, was unforgivable. For over a year the nation was

paralyzed by McCarthy's charges that many agencies of the federal government had been infiltrated by Communists or fellow travelers. It was left to the media, in particular to Edward R. Murrow, to show McCarthy for what he really was, an effort that received no help from the White House.

Regarding Sputnik, the president knew the Russians were rushing to be the first nation to put a satellite into space. In spite of this knowledge, he decided to go with an entirely new program, labeled Vanguard, to be built from scratch by the navy. It would have scientific and civilian application, and it was to be kept as far away as possible from our own military space program, headed by former German scientists.

Shortly after the Vanguard program was announced, I was in Huntsville, Alabama, where the German scientists, headed by Wernher von Braun, were working on our Jupiter missile program. I asked von Braun his opinion of Vanguard.

"Too sophisticated, too sophisticated," he said. "All we need to do is cluster four Jupiters and put a satellite on top. We'll be in orbit in three months." But a year was to pass before von Braun and his team were able to put that plan into effect. Meanwhile, Sputnik circled the earth first.

No matter what we thought of Eisenhower at the end of his time in office, he may have come to a slightly higher opinion of us by then. I understand that as he neared the end of his term, he told a close friend that the photographers, not the writers, were his friends. The photographers, he felt, could always be counted on.

Ike during the 1952 campaign wearing "I like Ike" eyeglasses. These were handed out by the thousands.

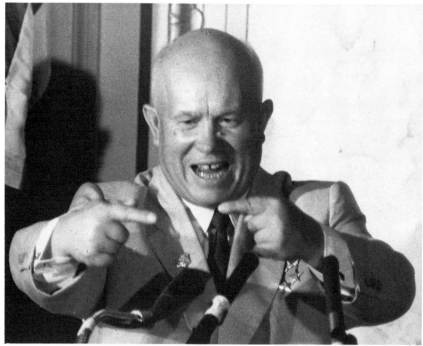

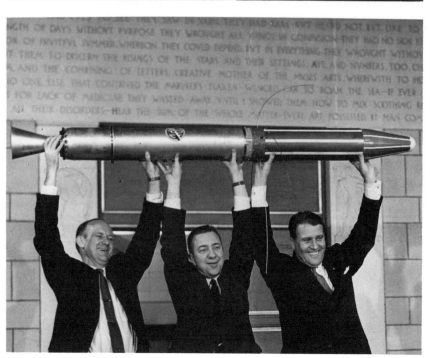

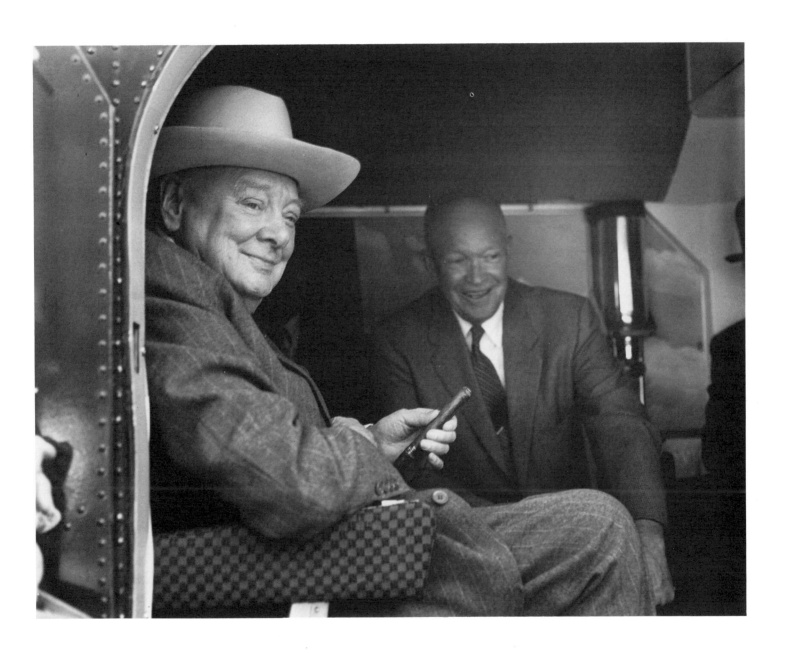

Army-McCarthy hearings, 1954—TOP LEFT: **Senator Joseph
McCarthy shown in center on stand;** BOTTOM LEFT: **chief
counsel Roy Cohn (left) confers with Senator Dirksen
(right);** RIGHT: **McCarthy on the stand.**

OPPOSITE, TOP

**Senate rackets committee hears Teamsters Union
president Dave Beck.**

OPPOSITE, BOTTOM LEFT

**Adlai Stevenson, Democratic nominee for president,
campaigning in Florida against Ike, 1952. Stevenson
holds a stuffed souvenir alligator.**

OPPOSITE, BOTTOM RIGHT

**Democratic candidate for vice president, Estes Kefauver
of Tennessee, smoking peace pipe with Blackfoot
Indians during campaign in the Dakotas.**

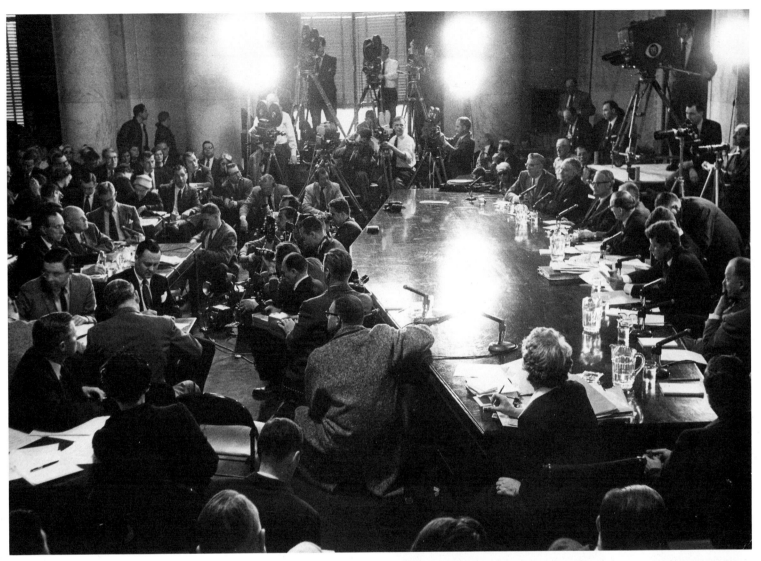

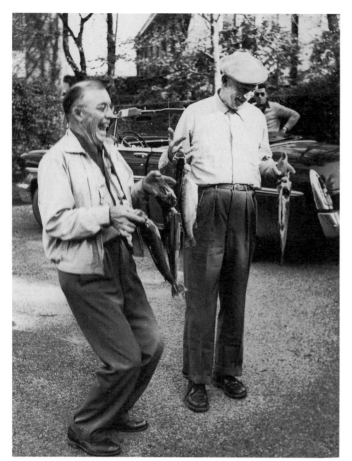

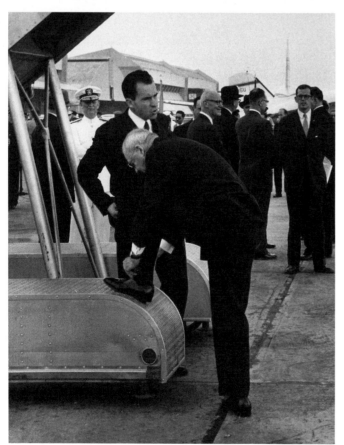

TOP LEFT

The brothers Eisenhower: President Eisenhower and his brother, Milton, at Penn State after they went on a trout fishing trip and returned with their catch, 1953.

TOP RIGHT

Mamie Eisenhower (left) and sister, Mabel Frances Doud Moore, kissing their mother, Mrs. Elivera Doud, during her visit to the White House.

LEFT

Vice President Richard Nixon and Secretary of State John Foster Dulles at National Airport, awaiting the arrival of foreign dignitaries.

OPPOSITE

Official Eisenhower photograph, 1953. The president asked news photographers for their favorite picture of him, and I submitted this one, which he chose for his official portrait. After his death Mrs. Eisenhower selected it to be depicted on the Eisenhower stamp.

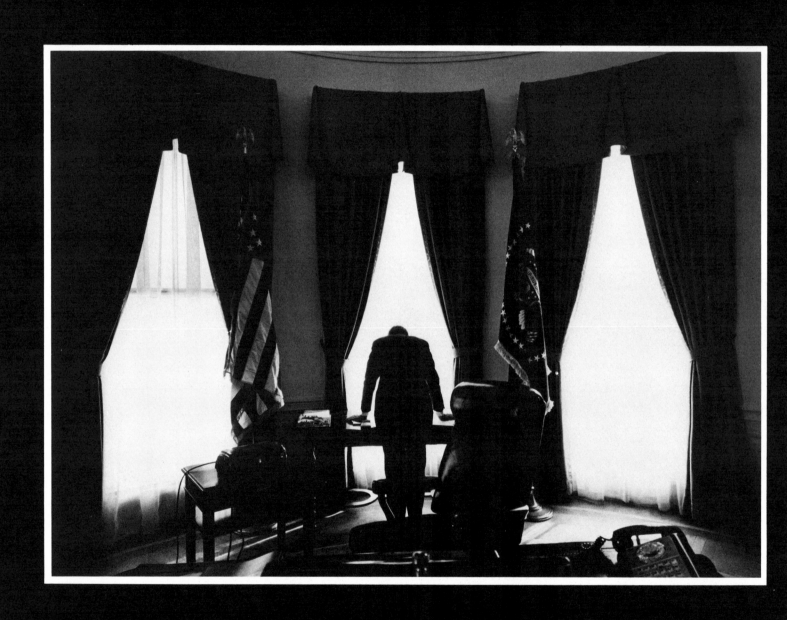

THE KENNEDYS

In the old State, War, and Navy Building, a woman's figure is silhouetted in one of the ornate Victorian windows overlooking the South Grounds of the White House. The room behind her is jammed with the personal effects of former President John Fitzgerald Kennedy. The soundtrack from a Broadway musical provides soft background music, King Arthur singing of an enchanted spot called Camelot with happy ever afterings.

The woman at the window is Mrs. Evelyn Lincoln, the slain president's personal secretary. With outstretched arm and jabbing finger, she points from the window toward a group near the Oval Office, saying in a low, bitter tone, "Look at him acting like he owns Jack's place." I walk to the window and stand beside her. "Him," of course, is President Lyndon Baines Johnson, Kennedy's vice president and successor, holding one of his walkaround press conferences.

We watch in silence for a few minutes until the group disappears from sight, then we turn and walk back into the room filled with memorabilia from Kennedy's Oval Office. While Mrs. Lincoln continues her task of sorting out the president's personal correspondence, I sit in JFK's rocker. We share remembrances and tears. I finish my assignment of photographing Mrs. Lincoln at her sorrowful duties and leave the office with the sounds of Camelot fading like a dream behind me.

With President Kennedy, there had been something extra, a depth of feeling which sprang from the conviction that our generation was coming into its political own and that we could and would make this a better world. Jack Kennedy was my senior by only two years. We both had small children and many times discussed problems with them and our hopes for them; we shared a love for the sea and sailing; but, most important, we shared the same political philosophy and dreams.

Mine was an unofficial role in his political kingdom, that of jokester and bringer of news, rumors, and spicy Capitol Hill gossip as I photographed

"The Loneliest Job in the World": President Kennedy in his office, 1961.

Kennedy and an inner court peopled by a young, eager, efficient, starry-eyed, and loyal staff. They and I and millions of other Americans believed in the magic of a man blessed with a special grace of mind and action. He gave us hope. And to this very day, whenever I hear a tune from *Camelot,* I feel a special loss for a dream and for a friend.

I first heard the name John Fitzgerald Kennedy during a radio news broadcast describing his heroic actions as a young lieutenant in the Pacific war zone during World War II. A Japanese destroyer had sliced diagonally into the PT boat under his command. Two members of his crew died instantly, but his leadership and bravery were credited with saving the rest.

In 1946 he ran for and was elected Democratic congressman from Boston's Eleventh District, and I met him in 1947, shortly after he was sworn in. My first reactions were unfavorable. I was expecting a wartime hero, but this man did not impress me as such. He was tall and thin and walked with a slight limp, and his strong Boston accent sounded comical to my ear. With time, I came to discover the man behind the accent, to slowly appreciate him as a human being. His humor, directed against himself as often as not, particularly attracted me.

I watched as he quickly learned the protocol of a first-term representative, following the rules and cultivating the friendship and trust of the older members. His legislative record in the House was not overly impressive, but he was becoming noticed.

The young congressman was a friend of Arthur Krock, and both a frequent visitor to the Washington bureau of the *Times,* over which Krock continued to preside, and a frequent contributor to the pages of the *Times,* particularly on foreign affairs.

One day after his reelection in 1948, I had lunch with Representative John Fitzgerald Kennedy in the cafeteria of the House's Longworth Office Building. We discussed Harry Truman's upset victory and Kennedy's overwhelming reelection, and I casually brought the question around to his future political ambitions.

He smiled and asked what I thought of his running for the Senate seat then held by Henry Cabot Lodge. I said I thought it was a good idea, though I doubted he could unseat the veteran Lodge after such a short time in the House. Jack acknowledged that it wouldn't be easy but said he had four years in which to make it happen.

For the next three years he spent as much time in Massachusetts as he did on the floor of the House, ranging far from his district to make political speeches all around the state. In 1952 he formally announced that he would oppose the reelection of Republican Senator Henry Cabot Lodge II. The familiar Kennedy family technique of holding tea parties, shaking hands at grimy factory doors, campaigning house to house, and advertising heavily by billboard resulted in an impressive victory for the young Democrat even while Republican candidate Eisenhower was carrying the state by 700,000 votes.

Senator Kennedy immediately started looking toward the presidency. In 1956 he made a strong run for the vice presidential nomination under Adlai Stevenson but lost in three ballots to Estes Kefauver, the Tennessee senator.

Still, Kennedy made a strong impression as an up-and-coming young politician. And in campaigning hard and long for the Stevenson-Kefauver ticket, he won the admiration of party leaders plus extensive national exposure.

He had also gained exposure through national newspaper headlines and appearances on the infant television networks as a member of the Senate permanent rackets investigating committee. (His brother, Bobby, was majority counsel for the committee and antagonized many of the people who appeared before it, none more than Teamsters boss Jimmy Hoffa, who several times challenged Bobby to step out of the committee room or to meet him in any ring at any time. The challenges were declined.)

On January 2, 1960, Jack Kennedy formally announced he would run for the presidency and fight for the nomination in the nation's primaries.

Kennedy's most serious challenger for the Democratic nomination was fellow senator Hubert H. Humphrey of Minnesota. The battleground was to be the state of Wisconsin, considered home territory for Humphrey. Senator Humphrey campaigned the state by bus, while Senator Kennedy used the family airplane named for his daughter, Caroline, born in 1957. Running against the Kennedys, Humphrey complained, was "like an independent retailer competing with a chain."

Campaigning with Hubert Humphrey was a real adventure: unscheduled stops, wayside diners, small rallies, seed stores and milk barns, where we were always late, always tired, with the bus bouncing over unpaved roads and potholes.

In the back of the bus Humphrey had a cot upon which he would try to rest between stops. Once while passing a small airfield, the bus hit a pothole and he fell off the cot. At that same moment a small plane was roaring in to land. As it zoomed over the bus, Humphrey, on the floor, shook a fist toward the sky and yelled, "C'mon, Jack! Fight fair!"

The Kennedys fought to win. A campaign plane and a campaign bus are worlds apart, both in organization, area covered, and impact. Travel by plane was more effective. Jack and his wife, Jacqueline, campaigned together and separately. Jack would work Main Street—barber shops, stores, and so forth —while Jacqueline talked to the women and made little runs out of town to visit farm families.

On one such early-morning run, we stopped at a milking barn to greet the milkers. Jacqueline was, as usual, stylish and trim. Her only concession to the barnyard muck was a pair of boots.

As we walked up the path, a woman in white with knee-high boots carrying two large pails of milk approached us, looking puzzled. Jacqueline stepped forward with arms outstretched and in that throaty voice of hers said, "Hello, I'm Jacqueline Kennedy. My husband is running for the nomination for president, and we both would appreciate your vote."

The milkmaid put her buckets down, wiped her fingers on her apron, and shook hands with Jacqueline without making any comment. The milkmaid and the princess may be sisters under the skin, but I believe that this is one vote Jacqueline didn't get, for all her great effectiveness as a campaigner.

Before the advent of instant television coverage, photographers and reporters traveling with political candidates were on privileged ground. Off-the-cuff remarks or overheard conversations were not to be repeated or reported unless specifically authorized by the candidate.

One time back aboard the *Caroline,* after a long, unseasonably hot day campaigning, Jack was removing his coat and I noticed his shirt was very damp under the arm. I grinned as he patted his armpits. He smiled and said, "George, to quote my friend Strom Thurmond, 'I sweated more than a nigger writing a letter.' "

I gave him a quizzical look. "Can I use that?"

"Not until I'm dead," he said. "It's a bad joke, but I was only trying to be funny, and it was a statement that Strom Thurmond made to me on the floor of the Senate, but it would be misconstrued and used by my opponents against me."

I told him I knew he meant it as a joke, but the image that came to mind the moment he said it was of my immigrant father struggling to write his name, and it was a bad joke. Politicians who like to joke can sometimes strain to be funny—with disastrous results.

Senator Kennedy handily defeated Hubert Humphrey in Wisconsin and went on to win in West Virginia, virtually clinching the Democratic nomination for president.

At the Democratic convention, he faced down opposition from former President Truman and Mrs. Franklin Delano Roosevelt, who were concerned about Kennedy's young age—he was forty-three at the time—and his lack of experience. Then he made the very shrewd political move of picking Senator Lyndon Baines Johnson to be his running mate, thus providing himself the margin of victory.

LBJ was a proud and sensitive Texan who ran the Senate with an iron fist and threats camouflaged by a light layer of honey-soothing entreatments. Playing second fiddle to President Kennedy was not LBJ's idea of political music. If he couldn't conduct the orchestra, he at least wanted to beat the drums hard enough so that he would not be completely ignored by the Kennedy administration. The unhappy vice president's contribution to the Kennedy years was minimal at best, and shortly after the inaugural there were hints that he would be dropped from the ticket in 1964.

President Kennedy was our first chief executive to fully appreciate and use to his advantage the new phenomenon of television. Immediately after his inaugural he staged the dramatic swearing in of his entire cabinet. Chief Justice Earl Warren did the honors, with the president, first lady, and vice president in attendance. The picture got wide play in the newspapers and, more important, also on TV. Later I congratulated Jack, telling him that his performance had an air of the excitement of the first hundred days of FDR's administration.

"George," he said, "my election was close and I must use every means to project a favorable view of my person, my family, and my administration.

During my first term I will build a strong foundation for my second, during which I hope and believe we will make a great and lasting impact on the lives and fortunes of our people." He was barely into his first term and already he was talking about the second.

With his political future in mind, President Kennedy made use of family members in supporting roles. Pictures of the proud parent playing with his young children in the Oval Office got big coverage in the papers and on television. Jackie's renovation of the White House was well documented, as was her stunning success as hostess and goodwill ambassador.

As a former photographer herself, Jacqueline Kennedy had a good eye for composition and also for what made a good news picture. She did everything possible to project the White House as a home as well as a national monument. After the year's first snowfall, Jackie drove her children over the South Grounds by pony sled, making a very dramatic picture that was released to the media with great effect.

President Kennedy was receptive to suggestions from reporters or photographers about possible White House stories. Requests were filtered through Pierre Salinger in the Press Office to the president. JFK would then call in the photographer or the reporter who had suggested an idea he liked, and they would discuss the project further. He might okay an immediate start, or he might suggest, "Maybe we ought to wait a couple of months for this one. Come back to me with it."

Photographers whose ideas were accepted were at once put in a state of presidential grace known as "being in the closet." They had access to the inner circles and workings at the White House. The Press Room was perpetually buzzing with envious speculation about which particular photographer was in the closet on a given date; I and about ten others who frequently were here kept constant watch of each other's publications to see whether we had been scooped or not.

One who was perpetually in the closet was a free-lancer, Jacques Lowe. He had sold the Kennedys on the idea of his covering the presidential primaries and election for a book that would later be written by the president. Lowe was not to release or sell any of his work without prior approval.

This free-lancer was a constant irritant to the regular news photographers, who dubbed him with the nickname "Jacques-Strap Lowe," and fortunately his position as unofficial personal photographer lasted only a few months, when he sold an unauthorized picture of the president.

The picture in question was one of Jack Kennedy in his office with a pair of eyeglasses on his head, an image President Kennedy was careful not to project, because he felt that his glasses hinted of an old man. The picture ran in the Sunday *New York Times Magazine,* and upon its publication I received a call that the president wanted to see me. I walked into his office and immediately he jumped up with a copy of the *Magazine* in his hand. Pointing to the photograph, he angrily said to me, "Why did you publish a picture of me like this?"

I said, "Mr. President, I did not make that picture. It was made by Jacques Lowe and sold to the *Times.*"

The president then picked up his phone and called Pierre Salinger and said, "Come in, I want to see you." He told Pierre to tell Lowe that he no longer had free access to the president. Pierre left and the president continued, "Jacques Lowe shit in the nest, and he's got to go."

By and large the media coverage of Jack Kennedy was favorable. Many reporters and photographers had known him as Congressman and Senator, forming relationships that lasted into his presidency, so it was easy to talk to him, to joke, and to conclude that this White House was a happy place.

Kennedy's news conferences were both a delight and a lesson in manipulation. He loved exchanging witticisms with members of the press, and he had favorites in the audience who he knew could be counted on to come up with a laugh when things were getting too serious. Even as questions about the latest crisis were being answered straightforwardly but within U.S. policy limits, he would be gesturing toward another reporter who he knew would come up with a different subject, if not some form of humor. President Kennedy's press conferences became Washington events for both the media and guests.

Meanwhile, his charming and attractive wife was presiding over social events that projected a younger, more gay administration than had occupied the White House for many years. President Kennedy's obsession with establishing a youthful image remained with him always.

One of the joys of campaigning with Jack Kennedy was the sheer chaos that inevitably ensued. Unplanned stops and unscheduled events gave us some of our best pictures.

A most noticeable phenomenon of a Kennedy campaign was the women along the route, whom we referred to as "jumpers." They would start jumping the moment Kennedy came in sight, and would continue jumping and screaming as he'd pass.

One day, a woman holding a young baby jumped in reaction to the closeness of the candidate's car, and one of the photographers yelled at her, "Throw the baby! Throw the baby! Throw the baby!" And she literally threw her baby at the candidate. Later, we were reprimanded by Jack: "Look, fellows, I could have missed the baby," he said. "Please, don't ever ask anyone to throw the baby again!"

We made one stop at the Maryland State Fair in Timonium, and Jack occupied one of the boxes in the upper tier of the grandstand, where he could observe the track and make a couple of bets on the harness races.

He drew quite a small crowd of autograph seekers and was very patient. But between smoking his cigar and joking and looking over toward the track, he would sign most of the papers absentmindedly, so I took one of my personal checks and made it out to the Nixon Campaign Fund for the sum of $100 and left the signature line blank.

I got in with the crowd, and folded my little paper, and handed it up, waiting for the reaction. Jack opened the paper, saw that it was a check, looked at the upper left corner. He signed my name to the check and he handed it back down. It is one of my most precious souvenirs.

In 1962, I received an assignment to photograph Hubert Humphrey with President Kennedy. So I put in the request, and when Hubert came down from the Hill to visit Jack, I walked in with him. The president got up from behind his desk, approached both of us, chatted a few moments, and then said, "Wait a minute, George, I'll tell you when to make the picture."

With that, he buttoned his coat around a stomach that was starting to grow a little large, causing him to be very defensive about the added weight. Then he took his forefinger and started poking Hubert Humphrey right in the belly button in a very forceful motion. Humphrey kept backing up every time he was poked and said, "What's wrong, Jack! What the hell are you doing; what the hell are you doing!"

Kennedy told him, "Just a little trick I picked up from Nixon. Not only do you keep your opponent off balance but you upstage him."

One who did not like being upstaged or, worse, ignored deliberately was LBJ. He would frequently be seen hovering on the fringes during receptions. His head would often pop up behind the president's during a bill signing or an official greeting ceremony. He seemed to be everywhere and yet nowhere. And his face reflected the same intense expression, a brow-creasing, squinty-eyed look that probably was caused by his refusal to wear glasses, a look that inevitably marked him as a very unhappy man.

JFK always had an eye for a beautiful woman. His eyes would glisten and his mouth would form into a barely concealed smile, and I could see the flirtatious words before they left his lips. Once I kidded him after observing such an encounter. He gave me a sly grin and said, "That's what it's all about, George. That's the bottom line of a man's life; it's women."

During Ted Kennedy's campaign for the Democratic nomination for president in 1980, several reporters were having drinks with Dave Powers, the curator of the John Kennedy Memorial Library in Boston and a member of the slain president's staff since his first run for Congress. In Powers' eyes President Kennedy could not and did not do any wrong, and his litany of colorful anecdotes of life with Jack was becoming more annoying with each retelling. At one point Powers said, "Jack, Jack, Jack. Jack so loved the sea, he so loved the sea."

In exasperation one of the reporters chanted back, "And Jack, Jack, Jack so loved the catch of the day!"

I always felt that Jack Kennedy loved his wife and valued her opinions, however his eye might roam. I first met Jackie when she was a roving columnist and photographer for the *Washington Times Herald*, stopping people on the street, photographing them, and interviewing them on the question of the day. She was regarded by colleagues as simply a rich kid with nothing to do, a friend of Eleanor Medill "Cissy" Patterson, the owner of the newspaper.

I first photographed Jackie shortly after she returned to Washington as the wife of Senator Kennedy. Over the years we became more acquainted, but never did I feel that I was getting through to her. She was always slightly aloof, even when asking personal questions.

Each of us who was here remembers Jacqueline in his own way. The image seared into my memory is that scene at Andrews Air Force Base when *Air Force One* returned to Washington from Dallas with the president's body. I focused my long lens on the cargo section, where ground crews were preparing to receive the casket. The cargo doors opened, revealing the flag-covered casket and the president's widow beside it, the embodiment of sorrowful dignity and self-control in that dress still soaked with his blood and his brains.

To me, at that moment, she was the symbol of all the women from the dawn of history who have watched their sons and husbands march off to war and seen them returned on their shields; who have grieved, washed their warriors' bodies, buried them, and then carried on.

And carry on she did, setting the pace for three days of mourning designed for Jack Kennedy's immortality. With her great sense of history and dramatics, Jackie worked out all the funeral arrangements that would be the focus for the world's grief. Nothing was left to chance.

Silent crowds lining the streets along the six-block route from the White House to St. Matthew's Cathedral saw her walk unflinchingly behind the caisson to the muffled cadence of the drums.

At the end of the funeral mass, standing on the steps of the cathedral as her husband's flag-draped casket passed, she nudged John-John forward to salute his father's body in as dramatic a gesture as six-year-old Caroline's kissing her father's casket in the Rotunda of the U.S. Capitol. The perpetual flame at the Kennedy grave site was Jacqueline's idea, and she would light it with a steady hand.

As far as I was concerned, she had been a source of strength we all could draw from. And whatever happened afterward, I always felt very sympathetic to her, for when it counted, she was there.

John Kennedy never made a major move without consulting his younger brother Bobby, his attorney general. During a crisis they were inseparable; their minds worked well in tandem, though Bobby was moodier, more thoughtful, more introspective. Bobby had a habit of looking you in the eye while you spoke that could be unnerving if you saw that his mind was wandering. He was direct and to the point and did not suffer fools easily.

One day I photographed Bobby in his office as the head of the FBI, J. Edgar Hoover, was giving his weekly intelligence reports on "evidence gathered, wiretaps, FBI information, and so forth."

Finally, Bobby cut him short, asking, "Can any of it be used in court?"

And J. Edgar Hoover said, "No."

And Bobby said, "What in the hell good is it?"

Later Bobby told me that he knew Hoover hated his guts and would try to get something on him the way he had on Martin Luther King, Jr.

Bobby brought to national politics that same enthusiasm and drive he gave to touch football. He was not above bringing a ringer into our Sunday sandlot games, a pro from the Redskins who used an assumed name. If that didn't work, Bobby would insist on having first pick of the players for his side, and

he would always choose the largest man around. A slight man himself, he loved to run behind somebody big.

After Jack's death, Bobby slowly started building a political base of his own. He ran for and was elected senator from the state of New York. He then set his eyes on the presidency, challenging the incumbent, Lyndon B. Johnson, whom he had always disliked.

The crackling magic of the JFK legacy was inherited by his brother. I was with Bobby when he opened his campaign in California. He was mobbed. People wanted just to touch him, and he got a great lift from the enthusiasm of the crowds.

One rally attracted so many people outside the Greek Theater in Los Angeles that there was a danger of their being crushed in the desire to press forward and touch the candidate. I spotted one woman with a small baby and warned her that she should leave, because the moment Kennedy came out of the theater and the mob pressed ahead, she could very well be crushed against his car.

She said that she had been standing there for over an hour and she wasn't going to move. When the crowd surged forward she started screaming, and I yelled to her, "Give me the baby!" She handed the baby up to where I was standing with the other photographers in a convertible. Then the convoy moved off with me holding the baby. At the first intersection where an officer was posted, the convoy slowed enough so that I was just able to thrust the baby into his arms and yell, "His mother is back in that mob somewhere!"

Between stops, Bobby always liked to take a nap. He would gather as many of the pillows as he could and make himself a little nest between the seats. So I watched him one day as he settled down, and when I thought he was asleep, I went over and fired off a couple of shots at about a half a second exposure. Zip—boom, zip—boom. Well, on the second boom he heard it. He popped his head up, looked at me, and said, "George, you're being unfair."

I said, "Shut up, Bobby; I'm going to make you famous!"

Bobby came and went all too quickly. His enthusiastic campaign was brief, his promise unfulfilled. With each succeeding candidate I have tried to see a little bit of the Kennedy magic, but to no avail. Changes have come since we dreamers marched in the Kennedy vision of hope and equality. The world has changed for the better, even if the pace is slower, less vigorous, less enthusiastic, and less compassionate without the leadership of these fallen heroes.

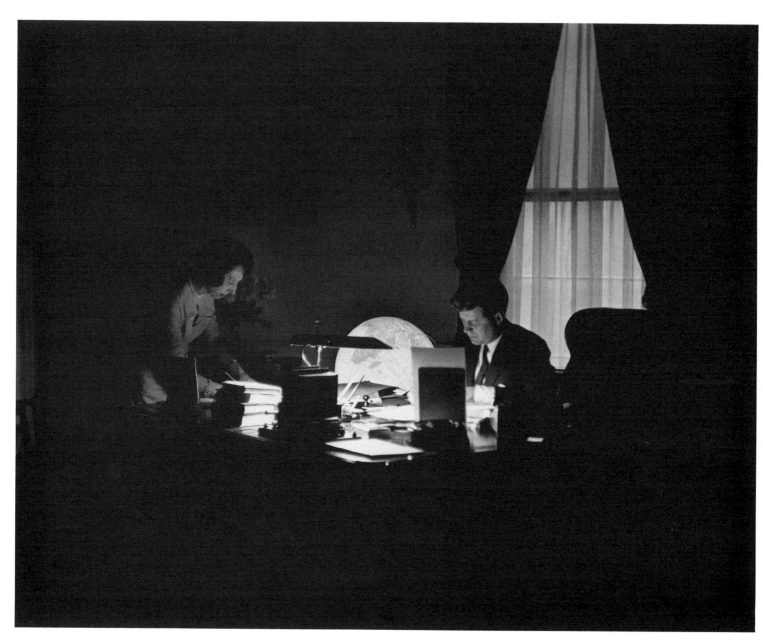

**Kennedy working in his office at night during the
Cuban missile crisis, 1962.**

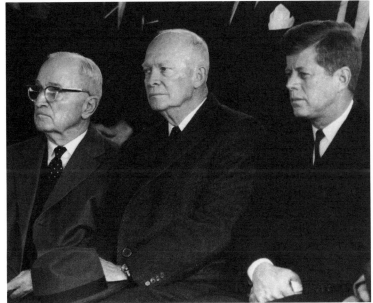

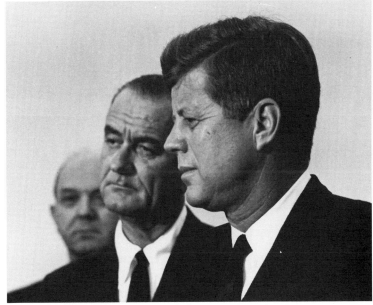

TOP LEFT

Attorney General Robert Kennedy, J. Edgar Hoover, and Kennedy aide Ken O'Donnell in the White House.

TOP RIGHT

Mrs. Roosevelt pays a visit to President Kennedy, Oval Office.

BOTTOM RIGHT

White House conference with LBJ and JFK.

BOTTOM LEFT

Three presidents: Truman, Eisenhower, and Kennedy at funeral of Sam Rayburn, 1961.

LEFT

Caroline and a young friend come down from the family quarters during a diplomatic reception and then, following Jackie's instructions, scurry upstairs.

BELOW

Mstislav Rostropovitch rehearsing in the East Room for a White House reception.

OPPOSITE, TOP LEFT

President and Mrs. Kennedy at White House reception.

OPPOSITE, TOP RIGHT

Mrs. Kennedy in Minnesota campaigning for her husband for the Democratic nomination, spring 1960.

OPPOSITE, BOTTOM

Mrs. Kennedy introduces John-John to astronaut Gordon Cooper. President Kennedy is on extreme left.

OVERLEAF

"Hitting the Wall": President Kennedy greets supporters on his western tour, 1962.

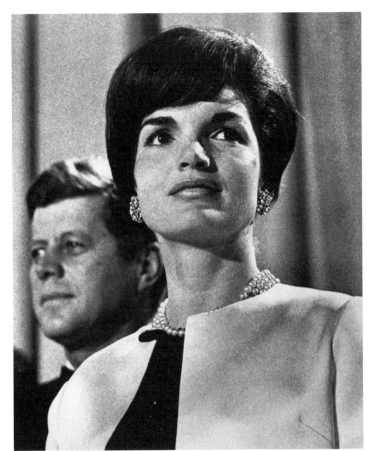

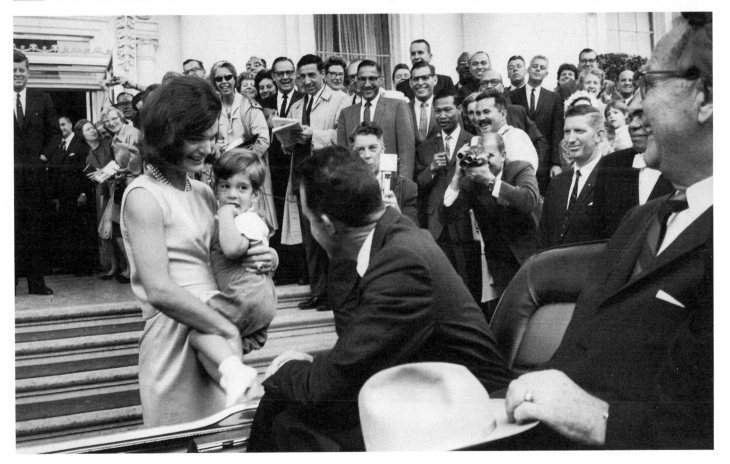

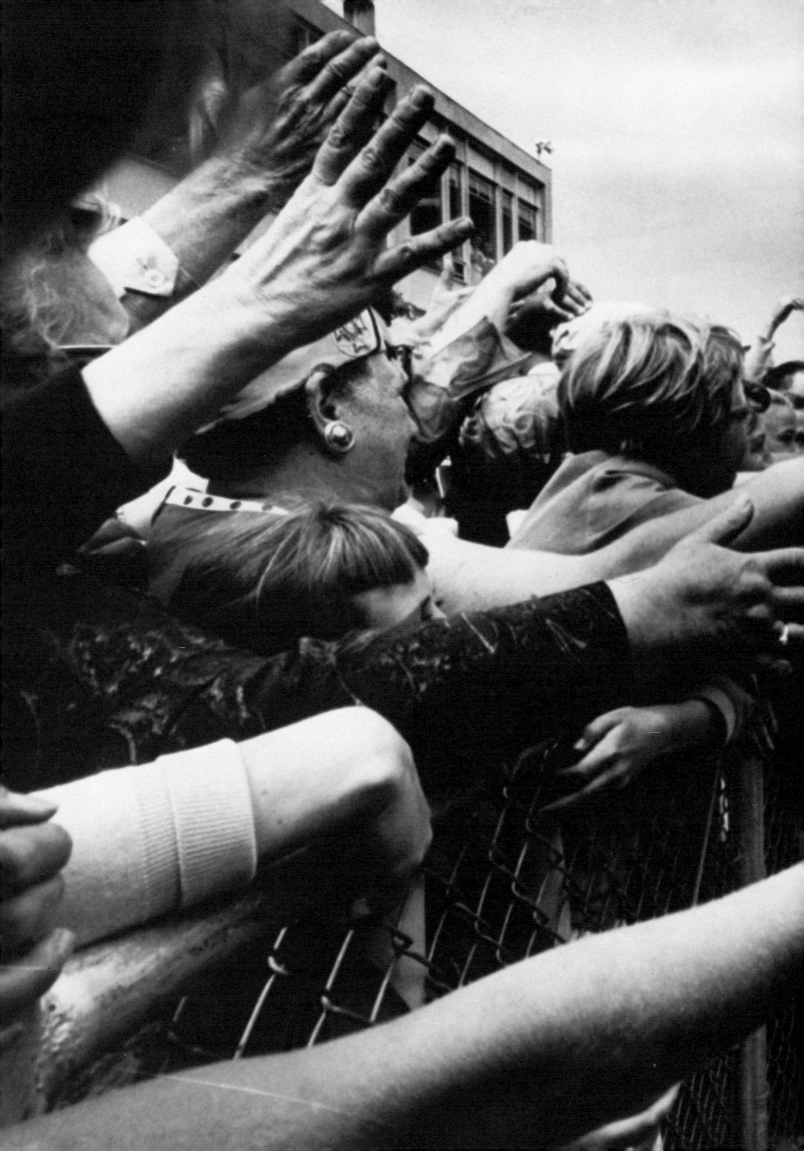

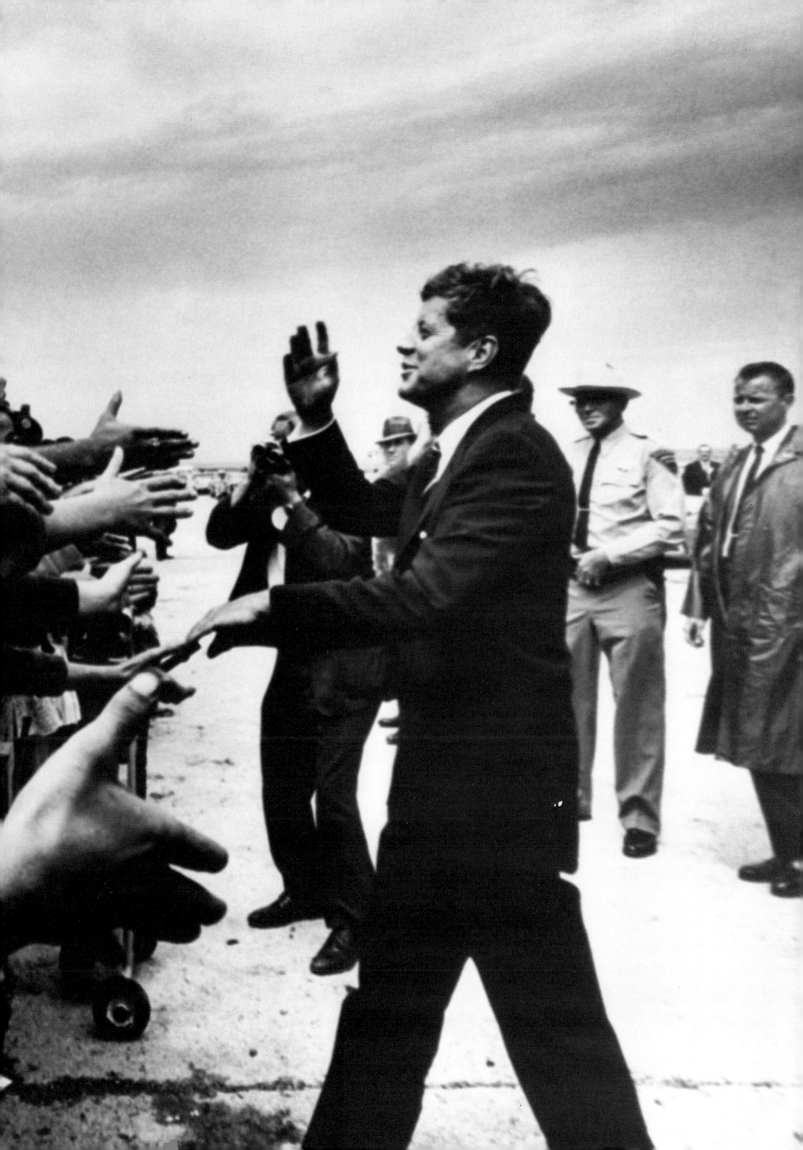

BOTTOM LEFT

Demonstrators against James Meredith, the first black to enroll at Ole Miss, outside the governor's mansion in Jackson, Mississippi, September 1962.

BOTTOM RIGHT

Widow of civil rights activist Medgar Evers at Arlington Cemetery during burial ceremonies for the slain leader, 1963.

OPPOSITE

Attorney General Bobby Kennedy in his office during Ole Miss crisis. Bullet-scarred helmet from Ole Miss on left, 1962.

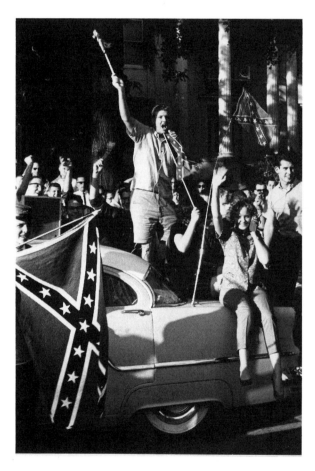

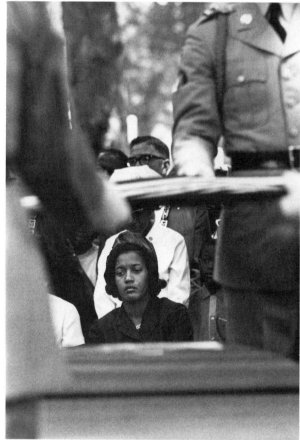

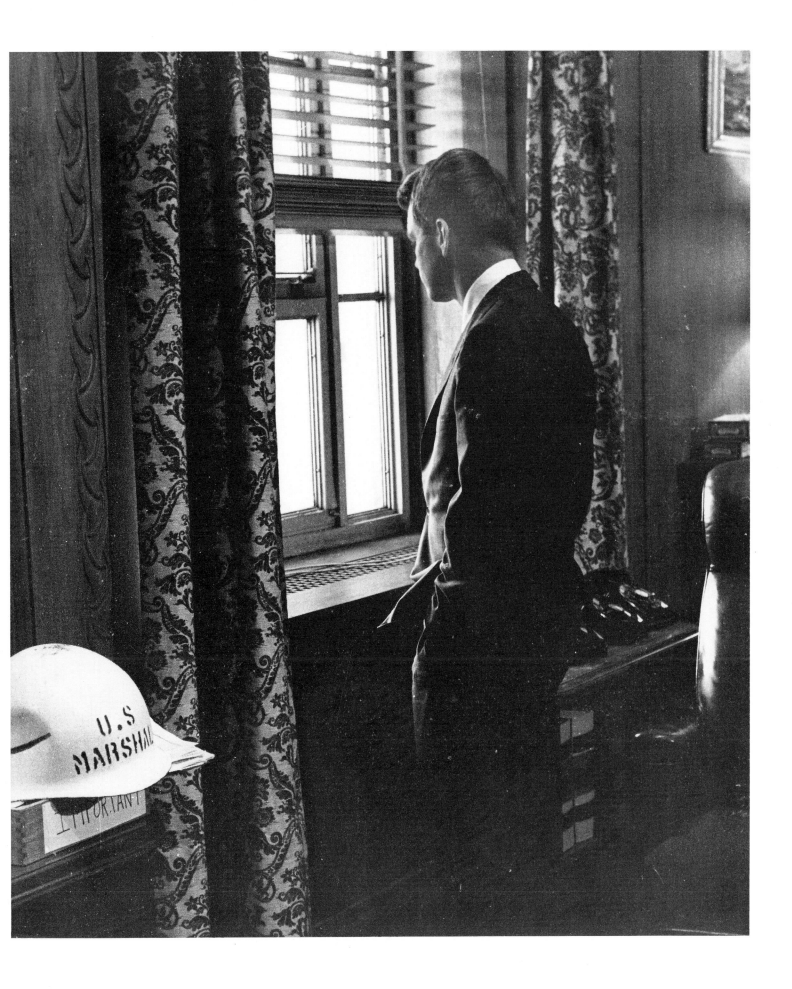

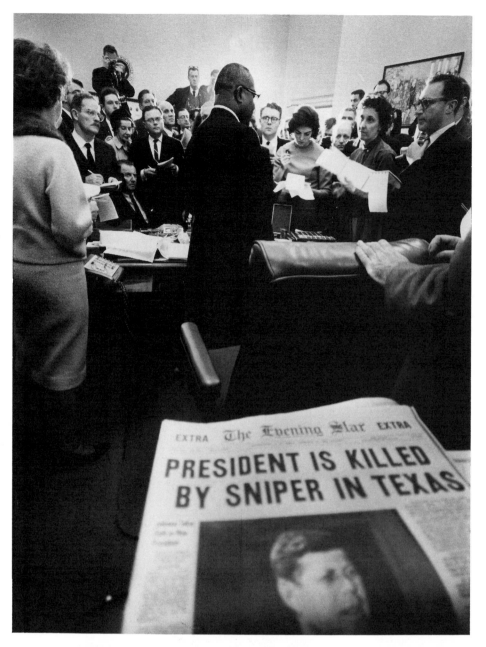

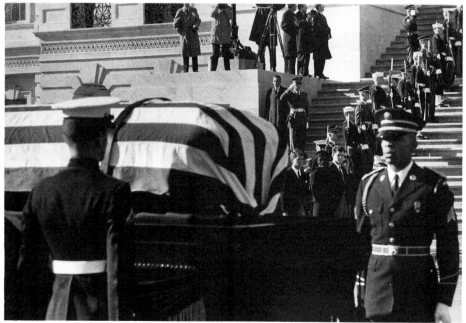

OPPOSITE, TOP

Assistant White House Press Secretary Andy Hatcher holds a press conference after the assassination of President Kennedy.

OPPOSITE, BOTTOM

President Kennedy's casket leaves the Capitol after lying in state.

BELOW

Mrs. Kennedy and the Kennedy brothers lead a procession of foreign dignitaries out of the White House toward St. Matthew's Cathedral. They are marching behind the caisson containing the body of the president.

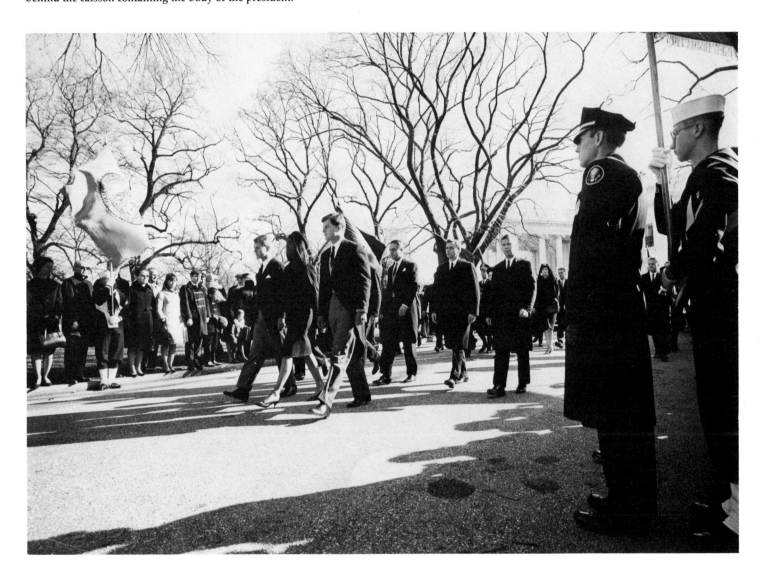

LYNDON BAINES JOHNSON

In the Oval Office the tall, lanky figure of our thirty-sixth president is bent over a pile of photographs on his desk. The 11 x 14-inch prints represent the previous day's work by Captain Cecil Stoughton, an army photographer assigned to the White House. Discarded photos litter the floor like leaves, while an obviously displeased President Johnson mutters profanities with each quick jerking motion of rejection.

"Goddamn it," he said, "why can't they make good pictures of me like they did with Kennedy?"

"Get me that Jap photographer," he yelled at Andrew T. Hatcher, the assistant press secretary who was standing by.

Hatcher hurried back to the press office, wondering all the time just who this "Jap" was that the president was talking about. Press Secretary Pierre Salinger and I were conferring about a photo request that the *Times* had made when Hatcher burst into the room with a laugh.

"Pierre," he said, "the president just asked me to get 'that Jap photographer,' and I don't know who in the hell he's talking about."

"Neither do I," said Pierre, "but we'd better find him."

I remarked that he was probably referring to Yoshi Okamoto, chief photographer of the United States Information Agency and one of the best in Washington. He was known with affection by the nickname "Oke."

A call was placed to Oke (pronounced "O-kee"), who then ran the one city block from USIA headquarters to the White House. I met him as he entered the Press Room door and asked, "What's up, Oke?"

"I don't know, but I'll soon find out," he replied.

About half an hour later, a beaming Oke stepped into the Press Room and beckoned me aside. He informed me in strictest confidence that LBJ had offered him the position of official photographer to the president of the United States, the first ever, but he was to keep it secret until the president made an official announcement. For the time being, he would simply be detached from USIA.

Democratic rally—LBJ reacts to the introduction of President-elect Kennedy, 1960.

The next day, Oke took over the photo office in the basement of the White House, and from then on fewer photographs hit the floor of the Oval Office.

President Johnson had hard-set notions as to what made a good photograph of him. Over the years, we discussed this quirk of his. I pointed out, for example, that I couldn't see any difference between the right side of his face and the left side.

He would grin and say, "Well, George, Lady Bird thinks so, so that's the way it's going to be. My left side whenever possible." And whenever possible, President Lyndon Johnson made entrances with left profile.

I once kidded him that if he got stuck on stage right, he would walk in backward just to show the left side of his face. He grinned, but he didn't think it was funny.

So obsessed was LBJ with photographs of himself that almost daily, until the end of his term of office, he edited all White House pictures that were to be released, and woe to anyone who acted without his authorization.

Okamoto told me that many times when he had a good picture which he knew the president would object to, he would carry it under his arm while the other pictures were being looked over and rejected. Oke would wait for the moment when LBJ would put down his glasses and move to the other end of the room. Then he would whip out his preferred picture and ask, "Well, what about this one?"

LBJ would squint at him, not really seeing the picture, and would give his OK. Later, when he saw it published, he would blast everybody around him. If aides pointed out that he had released it, he would say, "Well you should have known I would object to it! You shouldn't have even brought it up for me to see!"

He held me personally responsible for all pictures of him that appeared in the *New York Times* whether I made them or not. No excuse if the pictures were from the AP or the UPI. "George," he'd say, "you are my friend. You should see to it that they only use good pictures of me." Often he would spot me among the other photographers and grin and point at me. Later, back in my office, I would go through the *Times,* searching . . .

Only four months after his appointment, Oke fell from presidential grace as swiftly as he had ascended. He was gone within the day.

In shock and dismay, Oke called me for advice. I told him just to sit tight, that I would come to the White House and accompany him back to his former headquarters at the USIA building. That one city block Oke later described to me as the longest walk of his career. It had seemed no distance at all when he sprinted to answer the president's call.

Oke's offenses were actually not of his doing, but the incidents had been magnified in LBJ's mind by his unusual and largely unwarranted suspicions of his own staff, Kennedy supporters, and of the media in particular.

One incident involved Scotty Reston of the *New York Times.* As a weekend guest at the LBJ ranch, Scotty observed Oke flitting around during the

interviews and on the walks around the property. Later, Scotty asked Oke what he was doing. Oke responded that he had been detached from the USIA on a special assignment for LBJ. He mentioned that in this weekend alone he had shot more than thirty rolls of film.

Scotty took that figure, multiplied it by thirty-six frames per roll, and reported in his column that the president had a personal photographer who had shot over a thousand pictures of him in one week. LBJ gave Oke a warning.

Another columnist, picking up on the story, arbitrarily set a value of five dollars on each picture, concluding that five thousand dollars worth of pictures had been made of LBJ on his ranch in one weekend. Again Oke was dressed down.

Then *Newsweek* magazine's White House correspondent picked up a tip that Oke was to be named the president's personal photographer. *Newsweek* printed the story, and President Johnson fired Okamoto to prove the media wrong. That was LBJ's standard response when an announcement of a presidential appointment was made without his approval. The appointment died.

In August of 1964, just before the start of the presidential campaign, Press Secretary Pierre Salinger made an attempt to resurrect Oke.

Salinger and I discussed the need for such a photographer to record the campaign, and I suggested Oke should be that person. Salinger agreed and he typed a note to the president, pointing out the advantages of having a person such as Okamoto on the staff during the campaign. That same day I was shown the letter. Scrawled across it in bold handwriting was REJECTED, LBJ.

But in February of 1965, one month into his elected term, LBJ summoned Oke back to the Oval Office and to the post of White House photographer for the Johnson administration. The president told Oke to keep his nose clean and to mind his own business and not to talk with the media and to always remember that the president had Oke's pecker in his pocket and could rip it out at any time and throw it to the dogs.

Self-serving though the president's decision may have been, the nation's historical record is much richer for Oke's work, the depth and perception of which are unmatched.

LBJ's colorful expressions and scatological remarks were legion and legend in Washington throughout his political career. Two that I heard him use many times are "There's a whale of a difference between chicken salad and chicken shit" and, concerning a certain politician, "It's much better having him on the inside pissing out than having him on the outside pissing in."

I saw Johnson's humor as being basically what I refer to as "Texas roundup": sexist jokes better not repeated outside the closed circle that heard them. In truth, his sense of humor had definite limits.

One time I was in the White House Fish Room (so called because FDR had kept his fishing trophies and fish tanks there) while President Johnson addressed a military reserve group. Speaking of the brave but futile defense of the Alamo, he left the strong impression that one of his great-grandfathers

was part of this heroic group that died. I joked to the president after the meeting that, in my opinion, if there had been a back door to the Alamo, there wouldn't be any Texas today. "That ain't funny, George," he said, and turned away.

Two subjects were never to be the object of jokes in LBJ's presence: the state of Texas and the president himself. He would laugh at other people's expense, but not at a joke on himself.

I first met LBJ when he was a member of the House of Representatives, a tall, gawky, ambitious Texan wearing cowboy boots and a ten-gallon hat on the back of his head. He slowly matured from congressman to senator to senate majority leader, to vice president, and finally to president.

He was a strong, forceful, loyal, hands-on president with obvious human flaws. In his own way and in his own mind, he was loyal to and loved his wife, Lady Bird, and his two daughters. He once remarked to me that he wished he'd had as large a family as I did—five children—and that, if the good Lord had been willing, he'd have liked a son.

At times, he came to regard certain members of his staff as proxy sons. During his Senate years, I observed Bobby Baker more or less filling that role. Senator Johnson was the former page's mentor and avid supporter, and Baker adopted many of the senator's mannerisms and techniques. LBJ had a habit of standing in the doorway leading to the Senate whenever he was about to enter. Taking both hands, he would brush back his hair and make sure that everything was in proper order before walking onto the floor of the Senate. One day I got a big kick out of watching Baker standing behind LBJ, and observing that both were going through the same motions. Bobby Baker came to be recognized as the conduit to LBJ, but disclosures of the powerful aide's personal and official shenanigans led to his downfall.

During President Johnson's early White House years, the brilliant Bill Moyers was assigned the role of proxy son. This former divinity student turned presidential press secretary more than met Johnson's expectations.

In casual conversation one day after a Rose Garden ceremony, I mentioned to Johnson that I had photographed Moyers as he took the Peace Corps obstacle test. I described the various physical feats that Moyers had accomplished—climbing up ladders and over obstacles, hand over hand—and each time I mentioned a particular obstacle, the president beamingly said, "That's my boy, that's my boy."

Moyer's decision to leave the White House and join the media was seen by LBJ as a personal insult and a betrayal—desertion to the enemy camp.

In the mid-fifties, LBJ started laying the groundwork for a run for the Democratic presidential nomination. In 1960 he received the endorsements of influential senators and state governors, but the nation was not ready for a southern president, especially one who had neither a television personality nor a voice that could move the nation, as FDR had done via radio.

LBJ's most effective style was the one he had refined as majority leader in the Senate of a hundred members. If necessary, he would seek out each senator and confer privately, operating on the theory that personal contact

and compromise were the handmaidens of political progress and legislative action.

Johnson would often use his six-foot, six-inch size to loom over his subject on tiptoe, slowly descending to a wrestler's crouch and finally pinning him with outstretched jaw right in the face. Senator Barry Goldwater once remarked to me that Lyndon Johnson was the only man he ever knew who "when he'd talk to you would breathe in your mouth."

I don't believe LBJ ever came to grips with the power of television. "They are learning to smile and act on TV," he remarked to me one day, talking about political friends and enemies, "when they really should be learning ass kissing and ego rubbing, the only way to really get things done."

The great compromiser would not compromise with his new electronic opponent. LBJ needed to wear glasses but refused to do so and appear "old." To see, he had to squint, which gave him a perpetual scowl and grumpy countenance. His teleprompters had one-inch-high letters, but still he had to strain to see.

On one occasion in the East Room, during a diplomatic reception and television broadcast, LBJ tried using contact lenses. It was a disaster. His eyes watered and his vision blurred. At the end of the broadcast, he stalked in a menacing manner into the Green Room, where he tore the contact lenses from his eyes and stomped them underfoot. The air turned blue with curses.

I have always felt that LBJ was, overall, one of the best-qualified occupants of the Oval Office. His congressional background and his knowledge of how to influence and pass controversial legislative programs was unmatched. He knew where and how to apply pressure, where the bodies were buried. He was the capo who organized the executions, then led the burial ceremonies.

As president, he laid down the social goals of the Great Society, determined to out-Roosevelt Roosevelt on domestic issues, and saw himself winning the war against communism in Vietnam, just as FDR had smashed fascism in the West.

One evening, in the friendly old-boy atmosphere of the Senate Club, where tradition dictates there are no party lines after 6 P.M., just friends, the conversation drifted around to Vietnam. One of the senators—I believe it was Majority Leader Mike Mansfield—voiced the opinion that maybe the war was proving unwinnable and we should declare victory and get out and leave the well-equipped South Vietnamese Army to defend its homeland. President Johnson answered very firmly that he would not cut and run. No Texan had ever cut and run, and he would not be the first.

Ultimately, of course, Lyndon Johnson had to face the reality of the lack of domestic support for the Vietnam War, and if he didn't cut and run, he at least made a strategic retreat by deciding not to run for reelection in 1968.

The president who served out that term was reduced to making personal appearances only at military bases and other areas secure from the threat of violence—and from that sleep-robbing, national antiwar chant "Hey! Hey! LBJ! How many babies have you killed today?" He was far removed from the vibrant, earthy man who came into office.

During the Johnson years at the White House, visitors occasionally were startled by presidential invitations to use family facilities. One such facility was the swimming pool, built for Roosevelt and used by first families until Nixon replaced it with a new press room.

Once I was photographing a meeting of LBJ with a group of officials from industry. Obviously elated at the way things had gone, he ended the meeting with an invitation: "How would you all like to join me for a swim? C'mon, let's all go for a swim."

He led them out of the Oval Office, onto the Portico, and down to the pool. I followed along. LBJ put his arm around my shoulder and looked down at me and said, "Now George, no photos."

I said, "Oh no, Mr. President, I just want to see this."

What I knew and the industrial officials didn't was that LBJ and visitors swam naked. Immediately upon entering the building, LBJ took off his clothes and plunged into the water, to come up splashing and yelling at the bewildered guests, "There ain't no swimming suits! Just take your clothes off and c'mon in!"

They did. At once the room was filled with the splashing sounds and squeals of delight of men in their sixties swimming naked with their president. The splash party ended with drinks all around and toweling off while a still-dripping president stood talking into a phone and scratching his crotch.

My cameras were in my bag. I had deliberately put them there because I knew I would otherwise be tempted to photograph this scene, and that would have meant never working around the Johnson White House again.

In 1964, I was assigned to photograph McGeorge Bundy, President Johnson's national security adviser. I requested a chance to photograph him in conference with LBJ, and while waiting for an answer, I went to the Rose Garden to take pictures of Mrs. Johnson planting a new rosebush.

The president was in his office with members of his staff. He could see and hear the commotion in the Rose Garden, so he simply got up and strode through the doors onto the Portico and down into the garden, followed by Bundy, Secretary of State Dean Rusk, his assistant Jack Valenti, and several others.

Bundy kept trying to get Johnson's attention and the president kept brushing him off. Finally, Bundy reached into an envelope he had and thrust a piece of paper under Johnson's nose. The president just pushed it away and kept looking toward Lady Bird. Bundy dropped the hand that held paper and envelope to his side.

Well, I had been photographing this byplay from the other end of the Rose Garden with a 300-mm lens. When all my film arrived in New York, my editors informed me that I had captured exactly what they were looking for and they were going to use it full page in the *New York Times Magazine*.

On Thursdays, the Washington bureau always received advance copies of the Sunday *Magazine*. That Thursday I got my copy, flipped through it, and saw the full-page picture of the president and Bundy. Parts of the paper under Bundy's arm could be read very plainly: a few symbols and some gibberish and the stamp TOP SECRET. But nothing in the body of the letter could be deciphered.

I took my copy of the *Magazine* to the White House and conferred with Bundy. He told me not to worry about it, so I didn't. I then went back to my office and completely forgot the incident.

The following Sunday morning, I was in my garden digging away, preparing for the spring planting, when my wife called me to say that I was wanted on the phone. I went in and picked it up and a voice identified itself from the FBI.

"Mr. Tames?"

"Yes."

"About that picture that appeared in the *New York Times* today . . ."

"Oh, well, you don't have to worry about it," I said, "because I checked with the White House, and they said that it was OK, that it really wasn't anything."

He said, "Well, can we have the negatives?"

"You can have them as far as I'm concerned," I said, "but you will have to go and pick them up from the *New York Times* in New York, because that is where I sent the unprocessed film, and that's where they have them."

I gave the caller the names of people to contact and returned to my garden. In about an hour, my wife called me back to the phone. This time a caller described himself as being from the CIA and asked the very same questions.

"You're too late," I said. "The FBI has already called, and they are on their way to pick up the film now. You might have to coordinate with them."

He thanked me and hung up.

About another hour later, my wife summoned me again: "George, White House calling."

The next voice I heard was this deep southern drawl saying, "This is your president." Not "This is the president," or "This is President Johnson," but "This is *your* president."

Then he said, "George, why did you put that picture in your paper?"

I said, "Mr. President, I had nothing to do with it. I photographed you and Mr. McGeorge Bundy. I didn't see the paper. All I was looking at was the two of you, and I sent my film to New York unprocessed."

"I know, I know," he added in that southern drawl. "George, I love you dearly, but I don't trust those people in New York. Do you know what we got to do?"

"No."

"We've got to put one of those developing things in your basement."

And I said, "Yes, sir."

Then he added, "Well, don't worry about a thing. It was time for us to change the code anyway. Give my regards to the wife and the children and I'll see you later."

I said, "Thank you, Mr. President, good-bye," and I hung up.

Years later I was informed that this incident had cost the United States government in the neighborhood of ten million dollars. They had to go back and cancel all messages with this code and research previous messages that had used it to see how the government could have been compromised. Apparently, what had seemed gibberish was enough for anyone who wanted to break the code.

Every once in a while the president would bring up the incident like a dog digging up an old bone. "What about that picture, George?" he'd say, and I'd reply, "Mr. President, I had nothing to do with it."

One day it generated a shouting match between the two of us in the East Room. Much to my embarrassment and to the outright discomfort of some visitors, LBJ took me to task for this particular picture. I kept shouting that I had nothing to do with it, and he kept poking me in the chest, saying, "But you shouldn't have printed it." He never understood the process.

Entering the Cabinet Room shortly after this incident, the president was in an expansive mood. As photographers piled in, jumping and pushing and shoving, LBJ looked down toward the other end of the room, where Mc-George Bundy was busily picking up his papers and preparing to get up. "Sit down, sit down," the president said. "Tames ain't here, you ain't got a thing to worry about."

Then I came through the door and he spotted me.

"And there he is! What do you mean putting that picture in your paper?" Everybody just roared.

One day we photographers were to make a routine picture of him with a visitor in the Oval Office. He put his glasses down on his desk, strolled over, sat down next to the visitor, leaned forward, started to say something, and then saw me. He immediately got up, walked back to his desk, pointed at me, grinning, and made a great show of turning over all his papers. He never said a word, just pointed and grinned, and returned to his visitor.

The stately magnolia trees blanketing the south entrance of the White House were planted by President Andrew Jackson. The Jackson magnolias are constantly monitored for disease, and they receive the utmost care from the White House gardeners, including an annual spring spraying for bugs and other parasites. Since this involves bringing in trucks with spray guns and also a forklift to hoist the nozzles practically to the level of the Truman porch, the gardeners must be careful not to disturb the president.

One year they decided the best approach was to show up at dawn, do the job quickly, and get out. The spray was swishing through the trees and, unbeknownst to the gardeners, drifting through the window to Johnson's bedroom, which he had raised for some fresh air. He jumped straight up and, when he couldn't make himself heard leaning out the window, ran out onto the Truman Balcony, shaking his fists and yelling, "What in the hell are you trying to do, kill your president?" Future spraying operations were confined to the days LBJ was out of town.

LBJ had a way with women, and he never missed an opportunity for a kiss or a quick squeeze.

During the annual diplomatic reception in the spring of 1964, he charmed the wives as he danced, snuggled, and kissed them on the cheeks. To enable me to cover this event with a minimum of interference, the White House press office had built me a little nest of potted plants and ferns in the southwest corner of the East Room. Every time I spotted something of interest, I was to sally forth, make my picture, and return to my little nest.

I photographed President Johnson dancing with several of the diplomats' wives while Mrs. Johnson danced with the ambassadors. Then I spotted the president dancing with the wife of the ambassador from Sierra Leone, a striking black woman in native dress, while Mrs. Johnson danced with the ambassador himself. I photographed Mrs. Johnson, then went back to my nest.

I knew instinctively that LBJ did not want me to make a picture of him dancing with a black woman, because the campaign of 1964 was heating up and he was under fire for having signed the voting rights bill. But I decided that if I photographed LBJ dancing with white women only, this would be a direct insult to the ambassador and his wife, so I emerged to make the photograph I had earlier passed up.

Within seconds the plants around me were parted violently. In thrashed Liz Carpenter, Mrs. Johnson's press secretary, who proceeded to bang her fists and head against the wall, moaning in a low voice, "George, George, George, George. Why is it every time I have anything to do with you I get saddle sores?"

Given the circumstances, I told her it would have been obvious to all the diplomats that I was being selective, and that politically I had made the right decision. If the president objected, then we would not use it. She left muttering anxiously, "I know, I know. But he's going to ride me *up* and *down.*"

Within a minute the ferns parted again, and in strode LBJ. He stood there silently, hand rammed under his belt buckle in a hitching motion, a sure sign of displeasure. I knew this well, since he wore his pants low in the crotch for what he referred to as more "ball room."

"Well, George, I see you made another prize-winner."

"Yes," I said, "if you let me use it."

Looking down at me with a scowl, he gave my shoulders a hard squeeze and said in a low, sharp voice, "Don't use it."

In the Fish Room at the White House one day in early 1965, LBJ was to address a group of senior citizens. As he entered the room and moved down the line shaking hands with everyone, he came to a woman in her early sixties with stylish white hair, who was tall enough to look LBJ in the eye. He leaned in to give her a quick kiss on the cheek.

"Oh, Mr. President," she said, "that's the second nicest thing that has happened to me today."

Right away he was offended.

"What was the first?" he asked.

"Well," she replied, "I became a grandmother for the first time today."

He said, "Well, let's give old Grandma a kiss!"

And with that, he threw her down across his arm like Valentino and planted a big kiss right on her lips. When he let her up, he asked again, "What was the nicest thing that happened to you today?"

She was forced to agree that a presidential kiss topped being a first-time grandmother.

When LBJ gave an order, the staff jumped, whether they knew what he meant or not. The late Roddey Mims, a photographer for *Time* magazine,

related with great humor that he was in the Press Room around eight o'clock one morning when a frantic member of the press staff rushed in and called, "Come with me immediately, the president needs a photographer."

Roddey picked up his gear and ran with him to the president's personal quarters, where they found LBJ in the bathroom shaving. The president turned around, spotted Roddey, and said, "What in the hell are you doing here?"

He said, "I don't know, Mr. President. They said you needed a photographer."

"Goddammit," he said, "can't they understand English? I said stenographer, not photographer!"

President Johnson had two beagles when he became chief executive, Him and Her. He then was given a collie, Blanco, a high-strung thoroughbred that was kept tranquilized, and the president also picked up a stray.

On one occasion when I was photographing the dogs, Blanco and Him got into a scrap in which Him's lip was torn. Him raised such hell we were afraid the president might hear, so the caretaker put the two dogs in the room where they usually spent the night. Him cowered under the couch, which was where he would hide when the tranquilizers wore off Blanco.

The next morning the caretaker made a big thing of the fact that the dogs must have gotten into a scrap and that Him's mouth was torn. At the president's order, the dog was taken down to his personal physician and a navy orderly sewed up Him's mouth.

An enterprising individual once brought a dog that was in heat to the South Grounds while Him was running around and shoved her through the fence so she could mate with LBJ's dog and produce presidential puppies. Once this was known, chicken wire went up. LBJ said, among other things, that he didn't want anybody screwing with his dogs.

LBJ created the so-called walkaround press conference. On the spur of the moment, he would call in the reporters and photographers and escort them on a walk around the South Grounds. When things were going right for LBJ on these walkarounds, he would stop and be very expansive. But every time you'd see those long legs open up in a very fast walk, you knew that things were not going well and he'd literally have reporters trotting to match his stride as he made a beeline for the Oval Office, leaving them all outside in the Rose Garden.

Once a group of business leaders was in to see the president, and one of them asked me if I could make a picture of him with LBJ.

"But I have one request to make," he added.

I said, "Don't tell me that you want the left side of your face to be shown."

He replied, "Yes, that's my favorite side."

"Well," I said, "it's also his favorite side, so his left side is going to show."

The fellow was about six feet, four inches himself, and he said, "I'll handle this."

I told him, "Go ahead, I'll watch."

When the request was made, LBJ got up and stood next to the man with his left side showing. Just as quickly, the fellow grabbed LBJ by the elbow and spun him around. With equal swiftness, LBJ spun him around.

After they did this twice, I called a halt: "Wait a minute! You're both acting like a couple of dogs in heat. If both of you want the left side of your face to show, you'll have to stand back-to-back."

LBJ looked over at me and said, "Why, you know it makes no difference to me, George."

I said, "I know, Mr. President."

So the president stood with the right side of his face showing, and after I made the photo I suggested, "Mr. President, could you stand over here by the fireplace? I think that would be a better picture."

LBJ stood with his left side showing and I made that shot, and then LBJ came over and put his arm around my shoulder and said, "You pick the best one, you hear?"

I said, "Yes, I will, Mr. President."

The businessman wanted an autographed picture, so I simply took the shot of LBJ by the fireplace and lightly attached it to a board, leaving space at the bottom for the president's signature. I sent that picture in and Johnson autographed the board. When it came back out, I removed the fireplace picture and put the other one in. Both of them were happy.

The president loved to take visitors around the LBJ ranch. He would drive them in his personal car, which had a horn that sounded like a wounded bull: *ah-ooog, ah-ooog*. He loved pressing the horn and watching and hearing the reaction of the cows in the field, which would invariably answer back, *Moooooo*. He'd slap his hip and carry on.

One day while I was on the ranch, he asked if I wanted to make a picture of his bull.

I said, "Yeah, why not?"

He said, "I paid sixty-thousand dollars for that bull." Then he quickly added, "I did not pay the full price. I own one-fourth of the bull, but the bull is on the ranch here and we use him for breeding purposes. It's a beautiful bull, want to get a picture of him?"

I said, "Sure, why not?"

So we jumped into the car, his car, and we started driving, followed by the Secret Service car. As he drove, he pointed out various spots and animals until we ended up on a little knoll, where the biggest, blackest Black Angus I had ever seen in my life was lying on its side. I went for the door, and he said, "No. Wait a moment, George, don't get out."

He picked up the radio mike and yelled into it, "This is Eagle One, give me Eagle Four." And with that, the ranch manager got on the phone.

"Get your ass up here, I want to look at the bull," Johnson informed him and hung up.

We could see his dust plume coming, and the fellow arrived at full speed. He slammed on the brakes, jumped out of the car, went over to the bull, and put his finger in the ring in the bull's nose.

"Now, let's get out," LBJ said.

The bull, finally forced to its feet by a pull on the ring, just stood there breathing deeply and looking at us with red-rimmed eyes. I thought, "Wow! Now what do we do?" So I suggested that Johnson go over, put his finger in the ring, and hold the bull's head.

LBJ said, "No, George, that ain't what I bought." And then he went around to the back, held the bull's tail straight up in the air, and stood there looking toward me with a big grin on his face.

And I said, "No, Mr. President, no. That's not the kind of picture we could use. We're a family newspaper. We can't use a picture like that."

"You can't use it?"

"No."

"Well, then make it for me."

I was not part of the group, but I heard about another remarkable story involving LBJ and the ranch. He was driving members of the wire services and Tom Wicker, the *New York Times* correspondent, on a tour of the ranch grounds when he interrupted the conversation to ask, "Tom, do you have any toilet paper with you?"

Wicker, greatly surprised, replied, "No, Mr. President, I don't."

The president explained, "I wasn't feeling good yesterday. But Lady Bird gave me a glass of prune juice. Didn't do me any good. This morning she gave me another glass and I've had the shits ever since. What kind of paper have you got with you?"

"All I've got is my notebook."

"Give me a couple of sheets."

Wicker did and the president slammed on the brakes, jumped out, and dropped his pants right there on the prairie.

The Secret Service car following the president slammed to a stop and the agents popped out, hesitated, then formed a loose circle around the chief executive, speaking agitatedly into their wrist mikes and occasionally glancing back over their shoulders to the president and exclaiming, "Whooooowee!"

When this story started circulating back in Washington, I couldn't believe it. So I called my old buddy Captain Cecil Stoughton up to the Press Room and asked, "Is it true that you could have made a Pulitzer Prize-winning picture silhouetted against the Texas skyline?"

"Yes."

"Did you make it?" I asked.

"Hell no!" he said. "I don't want to go to Vietnam!"

LBJ's voting rights bill was, in my judgment, the most important piece of social legislation passed during his administration. With a sense of the dramatic, Johnson arranged to sign this historic bill in the President's Reception Room, just off the Senate floor.

During the less hectic times of our early history, this room was where the president of the United States signed legislation as it was passed on the Senate floor. In later years it was used by the senators as a reception room for meetings among themselves and with the press. It is a small mirrored room

barely able to accommodate two couches, a chair, and, in the center, the famous Lincoln table, used by him to sign important wartime bills and by every president since to ratify important legislation. Every inch of this historic room is covered with dramatic scenes, painted by the early American artist Constantino Brumidi.

On the morning of the signing ceremony for the voting rights bill, I was in the Oval Office with John Gardner, secretary of health, education and welfare, for a scheduled photo session with the president. LBJ and several of his aides were busy rewriting and polishing his speech, and every time we got ready to make a picture, something would happen to disrupt us.

Johnson had placed phone calls to civil rights leaders around the country, reading parts of the speech to them and asking for their comments and suggestions. When these were favorable, LBJ would smile and sit there with the phone to his ear, a great big grin on his face. But if the comments were unfavorable, he would cut the leaders short, once slamming the phone down, cursing, "Shit!" When I would grin, he'd point to the phone and say, "I only wanted him to feel important, not to hear his horseshit comments!"

Finally, he had to leave for the Hill. He turned to Gardner and said, "John, you come with me. You might as well learn about these things, and you, George, you wait here, and we'll make the pictures when I get back."

When he returned to the Oval Office, he was in a very elated state, floating four feet off the ground, he was so happy. He sat behind his desk and put his booted feet on top, holding court with a great deal of laughing and waving of arms.

"Well, they got no excuses now," he said in reply to my sincere congratulations on a good speech. "I want every elevator operator to register. I want every cab driver to register. I want every motherfucking cotton picker to register!"

Lady Bird Johnson, the president's wife and confidante for over forty years, proved to be a charming, friendly lady with a low-key wit and the polished manners of a political pro. She was the perfect counter to the volatile LBJ.

In the East Room of the White House one day in 1966, the president was holding forth in an excited, almost incomprehensible manner and suddenly decided to bring Lady Bird into the discussion. "Lady Bird! Lady Bird!" he shouted, glancing wildly from side to side over the heads of the assembled group. "Where are you, Lady Bird?"

Mrs. Johnson was standing directly in back of him. She very calmly put the palm of her hand in the small of his back and slowly extended it straight up to rest between his shoulder blades, at the same time saying in a soft voice, "Right behind you, Lyndon, where I've always been all my life."

The presidency might be, in Harry Truman's words, "the loneliest job in the world," but all the chief executives who have occupied the Oval Office during my career seemed more than willing to endure the isolation and torment for love of the job and for the power that goes with it.

I knew LBJ for twenty-five years. He was patriotic to a fault, as though convinced all our problems could be solved if we only remembered the Alamo

and hung tough. The Great Society would solve all domestic ills, and his foreign programs ultimately would make the world a much safer place to live in. LBJ was arrogant, whiney, rude, selfish, bad guy and good guy, gregarious, sullen, suspicious, introvert and extrovert. And I believe history will ultimately judge his accomplishments favorably.

That judgment was a continuing preoccupation of President Johnson, influencing even how he conducted the Vietnam War. He commented once that the majority of the American people remember only victorious presidents, and then he turned abruptly to me with a jabbing motion and ordered, "All right, George, name me the presidents of the United States. Quick! Quick now! Don't think, just name 'em, name 'em, name 'em!"

I started naming while he counted them off on his fingers, "Washington, Jackson, Lincoln, Grant, Wilson, FDR, Truman," and all the time he kept nodding, nodding, nodding.

"Every one a successful war president," he observed. "Get what I mean? I will not be the first to lose a war."

Lyndon Johnson liked to invoke the image of President Franklin Delano Roosevelt whenever he was trying to make a point or further some project. One day, while en route to the Capitol, he decided to stop by the only monument to FDR in Washington. It is a small, white marble slab in front of the Archives building on 9th and Pennsylvania Avenue, NW.

Johnson got out of his car, walked over to the monument, folded his hands in front of him, bowed his head, closed his eyes, and stood there for a moment. In that slightly slouched position, his already protruding stomach bulged like a cannonball. I knew instinctively he was not going to like the resulting photograph, and the next day in the Rose Garden he confirmed my guess.

"George, even when I pray, you people make me look like a fool!"

And with that, he turned on his heel and walked away.

LBJ gives the "Johnson Treatment" to Senator Theodore Green (Dem., R.I.). Senator Barry Goldwater once said, "When he'd talk to you, he'd breathe in your mouth."

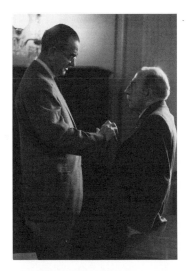
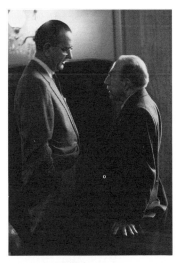

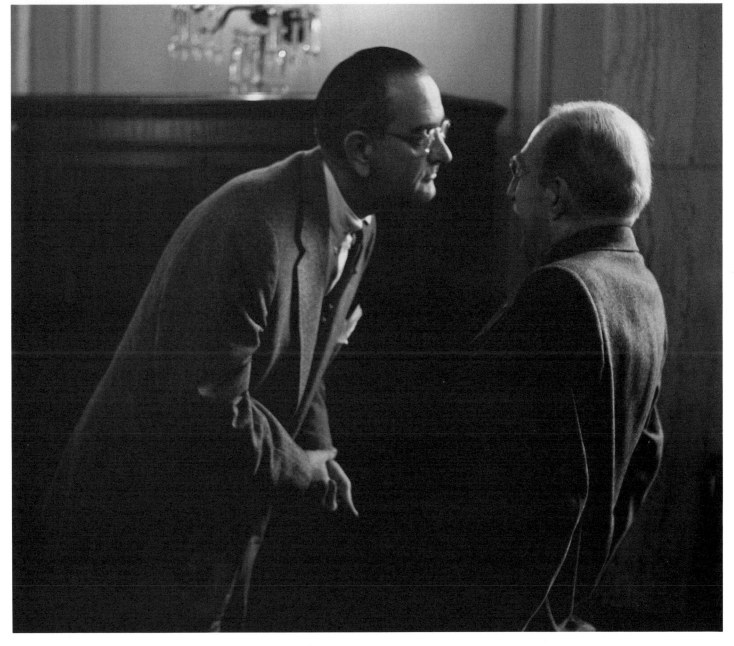

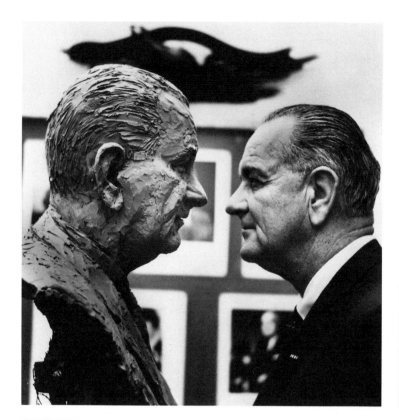

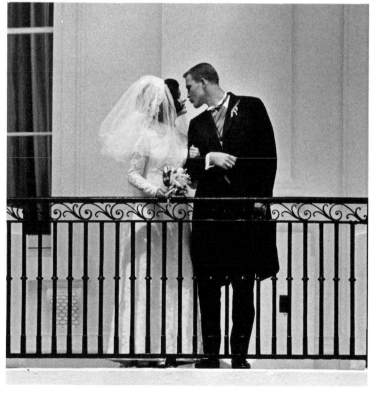

TOP LEFT

LBJ poses along with his own bronze bust at the White House. (credit:Tames/Okamoto)

TOP RIGHT

President Johnson shows off the newest White House dog.

BOTTOM RIGHT

Wedding day for Lucy Baines Johnson and Pat Nugent, 1966.

BOTTOM LEFT

Lady Bird Johnson, Mt. Vernon, Virginia.

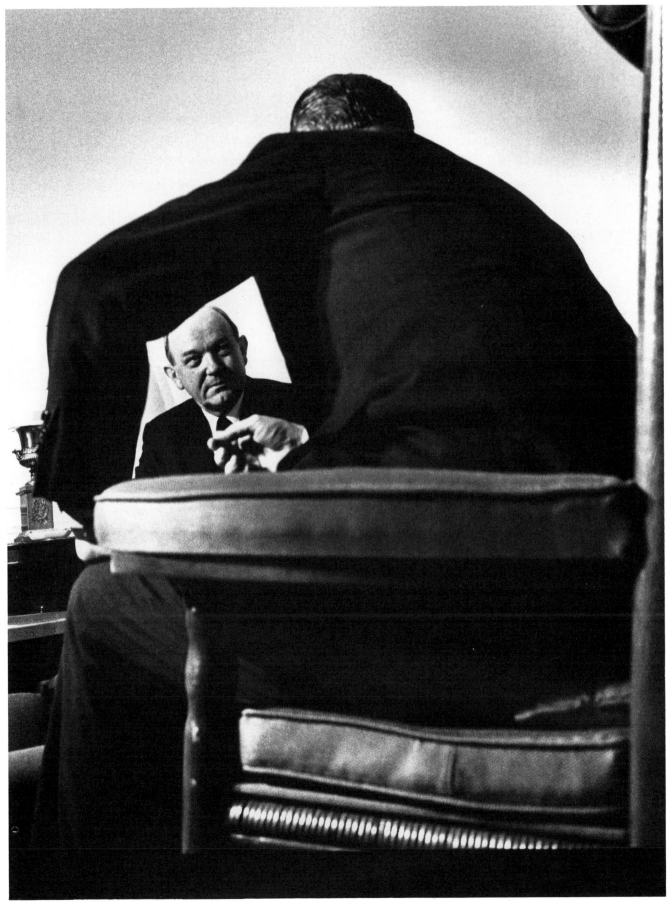

LBJ and Secretary of State Dean Rusk in Oval Office.

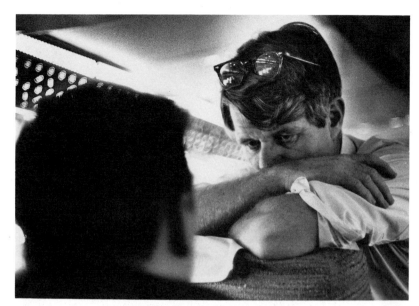

TOP LEFT

Bobby Kennedy en route to California to campaign against LBJ. He is shown conferring on the plane.

CENTER LEFT

Georgia state legislator Julian Bond (left) and colleague.

BOTTOM LEFT

Army maneuvers—Fort Bragg, North Carolina.

OPPOSITE

Vice President Humphrey at a rally in Washington, D.C., after it was announced that Martin Luther King, Jr., had been assassinated. Humphrey rose and called for a minute of silence.

RICHARD M. NIXON

Early in August 1952, on the morning of the day before the Republican National Convention opened in Chicago, I was coming out of the Drake Hotel as a cab pulled up. Out jumped Senator Richard M. Nixon, just arrived from California. We greeted one another, and he asked me what was going on. I told him that Senator Taft had lost his battle to seat the contested delegates who would have given him the presidential nomination and that Eisenhower would win on the first or second ballot. Really, the only news was who was going to be Eisenhower's running mate, I said.

Nixon asked me if I'd had breakfast, and when I said no, he urged, "Come join me. I'm hungry. Let's sit down and talk."

Over a leisurely meal we discussed the general political situation, bringing up various possibilities for the vice presidential nomination, but not once did Nixon indicate to me, then or afterward, that he already knew he was under consideration for that second slot.

Whether or not he knew then—and I don't believe he did—his selection was a surprise to many. However, it sailed through the convention nominating process without a hitch, and the Republican ticket was set: Eisenhower and Nixon.

It was revealed later, of course, that Senator Nixon had received a large sum of money from businessmen, and the resulting charges of corruption embarrassed Eisenhower to the point that there was much talk of dropping Nixon from the ticket.

The vice presidential candidate's defense was a brilliant counterattack on national television that left viewers with the image of a tearful Nixon defending himself with his wife, Pat, and his dog, Checkers, beside him.

Nixon's natural political instinct to go for his opponent's jugular had been honed to perfection while he served on the House Un-American Activi-

Vice President Nixon at Burning Tree Country Club, Bethesda, Maryland.

ties Committee, so his defense against corruption charges was in fact an attack on the patriotism of his opponents and a suggestion that the media, in airing the charges, were at best politically naive and at worst pro-Communist.

It was an extraordinary performance and he remained on the ticket, defined in the public mind as a strong, combative, controversial politician.

I first encountered Richard and Pat Nixon while on assignment to photograph the cherry blossoms around the Tidal Basin in the spring of 1947. They were riding their bicycles and enjoying the springtime sunshine and scenery. He stopped, saying he recognized me from Capitol Hill. I was pleased, in particular, when he invited me to drop by his office to give him the benefit of my knowledge of the Hill, which, I must confess, amounted to very little at that time.

He impressed me then as a hardworking, energetic, conservative first-term congressman. In my eyes, his domestic politics were right of center, invoking standard Republican positions in favor of less bureaucracy and more individual and state's rights. And when it came to foreign affairs, the sinister specter of international communism was always on his mind.

Once, in an attempt at humor with him, I pointed out that he could even find a "red tinge" in the green grass growing on Capitol Hill. He grinned and rather sheepishly said, "I'll take care of that."

He followed up with an invitation about a month later for a picnic dinner on the lawn facing the west side of the Capitol, and he told me to be sure to bring my camera, with color film.

I did, and we ate and talked as the sun went down behind the Lincoln Memorial, bathing the Capitol in a rosy glow.

"Quick, George," he said, "make a picture of the Capitol."

And I did.

And then he said, "Make a picture of the grass."

And I did.

And he said, "Come back and see me after you process the film."

And I did.

He noted the rose glow on the dome of the Capitol, then he pointed out the tracings of red on the green grass: "See, George, if you look hard enough you will find a trace of red in most everything. That is what my fight is all about."

Attempts at humor always tended to fall flat with Nixon; at least mine did. If I made some outrageous statement about a political figure, Nixon would take my words as gospel, so I would start off by saying, "Mr. President, this is a joke" or "This is something funny that I heard up on the Hill today."

The moment I alerted him that a joke was in the making, a small smile would play around his lips in anticipation. I can remember instances before I learned this trick, however. I have in mind, particularly, an incident that occurred in 1960, early in his presidential campaign against Senator Kennedy, when Vice President Nixon was in Walter Reed Hospital for chronic phlebitis.

Nixon was being treated for the inflammation of a vein in his left leg, but jokers in Washington jested that he was really having a sexual problem.

The vice president's staff had arranged a photo op to show that Nixon was in full command even though ill. The photographers were ushered in to find Nixon in his hospital bed very busy, staff members around, reading reports, dictating, and so forth. After we recorded this scene and the other photographers and the writers were heading for the door, I lingered behind with some small talk, intending to tease him a bit.

When we were alone, I turned very dramatically, leaned over, and said, "Mr. Vice President, we understand that your problem is not really your leg."

He said, "Yes it is, George!" and threw off the covers and pointed to the incision on his leg.

I looked at him blankly, nodded, and said, "Well, I guess that's right."

During the midterm congressional elections of 1954, Vice President Nixon mounted a nationwide campaign to elect a Republican Congress, and I traveled in his campaign plane for about a week. The trip quickly became boring with repetitive standard photo ops, and I spent most of my time on the fringes, trying to pick up something a little different, a little local color on the edges of the rallies.

On one of our stops in Kentucky, I found some of my colleagues sitting on the curb, eating a quick lunch of hot dogs and listening to the vice president give his standard speech. To liven things up, I stood with my back to Nixon and the crowd and delivered his standard speech in almost perfect sync with his staggered speech and with a passable imitation of his style.

My colleagues were amused, but a couple of Nixon supporters who saw and heard me commented that clearly the media were always incorrectly reporting the events surrounding a Nixon campaign because we really never paid any attention.

I pointed out that I had accurately heard the standard Nixon speech, or my imitation would not have been near perfect. We had heard the speech so often, I explained, that we didn't have to hear it again—we were just waiting in case he did say something different.

The episode taught me an important lesson. I never again attempted to imitate or poke fun at a candidate while he was on the stump; I always waited until I was back in a press room or in the candidate's airplane and the candidate was present.

I must add that when I did this with Nixon, he would grin and give a light laugh, but I always got the feeling that he really didn't think it was funny.

The vice president's efforts to elect a Republican Congress failed; in fact, his party also lost the Senate, which they had controlled with Eisenhower's election. I found Nixon as a campaigner to be rather lackluster, with no moral tone and very little wit, just a steady attack, attack, attack.

During his years on Capitol Hill, first as a member of the House and then of the Senate, Nixon had cordial relations with reporters and warmer, more personal relations with photographers. His accessibility and willingness to accommodate photographers resulted in extensive personal publicity during hearings held by the House Un-American Activities Committee.

Pictures made during a congressional hearing are predictably repetitive and can easily become boring. When that happened, a photographer might whisper the suggestion to Nixon that a witness be summoned to the dais to examine some piece of evidence. At once Nixon and the compliant witness would become the center of attention for still and newsreel photographers.

As the first member of the committee to pose with the so-called pumpkin papers during the Hiss-Chambers hearings, he got widespread publicity. Nixon acknowledged that those pictures of his examination of the film, and the national recognition they brought, helped tremendously in Nixon's campaign for the Senate.

It was not unusual for Senator Nixon and then Vice President Nixon to invite photographers to his home for social occasions, and I well remember one such time when his very young daughters, Julie and Tricia, entertained us with a little ballet. His pleasant relations with photographers continued through his unsuccessful run for the presidency in 1960 and beyond, until he became almost totally isolated from an enemy press.

President Nixon appointed as his personal photographer Ollie Atkins of the *Saturday Evening Post*. The decision to continue the position of White House Photographer, created by LBJ, was warmly received by news photographers, and Atkins, a veteran familiar with the frustrations of the White House beat, met with his former colleagues to outline his views on access to Nixon and on his own role in recording the intimate history of the Nixon years.

But Ollie's dreams died aborning when he was placed under the direct thumb of the president's press secretary, Ronald L. Ziegler. No top-secret clearance, no personal and direct access to the president, all picture opportunities cleared with the press secretary.

It wasn't until the very last day of the Nixon administration, when all restraints broke down, that Ollie had a free rein. In the presidential quarters, with the president and his family as they reviewed his decision to resign, Ollie made pictures of Nixon hugging individual members of his family that are the best and most intimate shots to survive from the entire administration.

Long before then, Ollie had lost respect for Ron Ziegler. One young member of the White House photo staff told me this story: It seems Ziegler called Ollie's office and in great agitation demanded to see him immediately. Ollie was in the men's room when a young staffer rushed in and yelled at the top of his voice, "Ollie! Ollie! Come quickly! Ziegler wants to see you and he's really mad!" Ollie's voice rose from a stall, saying, "Tell him I can only handle one shit at a time!"

Representative Richard Nixon riding a bike under the cherry blossoms in 1947 and President Nixon riding herd on the press and the nation while facing impeachment proceedings twenty-five years later were two very different men. It was the result of much more than just the passage of time. The Nixon of 1947, in my opinion, was more in tune with the world, more at ease with himself. The Nixon of Watergate was a man isolated from reality, warring with the press through the days of struggle within the administration and the revelations of Watergate and the cover-up.

In the final two years before he resigned in disgrace, the atmosphere around the Nixon White House was that of an armed camp under siege. The Press Room was an enclave surrounded by hostile territory that was the White House proper, with only the driveway a neutral-zone territory, and that solely to enable the press to come and go. Off-limits rules were strictly enforced, with the White House guards reporting any deviation from prescribed pathways by any member of the press. Contact with the White House staff was severely curtailed, sometimes nonexistent.

To this day, I find it hard to discuss Richard Nixon's political career without emotion and strong negative feelings. During his last two years in office, I felt for the first time like an alien in my own country, and I cannot describe the depth of my relief as I photographed that gentle man Gerald Ford being sworn in as president of the United States.

Nixon had begun to change even before Watergate. I cannot help but believe that in the first days of his presidency he was aware of the ghost of John Kennedy and constantly looked over his shoulder to see whether JFK was observing his fumbling attempts to emulate the style and dramatic way with words that the former president had possessed. Certainly Nixon resented Kennedy's love affair with the press and never understood the clublike atmosphere of the Kennedy Press Room.

Suspecting rightly that he was never considered one of the boys with whom reporters would feel free to talk about anything, from politics to women, Nixon kept them at arm's length, deepening the isolation and suspicion on both sides.

I am not aware, for example, of any member of the media's receiving a midnight call to come join Nixon and friends in an informal political round-table discussion of current events, as happened with presidents Kennedy and Johnson. When he got into trouble, he had no one in the media who knew the real Nixon, the human being. His isolation and brusque manner led to additional misinterpretation and misunderstanding.

Then, too, Vice President Spiro Agnew was constantly attacking the press publicly, which did not ease matters. Finally, the Watergate burglary and subsequent congressional hearings made the adversarial atmosphere pervasive.

Only with the photographers did Nixon feel any remnant of affinity. We—particularly the wire service photographers—had captured his triumphs in Russia and China, and thus shared them.

Both my father and Spiro Agnew's father were Greek immigrants. As the only Greek-American in the White House News Photographers Association, I had naturally been very proud of and had a warm relationship with Vice President Agnew. It was a great shock and keen disappointment that he was forced to resign after corruption charges stemming from his years as governor of Maryland were brought against him.

On the day he left office and was bidding farewell on national television, I stood with others to say good-bye. While we shook hands, I palmed him a silver dollar. It is an old Greek tradition that no man should ever be without

a coin in his pocket or he will lose face. He was aware of the tradition and thanked me. Shortly after this incident, I received the following letter:

October 17, 1973

Dear George,

I will carry your silver dollar with the hope that the horrors are finally ended, but it will signify more than that to me. It will remind me that at a moment when most media people were clinically watching the destruction of a politician, one was doing his best to extend a companionate hand to a tortured human being.

And that is a measure of your worth. Thank you for your steadfast friendship.

Sincerely,
Ted Agnew

My personal contacts with Nixon all but disappeared during his presidency, and I think his hate and suspicion of the *New York Times* were one reason. He would remind me that he hadn't seen me around and would ask after the welfare of my wife and children, noting that his affection for me had never diminished, though "I have to admit, I do hate that goddamn unfair *New York Times.*"

The besieged president's last two years, a time of emotional warfare and outright hostility on Nixon's part that were reciprocated by the press, clearly were his low point, and they were not always the media's high point. In my view, the majority of the White House press corps were outright biased, reporting even the most insignificant new information with thinly concealed glee. They regarded themselves as the cutting edge of public opinion and saw it as their duty to bring this man down.

As a tide of rumors ran in and out, reporters responded like herring on a spring run, darting here and there in small clusters, then back again and forward, always following the same leader, snapping up informational tidbits chewed and dropped by that leader.

They displayed the first symptoms of a "pack-attack" syndrome. One reporter scratched a source, and the resulting blood drew the rest of the pack. On the Hill, where the Watergate hearings produced much Nixon red meat, reporters waxed very fat. In the barricaded White House, where only bone and gristle were ladled out at the daily press briefings, reporters were lean and mean and worried every hint of a fact to death.

Nixon's own actions, and those of his staff, fueled the hostility instead of defusing it. Take, for example, the erasure of tape-recorded conversations in the Oval Office and attempts to prove it was inadvertent.

The fact that such conversations were being recorded without some participants knowing was looked upon by many members of the media as somehow unethical or at best opportunistic. This practice had been going on since Roosevelt's time, but previous presidents had used foot switches and buttons to record conversations selectively. Nixon had installed state-of-the-art recorders that were voice-activated, so nothing was left out.

While I believe that such tapes are the property of the president of the United States and that under the Fifth Amendment of our Constitution he had every right to destroy them when the Watergate hearings began, I do not think he should have destroyed or altered them once the hearings revealed that they existed. Thus when Rose Mary Woods, President Nixon's personal secretary, reported that during an attempt to transcribe part of these tapes, she had inadvertently erased a critical segment, this statement to the Congress and the press drew howls of indignation and outright laughter. Secretaries across the country told enterprising reporters that such an accident was a virtual impossibility.

The White House set out to prove that they were wrong, and the result, in my opinion, was the most ludicrous picture ever released by the White House Press Office. The photo showed Rose Mary Woods typing, with her foot stretched to the utmost to touch the wrong pedal. Obviously, she was straining and never would have been able to type in that position. Later, after Nixon's resignation, Ollie Atkins confided in me that the whole situation was a fake, that it was a deliberate effort to deceive.

President Nixon might have held out against the efforts of investigative reporters, but the Watergate hearings and the impeachment proceedings in Congress were ultimately too much for him, and he resigned.

As hearings by the House Judiciary Committee proceeded, congressional leaders had gone so far as to meet informally to plan for a trial of President Nixon, as prescribed by the Constitution. An informal committee met in the offices of the Democratic majority leader of the Senate, Mike Mansfield, and I was invited to give the views of the still photographers on how best to shoot this event with a minimum amount of disruption. Television would be permitted into the Senate chamber for the first time.

Of course, President Nixon's abrupt resignation ended these proceedings. Senator Mansfield told me later he regretted that the Senate did not proceed with the impeachment, ignoring Nixon's resignation and forcing him to stand trial and, thus, showing the American people that our Constitution does work.

The majority leader's opinion was that the national emotional purge which would have resulted from Nixon's standing in the well of the Senate to defend his record and face his accusers would have led to a cleaner healing of the wounds inflicted by the events of Watergate. I tend to agree with him.

During the last six months of Nixon's term, several members of the staff told me that the president was literally driven against the wall, that he'd become a recluse, drinking himself senseless in the private quarters of the White House. I have no personal knowledge of such, however. It is the almost embarrassingly emotional scene that was President Nixon's final departure from the White House that is etched so sharply in my memory. The Nixon of that last day in office, August 9, 1974, left the White House with strength and dignity and no confessions of guilt. But never in our history had a president been forced to resign, driven from office by disgrace. It remains the benchmark of the Nixon presidency.

TOP LEFT

Attorney General and Mrs. Mitchell at a Washington cocktail party.

CENTER LEFT

Watergate hearing: Maureen and John Dean having a laugh before start of afternoon session. That morning, Dean revealed he had borrowed five thousand dollars of the Watergate funds to take Maureen on a honeymoon. A delegation of photographers notified Mrs. Dean that we had voted and decided five thousand dollars was not enough money for this purpose. She went over and told her husband, with the resulting laugh.

BOTTOM LEFT

Republican National Convention, Miami, Florida: John Ehrlichman and Henry Kissinger at Nixon headquarters.

OPPOSITE

Judge John Sirica in his chambers going over papers before charging the jury in the Watergate case.

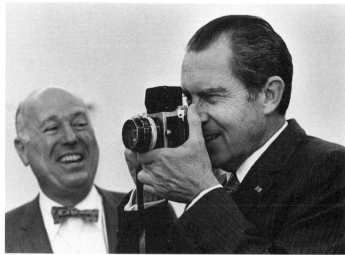

BELOW

Former president Nixon's first speaking appearance after Watergate and his resignation. Pictures were made during ceremonies naming the Hyden, Kentucky, high school gym in his honor. The president vigorously defended his record.

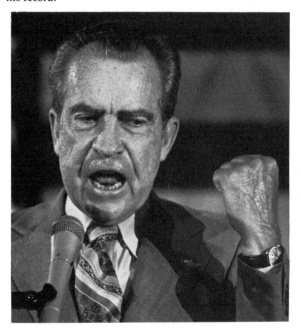 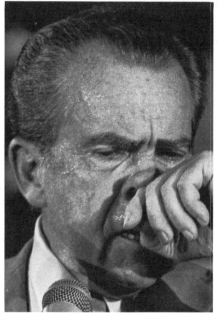 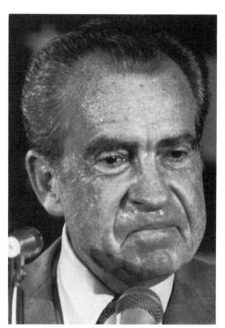

OPPOSITE, TOP LEFT

Democratic candidate George McGovern campaigning in Massachusetts, 1972.

OPPOSITE, TOP RIGHT

White House News Photographers Association president George Tames gives the president instructions in the use of a 35-mm camera. Oval Office.

OPPOSITE, BOTTOM RIGHT

Vice President Spiro Agnew at a Republican fund-raiser, Washington, D.C., 1969.

OPPOSITE, BOTTOM LEFT

McGovern National Headquarters in Washington, D.C. Frank Mankiewicz and Gary Hart, who ran the campaign for McGovern, are shown conferring.

OVERLEAF

Mrs. Martin Luther King, Jr., George McGovern, and others at an antiwar march in Washington, D.C., 1969.

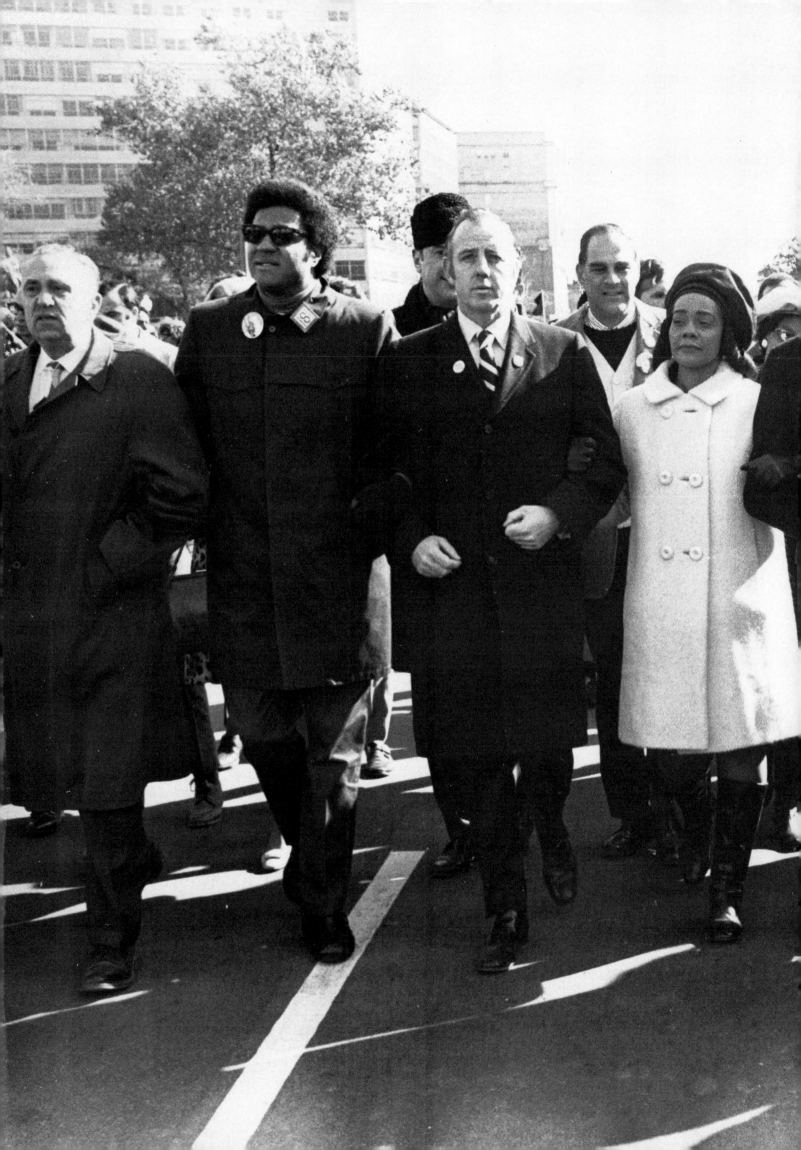

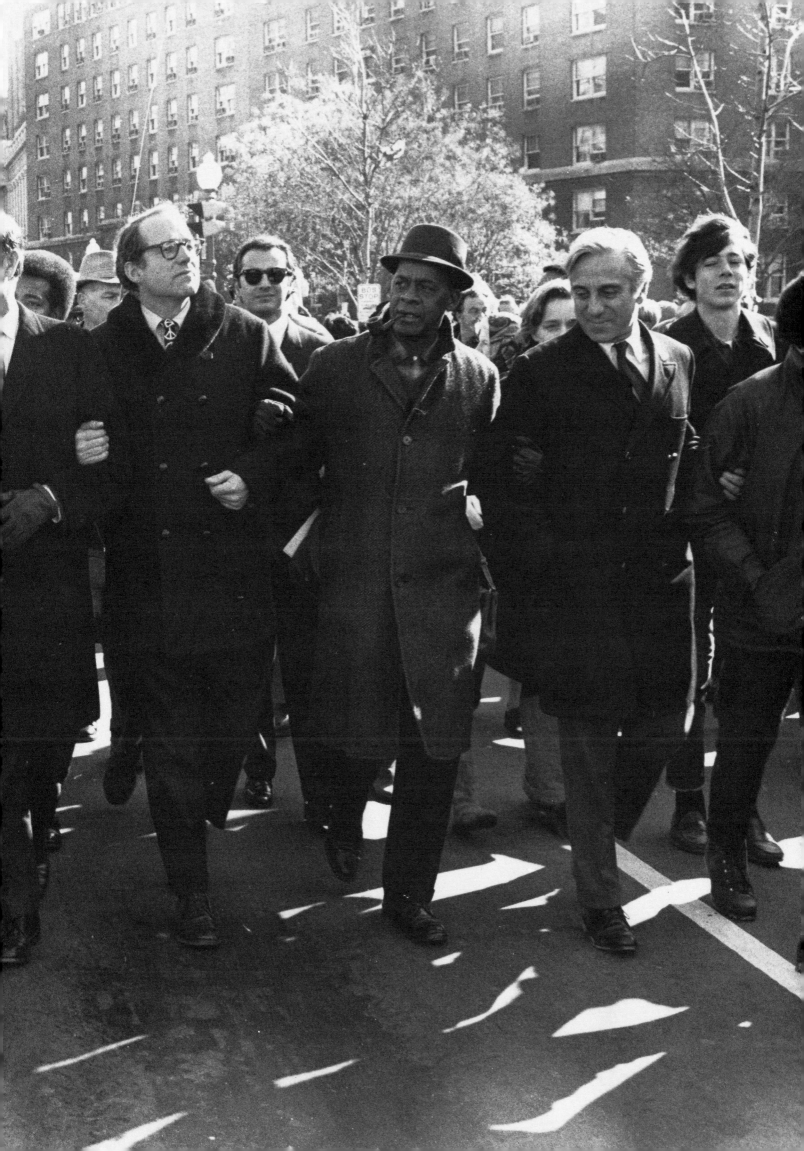

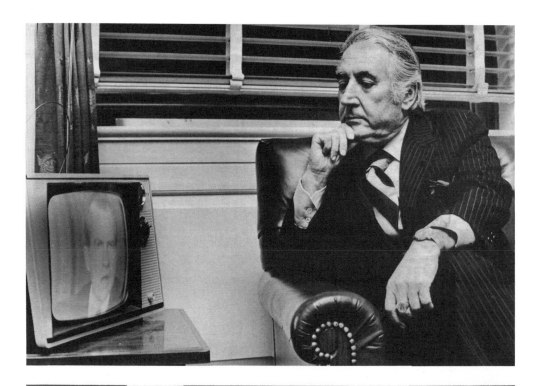

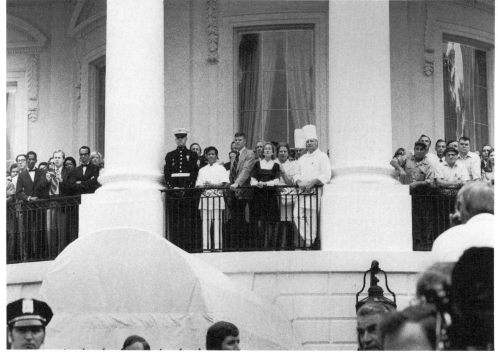

TOP

Peter W. Rodino, Jr., chairman of the House Judiciary Committee, watching the president's resignation speech from his office on Capitol Hill.

BOTTOM

Members of the White House staff watching President Nixon leave.

OPPOSITE

President Nixon departs from the White House after his resignation.

GERALD FORD

It was 10 A.M. on Friday, August 9, 1974, an overcast and unseasonably cool day, with a threat of rain in the air. A large crowd filled Pennsylvania Avenue and Lafayette Park in front of the White House, drawn magnetically to this spot by days of rumors involving President Nixon. They stared silently, thoughtfully, faces pressed against the high wrought-iron fence surrounding the White House, looking toward the well-lighted East Room while their transistor radios reported that Nixon was making his farewell speech to his staff and friends after resigning his office.

I quickly photographed these witnesses to the last and final act of the tragic Nixon presidency and then hurried toward the diplomats' entrance to the White House to record Nixon's departure.

The South Grounds were choked with people from nearby government agencies. The presidential helicopter was on the pad waiting. White House staff members packed the Portico and stairs flanking the diplomats' entrance —the military in uniform, the kitchen staff in high, white cylindrical hats, butlers, secretaries, maids, and grounds keepers rubbing elbows and jockeying for position. All eyes, some already tear-filled, were riveted on the diplomats' entrance, waiting to see the finale of the political career of President Richard M. Nixon.

I scrambled around trying to decide which would be the most favorable position from which to record this historic event. Shortly afterward, a flutter of press staff poured out the door followed by our thirty-eighth president, Richard Nixon, and our soon-to-be thirty-ninth, Gerald Ford.

The crowd immediately burst into cheers and applause, punctuated by sharp cries of support for Nixon. He in turn smiled and waved as he walked down the line toward the helicopter, followed by a very serious and somber-looking Vice President Ford and Mrs. Ford and members of the Nixon family.

The president was the last to board the helicopter, and at the door he turned around and, with one dramatic wave, bid good-bye to the White House, his last gesture in office.

President Nixon's departure. Pictured are Julie Nixon Eisenhower, David Eisenhower, Mr. and Mrs. Ford.

A very sober, quiet Gerald Ford, with head low, eyes to the ground, turned and started walking back to the White House. I photographed him, and then as he passed me, I called, "Good luck, Mr. President!" Deep in thought, he didn't hear me. Again I called, "Good luck, Mr. President!"

This time his head snapped up, and he saw me, walked over, and shook my hand. "I'm not used to that title," he said in a low voice. "Thanks for your support and help."

He continued on with Mrs. Ford into the White House, where shortly he was sworn in as president.

If Gerald Ford was slow in responding to his new title, I certainly felt strange about using it. I had known Ford as a member of the House and as Republican minority leader, but not once in all those twenty-five years had I ever dreamed that I would be addressing him as "Mr. President."

Nor had he.

Watching his retreating back, I reflected on many of the personal contacts and conversations I had had with him through the years, including political discussions over a drink in the minority leader's office.

Many times he had made it plain that his principal ambition was to be Speaker of the House. He tried five times and always failed. The Republicans had a majority in the House only once in his entire career, and that was very early in 1952, when Joe Martin became Speaker.

When Spiro Agnew resigned his position as vice president under fire and Nixon appointed Gerald Ford, I along with most of my colleagues and members of both parties on the Hill thought the president could not have made a better choice for the good of the nation. And the House Judiciary Committee agreed by voting 29 to 8 to approve his nomination.

I recorded this event by concentrating on the committee counsel's hands as he tallied up the vote on a roll call sheet. Then I took the sheet with me as I went over to Ford's office to photograph him as a newly approved vice president. After photographing him, I had Ford sign the sheet, and that framed document is one of my most precious possessions.

I slowly walked the less than 100 yards back to the White House Press Room after Nixon's departure, recollections of Ford flashing through my mind. And I entered a different world from the one I had left less than half an hour before.

It was as if a siege had been lifted. There was an undercurrent of quiet jubilation. For the first time in more than two years I felt strangely free. I could walk around without thinking that I was intruding. This was once again my White House, the American people's White House.

Several reporters tried to assure me and one another that they were not really gloating over Nixon's downfall, that they were Americans first and reporters second and felt deeply about this terrible tragedy. But I couldn't shake the notion that this was what they had wanted all along—that they had felt Nixon had to go. I must confess that I shared this belief.

It felt good once more to walk into the White House without a tinge of apprehension. Reporters and photographers milled around, joking and

shouting greetings across the Press Room as they waited for the first briefing by the new presidential press secretary, Jerald F. terHorst.

TerHorst was the first appointment made by Ford after Nixon's formal announcement that he would resign, and that Ford briefing stands out in my mind as the first in more than two years without even a hint of animosity or bitterness between the media and the White House representative. Smiles and pleasant banter were to be the hallmark of all press briefings for the rest of the Ford administration, almost without exception.

Gerald R. Ford, fifty-four years old, was tall and exceptionally fit physically, an ex-football player assuming the presidency. He was a gentle man by nature, one who suffered fools easily. In other times he might well have been known as Gerald the Conciliator.

Untainted and untouched by Watergate, he was in a perfect position to assume this new role of president. No political philosopher or instigator of new programs, Ford was a man whose service in the Congress generated a reputation for honor. And his integrity was his main attraction for the American people, rather than any intellectual leadership or inspiration. In his short 30-month term, he made believers of Americans again, and he received high marks for his moral rectitude, his honesty, and, more important, the openness of his administration.

I deeply regret that Gerald Ford never won the presidency on his own, by a vote of the people. I have always felt that he did a great job of healing the nation. That he was not elected, I believe, was attributable to his immediate pardon of Richard Nixon, an act that I have heard Ford say he thought was proper and correct. Delaying the pardon two years, until after the election, might have given Ford a close victory instead of a narrow defeat.

For years, political opponents and media people repeated tired gags about Ford's alleged lack of intellect and supposed inability to walk without stumbling. It was Lyndon Johnson who cracked that Ford, the onetime star lineman at Michigan, had "played too much football without a helmet" and could "not piss and chew gum at the same time."

Actually, Ford was probably the most physically fit president who ever occupied the Oval Office. He was tall, lean, and hard, and took pride in the fact that his weight was remarkably close to what it had been when he played football. Physically, he kept a vigorous daily routine from the early days in Congress through his presidency—and still does.

I first became aware of this when I was assigned to do "A Day in the Life of Gerald Ford," the minority leader of the House. His regimen began at 6 A.M. with half an hour of exercises and then a swim in his heated pool, sometimes with the family dog.

I arrived at his home, was greeted at the door and asked if I would like to have some breakfast. I declined and urged him to continue with his schedule. I photographed him doing his exercises and then the swim, and then we went back to the kitchen, where he prepared a breakfast of two pieces of whole wheat toast and a thick slice of Bermuda onion. I remarked that it was no wonder he had to swim alone.

He then read several of the daily papers, including the *Washington Post,* the *New York Times,* and the *Baltimore Sun,* and was at his office on the Hill no later than eight o'clock in the morning.

Ford's stumbles were due entirely to a trick knee that resulted from a football injury. The knee had a tendency to give way without any notice, so he had to be very careful, but sometimes he was unable to avoid a fall.

When he was in the White House, I had occasion to get a picture of him doing a special exercise for his knee (as well as making another onion sandwich!). The exercise consisted of attaching a weight to the foot and lifting the knee, working the knee, and lifting the leg up. He would do this as many as forty times every morning. But even with all his exercising, the knee occasionally failed him.

Another of President Ford's daily exercises consisted of doing twenty-five pushups. As he started his routine, I ran out of film and said, "Hold it, Mr. President, until I reload."

He held the position, but I kept having problems with feeding the film because I was in too much of a hurry. Finally, with a sigh, he lay flat on the floor and said, "George, even for you I can't hold it."

The picture that ran in the Sunday *New York Times* was made after I reloaded and he went back to his pushups.

After I followed Ford through his White House exercise routines, I watched him sit down to rest. He propped his feet up and continued where he left off with the daily newspaper until it was time to go down to the Oval Office. There, after a brief meeting with some aides, he picked up the phone and called a member of the House, chatted with him for a while, and asked for his support and his vote for a pending bill. After he hung up, he lighted his pipe and thoughtfully puff-puffed for a bit. He looked over at me and with a smile said, "That's the way to do it, George—the personal touch."

Mrs. Ford was a most gracious and kind first lady who displayed an effervescent, loving nature. She always had a good word for me and I had great respect for her. Her bouts with drugs and alcohol were revealed much later, after the Fords left the White House. All I can say is that I never saw any evidence of it the entire time that I was acquainted with Mrs. Ford.

One day, I was assigned to photograph the first lady and proceeded to make an appointment. Subsequently, the story was canceled, and I called Mrs. Ford's office and left that message. Apparently, it never got through. Mrs. Ford made a great thing of having her hair done and getting prepared, then sat and waited for my arrival. Since I was not even in town, her phone calls led her nowhere, and she gave up on me. But she got a kind of revenge eventually.

About two weeks later, I put in a request for a picture of President Ford leaving his office and walking to the family quarters. I was in the Press Room when I was informed that the president was ready to go. I ran out and stood in the Rose Garden in a drenching rain, huddled over, trying to keep my cameras dry as one interruption after another kept Ford from leaving the Oval Office. I was afraid to leave and chance missing the picture.

All of a sudden I heard a female voice yelling, "George! George! George!" I turned toward the family quarters. There, leaning out of a window, was Mrs. Ford. She called, "I hope he makes you wait for two hours like I did!" before slamming the window down.

I find it difficult to sum up the presidency of Gerald Ford. I cannot help but wish that he had been elected to a four-year term on his own. Two and a half years is too short a time to make a lasting presidential record. We have been friends for over thirty years, and I number him, along with John F. Kennedy and Harry Truman, as one of my three favorite presidents.

President Ford working in the Oval Office, with bust of President Harry Truman in the foreground.

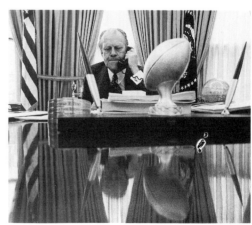

ABOVE

Mrs. Ford with pet cat at the White House.

TOP RIGHT

President Ford doing push-ups during his daily morning-exercise routine.

CENTER RIGHT

President Ford swimming at the White House.

BOTTOM RIGHT

The president telephones Senator Percy to rally support for a forthcoming vote on aid to Cambodia. The football is inscribed "South High Football Club." It was a gift from teammates, with whom he still has annual reunions.

ABOVE

President Ford in the Oval Office.

LEFT

Vice presidential nominee Nelson Rockefeller before Judiciary Committee, with Mrs. Rockefeller directly behind him.

JIMMY CARTER

The note in my message box at the Great Western Motel in Plains, Georgia, read simply that the Carter family would be honored to have me join them in a "pond draining" and fish fry that afternoon at the home of the presidential candidate's mother.

I knew what a fish fry was, but I was puzzled about a pond draining. As I would discover, arriving at Miss Lillian's home on the outskirts of town, the property had a small pond, about half the size of a city block. The pond had been drained to a pool of about 100 feet in circumference, with a maximum depth of 5 feet. It teemed with slithering bass and catfish that were chased by a small, mud-splattered group of laughing men, women, and children, fishnets in hand, who repeatedly dipped and scurried to put their catches in burlap bags.

I looked on with amusement as I slowly walked around the pool toward Rosalynn Carter, who stood watching just at the top of a slippery bank. I introduced myself and asked where her husband was. She laughed and pointed down into the pond at the Democratic candidate, up to his neck in the muddy water.

I was galvanized into action. I took off my shoes and tried to slide down the bank. Halfway there I slipped, but fell on my back, holding my cameras aloft to protect them, and slid feet first into the water, where a laughing Jimmy Carter looked at me and said, "Welcome to Plains."

This was my first meeting with our thirty-ninth president.

I returned his greeting, got to my feet, and started taking pictures. The series of the Carter brothers and their families in the water chasing those fish and frying them includes some of the best of my career.

My first impressions of Carter were good, and they remain so. I felt at ease around this sober man, with his honesty and consideration toward others, tinged always with a sense of the religious. Even so, our contacts were limited during the campaign and while he occupied the Oval Office. I always had the

President-elect Carter, Mrs. Carter, and daughter, Amy, at home in Plains.

feeling that Carter considered photography superfluous. He seemed not to be enamored of his physical appearance, of his photographic image, but rather to be interested in what the written word was recording about his political career.

Shortly after Carter won the election, a member of his team inquired whether I would be interested in running the White House photo department. I said I was but wanted the title "Personal Photographer to the President." I was informed that President Carter thought this contained echoes of an imperial presidency, an image that he wanted to avoid.

I have always dreamed of being personal photographer to the president of the United States, of being in the position to record history from the inside, but I made it plain that I would not do so without the title, the same one that the first official White House photographer, Okamoto, had had under Lyndon Johnson.

No one became personal photographer during the Carter administration and, to my mind, the result is obvious. Almost no candid photographs came out of the White House in the four years of the Carter administration, and very few pictures that showed the innermost feelings of the man, his deep faith, his caring nature. Nothing to show a grieving Carter at the news of the abortive tragic action to free the American hostages in Iran. He mourned privately when he really needed public sympathy.

The best, most dramatic and candid, pictures made by the White House photo team showed Carter and his staff in the Oval Office during his last week as president, struggling with the pending release of the hostages by Iran. This was the first time his team had been given free rein. Even at the moment of Carter's greatest achievement, the Camp David Accords, the best pictures were made not in private by his staff but in public during the signing ceremonies.

Working around Carter in the Oval Office was always strictly business. No small talk, no banter back and forth, particularly no jokes. I always had the impression that, although he was talking to me, his mind was on other matters and I was an intrusion he wanted to finish with as fast as possible. He was perfectly pleasant, but his years in the White House had tightened him up. He felt the load of his office, and his eyes and his manner, even his voice, reflected it. As a candidate, he had been much more relaxed.

At the pond draining and fish fry I mentioned earlier, a water moccasin came slithering across the pool, heading toward Carter. One of the agents took out his pistol and looked as if he was going to shoot the snake. Carter immediately started yelling, "Don't shoot! Don't shoot! Don't shoot! Don't shoot! It will ricochet into me! Let him go, he's not going to hurt anybody!" The snake went straight past and up the other side.

All during the campaign and right up to and including the day before his inauguration, Carter made a point of carrying his own luggage. He thought this projected an image of the frugal common man, but some of the people who knew him around Plains remarked that they thought Carter was so tight with his money that he didn't want to tip a bellboy.

When Carter arrived in Washington for his inauguration, he stepped out of the car, went around to the trunk, retrieved his luggage, and walked into the Blair-Lee House, where he would stay until he was sworn in. As he removed his hand from his pocket to reach for his luggage, a dollar bill fell to the ground. When the Secret Service car pulled away, the bill was flattened and I picked it up. I still have it, being tightfisted in a different way.

Election Day 1976: I was with Carter through that long day and night as the election teetered between him and President Ford. Finally, we photographed a victorious Jimmy Carter broadcasting to the nation, then rushed aboard a plane to go to Carter's hometown.

Aboard the plane, Carter was very animated, very upbeat; he mixed with the media, posing with the photographers. I asked him to sign my Carter/Mondale press pass as a memento and he did so, dating it November 2, the morning he was notified that he had won the election.

When we arrived in Plains, Carter emerged from the plane carrying his sleeping daughter, Amy. A very large, enthusiastic crowd was waiting, and he was met with cheers and waving flags and a cake the women of Plains had baked in the form of the White House. From the portico, where that great chandelier hangs, the women had hung a peanut on a chain, and on top was a U.S. flag. I have the peanut and chain, the flag, and a now dried-up piece of that cake.

Election Day 1980: I was in Plains the night of and morning after President Carter's defeat. The streets were empty. Nobody was around. The bandstand and the barbecue area where they had hoped to have the victory celebration was a shambles. The Carter headquarters was deserted. The train station was locked.

The only smiling person I met was Billy Carter, who saluted me with a can of beer as I walked past. "Here's to victory," he yelled, and took a sip.

I grinned and waved and went on.

Later I had a beer with Billy and we talked. He expressed relief that it was over. He was sorry that his brother had lost but confided that he had seen it coming for the last two years and that he would be just as happy being out of the limelight, a simple gasoline station owner in Plains, Georgia.

That was the last conversation I had with Billy Carter, the good ol' boy who was happiest hunting and fishing with his cronies, or sitting with them sipping beer and talking about hunting and fishing—and women.

The words *born again* evoke grins and snide remarks from a great number of people. But I envied Jimmy Carter the serenity that came with his conviction that there is a God and that one may be in His grace.

In Plains I attended his Sunday adult religion classes. He came prepared and he spoke eloquently, with passion and conviction. It was no surprise to me that visitors to a photo show of mine in New York commented most on and asked most about a picture of President Carter saying grace with simple dignity before a lunch with Vice President Mondale in the Rose Garden, a Wednesday ritual. That picture is the inner man revealed.

In 1985 I covered Carter's staff and press reunion in Plains. I found the former president relaxed and philosophical after his time out of office. His main interest, he told me, were the Carter Library and special projects he and Rosalynn were contemplating. He was physically fit and much interested in his softball game, particularly in competing against media representatives.

I had noticed that he was a straightaway hitter, usually between first and second base. In the final inning, the press was leading, but there was a runner on third when the former president came to bat with two outs on the side.

I was playing right field deep to give him a nice hole to shoot at, and the moment the pitcher wound up I started running. He drove the ball into that once-open space between first and second and I caught it, retiring the side, and the press won the game.

Afterward, I took the ball and asked him to autograph it for me. "George," he said, "I didn't think you were going to catch that ball."

"Mr. President," I replied, "I was torn between letting you win one and making a hero of myself."

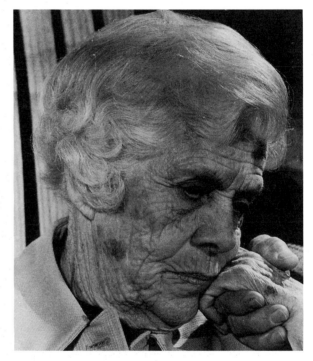

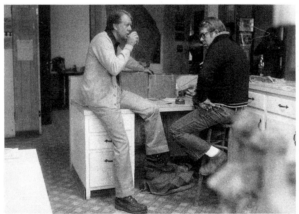

TOP LEFT

President-elect Carter in Plains confers with his brother, Billy, at the headquarters of their peanut business.

TOP RIGHT

"Miss Lillian": President Carter's mother on election night, Plains.

BOTTOM LEFT

"The Good Ol' Boys": Billy Carter and friends in Billy's gas station in Plains.

OPPOSITE, TOP

"Pond Draining": President-elect Carter and Amy in Plains.

OPPOSITE, BOTTOM

Carter alone in the pond.

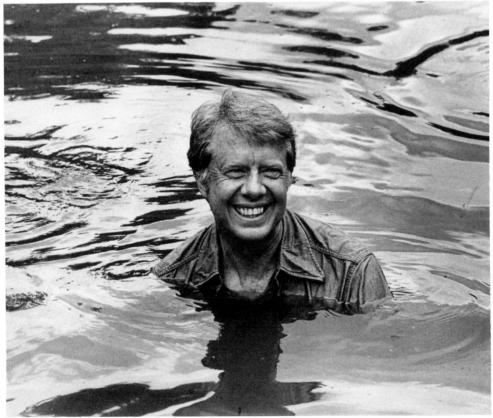

TOP LEFT

Senator Ted Kennedy making a point during a debate on civil rights—Judiciary Committee, U.S. Senate.

CENTER LEFT

Democratic leadership meeting.

BOTTOM LEFT

Presidential candidate Bush watches President Carter during a primary, 1980.

OPPOSITE, TOP

President Carter and Vice President Mondale saying a prayer before eating a very sparse lunch in the garden of the White House. This was one of their weekly Wednesday meetings.

OPPOSITE, BOTTOM

Signing of Camp David Accords at the White House. Egyptian president Sadat, President Carter, and Prime Minister Begin of Israel.

ABOVE

**Farmers' protest march on Washington, D.C., during
which farm equipment was burned.**

OPPOSITE, TOP

**Hubert Humphrey's farewell speech to a joint session of
Congress. He was dying of cancer and lived only a few
months after this picture was made. Congress paid tribute
to the dying senator.**

OPPOSITE, BOTTOM

**Funeral services at the Capitol for Senator
Hubert Humphrey.**

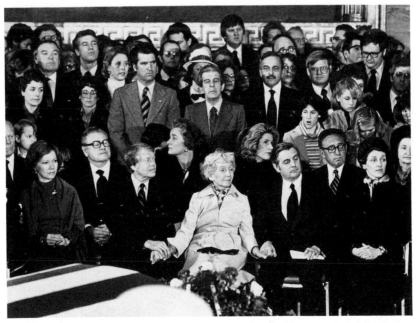

RONALD REAGAN

Why do you seem so stiff, uptight?"
I asked President Ronald Reagan, the "great communicator," during a photo session in the Oval Office in 1985. "For the last six years I have watched during TV taping and filming sessions, and you are more relaxed, more at ease, seeming to enjoy yourself."

"I am," he replied. "On movie film or TV tape I can drop the ball and still recover with a little joke or gesture. But with still pictures I am frozen in time, and it is much harder to project my true self or the part, the image, I am trying to create."

I said that I could understand his feelings but pointed out that we "stills" don't record sound and traditionally never hear the spoken word and he should be more natural around us. He was not convinced—as I believe subsequent still photos prove. I can't recall a truly great picture of President Reagan during his whole term in office—just many good ones, not unlike his film career.

I asked several of my colleagues to tell me which picture of President Reagan they recall as the most memorable of his term. Unanimously, they chose the picture of him during the assassination attempt, when he was shot in the chest.

To my mind, that's a shame. To work around such a good-looking man with such a pleasing personality and fail to come up with anything strikingly presidential was truly frustrating.

My assignment for the *Times* was to photograph a dramatic cover and a good lead picture for an article entitled "The Mind of the President" to be run in the Sunday *Magazine*. It was a story that I had been suggesting for several months. I had pointed out to my colleagues in the Washington Bureau that during my forty years at the paper, we had published such a story on every president, using as a gauge each one's list of his ten favorite books.

Reagan had been five years in the White House, I said, and still I had no inkling how his mind worked. What were his favorite books? Who were his

**"Singing in the Rain,"
White House.**

favorite philosophers? What piece of literature did he turn to in times of stress?

I made several guesses about what the books would be, each one greeted with laughter, and the comment was heard that Reagan had probably never read ten books in his life. Be that as it may, I said, we should do something to try to penetrate this man's mind.

I noted that Ronald Reagan was spending more time away from the Oval Office than any president I had covered. Every weekend he went to Camp David, a familiar and favorite spot of mine. As my colleagues giggled, I wondered aloud what Reagan did at this Maryland retreat:

Did he walk along a certain path leading to the edge of the mountain to look left and see Gettysburg, where our nation almost fell apart?

Did he turn right and look toward Frederick and the road leading west through the Cumberland Gap, wondering how he fit into all this and how history would remember him?

And then, in the afternoon twilight, did he sit down on a log, reach into his back pocket, and take out a favorite book of poems to soothe his soul?

I wanted to read that story.

Leslie Gelb was assigned to write the interpretation; I was sent to illustrate his piece.

I must confess, I did not get a cover shot.

When I asked for a one-on-one assignment with President Reagan, I was offered eleven minutes in the afternoon, immediately after his nap. I arrived and set up a couple of lights and waited for the president.

To my dismay, several members of the White House photo and press staff accompanied him. So much for my one on one that I had counted on to help me form some sort of rapport with the president.

I pulled his chair slightly away from his desk, hoping he would sit so that I could photograph him with the light coming in from the window while he flipped over papers and relaxed back in his chair.

They called in the president from one of the outer offices. Smiling, he walked in briskly, extended his hand for me to shake, grabbed the chair and shoved it to its usual place, and commenced tossing me one-line jokes.

I just laughed and carried on and finally made a few shots of him laughing. Then I said, "Excuse me, Mr. President, but this is a very important piece we are doing. It's called 'The Mind of the President,' and it's all about how you make decisions and how you come to conclusions.

"I don't want a smiling picture of you," I continued. "I want a very serious picture of you. When you receive a position paper or some other thorny problem is given to you, do you sit here and scratch your chin, rub your head, shuffle some papers around, get up, walk in the Rose Garden, look out the window? What do you do?"

He said, "I do nothing like that."

"Well, then don't do it for me!" I said. And I made a few more shots and announced, "I'm finished."

"You've got five more minutes!" the aides said.

"I've got all I can get," I told them.

From long experience, I make it a point to hold back with a few frames in case something more picturesque or dramatic or candid happens in those

last few seconds of a session. And this time, watching the president at his desk shoving papers around, I was very deliberate in taking down my gear.

I backed toward the door, and just before I stepped out, he stood up, turned slightly toward the window, and started flipping over some papers. From the doorway, with an 85-mm lens, I shot my picture. It ran a full page in the Sunday *New York Times Magazine*, and I received many requests for it, as being one of the best candids made of this president, from other publications.

It came hard, but at least I got one out of him.

One of the things that struck me most about President Reagan was how well he dressed. I believe he put on two sets of clothes daily, that he put on something different after his nap, although I could be wrong. But certainly I saw him wear two different suits in the same day, and he was always neat, always well pressed, always fashionable. There is no doubt in my mind that he was the most clothes-conscious president we have had from Roosevelt to Bush.

In 1944, as I said earlier, I photographed Franklin Delano Roosevelt and Harry Truman having lunch under the Jackson magnolia on the South Grounds of the White House shortly after the Democratic convention selected Truman as Roosevelt's running mate. They invited the press along while they lunched and made their plans for the forthcoming campaign.

I decided that I would like to photograph President Reagan and Vice President Bush in the same chairs at the same table in the same place and also in shirtsleeves. I would title it "Forty Years Apart."

The White House agreed.

As I set up, waiting for the president and vice president to arrive, the White House staff placed the Coolidge china on the luncheon table, the same service Harry Truman and President Roosevelt had used.

Reagan and Bush came over and sat down, and we shook hands. I made a few shots. Then, to match the Roosevelt-Truman picture exactly, I asked the president and vice president to please remove their coats. Bush immediately stood and took his off. The president sat there, looking up at me, not making a move. I glanced quickly at the vice president, who then immediately put his coat back on and sat down.

I have learned from long experience that once you ask a public official to do something and are refused, you just go on. And so I did. But I have never been able to figure out why Reagan didn't want to remove his coat. Nor do I remember seeing a picture of him without his coat or jacket in the Oval Office or even on the South Grounds of the White House. Only when he was dressed to go riding or to Camp David have I ever seen him in a sports shirt or other informal clothing. In his mind, perhaps, he had to look presidential, and a president is always neat and always keeps his jacket on.

One White House ritual that has stood the test of time is the delivery of the president's Thanksgiving Day turkey: the annual "Turkey Shoot," as it was named by the photographers. It started with Roosevelt as a means of promoting the sale and consumption of turkeys at Thanksgiving, and it continues to

this day. The turkey association gets its publicity, the president gets his turkey, and with luck we photographers get to create something unusual out of a fun occasion.

The turkeys are large, in the neighborhood of forty to forty-five pounds, and very independent-minded. At least they were in the early years, until photo sessions became rather rambunctious. I believe they are being fed tranquilizers these days, although that charge has been denied, and now they just sit or stand lethargically. We shooters were used to having the turkey jump or make some unusual movement for us to record.

An old farmer like Truman simply grabbed the turkey's legs and held him up. But the other presidents just sort of stood by, particularly in their first years, not realizing what could happen, so if the turkey erupted and tried to fly away, we got a pretty good picture.

Well, President Reagan was a little shy early on, a little cautious. Maybe he had been informed that the turkey has a tendency to jump and could fly in his face. So this particular one just stood there, clucking away, not doing much.

In frustration I started making turkey sounds, and still the turkey wouldn't do anything. In desperation I yelled, "Mr. President, what do you plan to do with that turkey?"

"I'm going to eat him!"

"Well, if you're going to do that, why don't you just go over and pet him and show that you don't mean it personally?"

So he went over and petted the turkey's head. The turkey went straight up in the air, the president jumped back, and we got a very nice picture.

He was very careful after that. The president, I mean. Things weren't the same, but the turkey shoot was still one of the few predictably fun days around the White House.

One distinctive characteristic of a Republican rally in the last twenty years has been the enormous use of balloons, and one could always count on them to appear at the end of any Reagan rally. The president thoroughly enjoyed them, reacting much like a kid who sees balloons going up for the first time. He was forever batting at them when they came close.

One day he went to a rally on the West Grounds of the Capitol to commemorate the two hundredth anniversary of the Congress. At the end of his presentation, it was announced that one million balloons had been released. The president came back to the White House, his mind bubbling over with the thought of that tremendous number of balloons.

I was in his office waiting to photograph him with the Arthritis Foundation's poster child of the year. His first words when he came in were "Did you see the balloons at the Capitol?"

"No, Mr. President," I said, "I was in the Press Room waiting for you to return, and I watched it on TV."

"One million balloons," he said in awe. "Never seen anything like it in my life. Balloons everywhere!"

That fascination of his has always tickled me.

President Kennedy was the first chief executive, in my opinion, to understand fully the potential of personal media contact and, more important, of using the evolving medium of television to his advantage. FDR had depended on his wonderful voice to communicate with and to rally the American people via radio. Both Truman and Eisenhower used radio effectively, and they had limited success with television. But it was Kennedy who first realized the dramatic impact of a president's or presidential candidate's talking directly to and being seen by the individual voter in his own living room. It became the new political game.

Appealing directly to the voter meant bypassing the traditional political parties, which slowly diminished in importance. The personality of the candidate and the image he projected became more important than the issues. And the winning candidate in each successive campaign was likely to be the one with the better staff of pollsters and television image-makers.

The whole idea, it seems to me, was to make every voter feel good and to associate that good feeling with the candidate on the screen at the moment. The people who made that happen became more and more proficient until they finally produced the ultimate in prepackaged candidates—Ronald Reagan. Harry Truman's prediction of 1946 has come true: A successful candidate has to be 70 percent actor and only 30 percent able.

I particularly detest the so-called TV presidential debates, silly pat-a-cake versions of the political debates of earlier times and not worthy of the name.

One interesting by-product of the campaigns—which depend less on issues, parties, and clearly defined goals than on the individual candidate's personality—is what we have seen in five of the last six elections, where Republicans have won the White House but have remained the minority party in Congress. The result has been a divided political atmosphere and no agreed-upon, clearly defined mandate. Maybe we are becoming more content with this arrangement as evidence of the separation of powers, but, sadly, it means that the issues are being increasingly ignored.

Annual White House "turkey shoot."

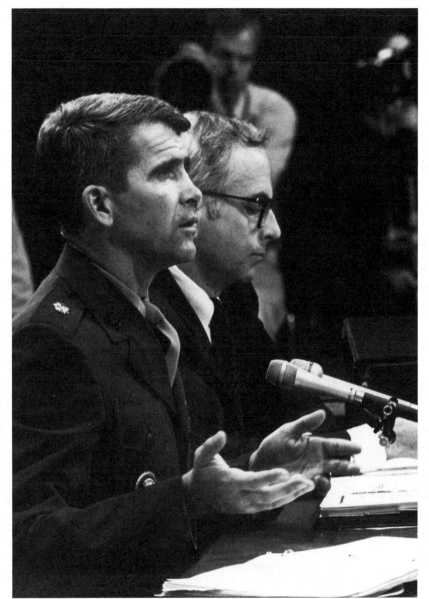

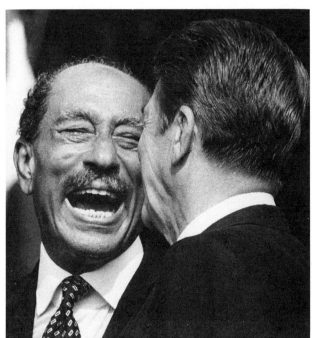

OPPOSITE

President Reagan working in the Oval Office.

TOP LEFT

President Reagan and Egyptian president Anwar Sadat.

TOP RIGHT

Iran-Contra hearings: Col. Oliver North and his attorney, Brendan Sullivan.

BOTTOM LEFT

Four presidents at White House ceremony prior to the departure of the official delegation to Sadat's funeral.

ABOVE

President Reagan is greeted by members of his cabinet.

RIGHT

President Reagan escorts Supreme Court nominee Sandra Day O'Connor to the Rose Garden.

OPPOSITE, TOP

Senator Pat Moynihan of New York reacts to news that he was an Abscam target by the FBI. "To hell with them," he says. "I've got the Constitution on my side." Moynihan is the only real character left in Congress today.

OPPOSITE, BOTTOM

"Homeless": Four men have set up camp near the DAR building, Washington, D.C.

LEFT

Member of fundamentalist sect petitioning Congress for school prayers and pro-life legislation.

BELOW

Dedication of "The Wall," the Vietnam War Memorial.

OPPOSITE

"Unknown Soldier" from the Vietnam War lies in state. Rotunda, U.S. Capitol.

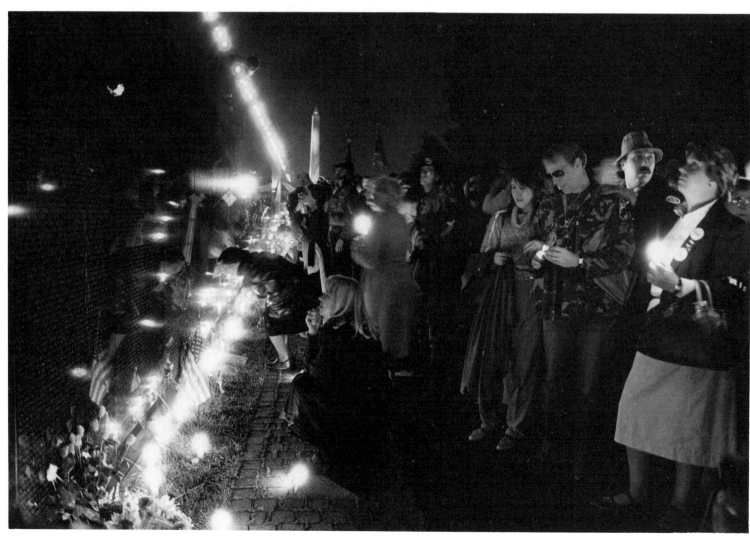

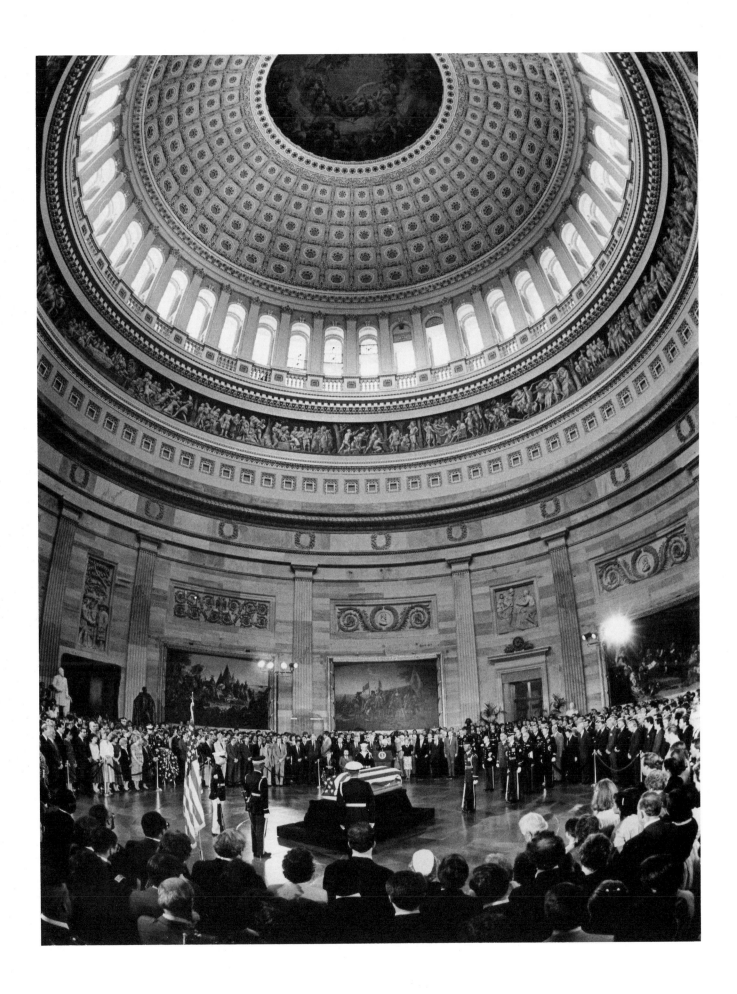

GEORGE BUSH

To this veteran photographer, President George Bush is the nearest thing to Harry Truman that has occupied the Oval Office: two men forty-three years apart, from totally different backgrounds, having strikingly similar impacts on their personal presidential environments. One a Missouri farmer, small businessman, and mostly self-taught, the other from the nation's privileged class and a Yale graduate. Both considered the White House as home, with staff and press as members of an extended family that ultimately would embrace the whole nation.

Both were vice presidents to controversial charismatic leaders and suffered the same humiliation and personal abuse as designated whipping boys. Both won hard-fought elections that left a bitter aftertaste. Both moved quickly to heal the political wounds and blunders of the campaign.

President Truman welcomed back to the Democratic fold the rebellious states-righter South Carolina governor Strom Thurmond along with his schismatic right-wing Dixiecrat party. From the extreme left, former vice president Henry Wallace and his Progressive party returned home. President-elect Bush moved quickly to placate and charm a seething Democratic Congress that was smarting from another loss to the Republicans and eagerly plotting revenge. Both veteran campaigners realized instinctively that compromise is the true art of politics and that, while strong orthodox views may be fine for campaigning, they must bend before any real progress can occur within our government.

This fact has been self-evident from the first day I walked the halls of Congress in 1939. President Bush, in his own low-key way, is well aware of it. I find it rather ironic that the most violent attacks against both these presidents came from the right wing of their parties.

President Bush's instincts to bind his party's wounds were already evident when he served as party chairman during the bleak Nixon years. I was at my desk at the *Times* bureau when he arrived for a staff luncheon during the Watergate era. Passing by, he said, "Hi, George." To which I light-heartedly responded, "Mr. Chairman! How are things back at the *Titanic?*"

President George Bush and Vice President Dan Quayle having lunch under the Jackson magnolia tree on the South Lawn of the White House. They are using the Calvin Coolidge china that was used forty-five years earlier when I photographed President Roosevelt and vice presidential nominee Truman in the same spot.

Shaking his head in an abashed, chagrined way, he wearily pulled up a chair and sat beside me and confessed, "I've been battered with similar taunts in the last months. It's funny, but it's not funny." There was strong talk around the country that even the fate of the Republican party was hanging in the balance of the hearings. We talked. For the first and only time I called him George. My feeling was that he knew where he was heading and would do his best to help the GOP recover. And it did.

For photographers, covering both Truman and Bush was fun. Truman was always relaxed and put you at ease and Bush has no visual image problems. Even calloused and cynical White House reporters are finding it increasingly hard to be objective about White House policy when the president calls them by their first names and asks about their families. The Reagan shouting matches are long gone. Not only is President Bush friendly with most of the photographers, but, what's more important, he is aware of the whole range of their work. He seeks out bylines and will compliment an individual photographer on pictures unrelated to politics or the White House.

At our annual dinner in his honor, President Bush noted that he started referring to us with "affection" as "Photo Dogs" after he heard our humorous protest-barking while being herded en masse behind ropes during photo ops in the Rose Garden. More and more the White House is penning and restricting media movements, ostensibly for security and crowding reasons. President Bush is well aware of these problems and has tried to make up for them by impromptu limo stops to kiss a bride or buy a pizza, or by ending a fishing trip with a dive into the cold Atlantic on a bet. Some call this politically self-serving and atypical. I call it his natural style, which reflects the fact that he is free to be his own man after eight years under President Reagan's thumb.

On President Bush's return to Washington after a Kennebunkport vacation, I asked a White House staffer if he wasn't apprehensive that the president might die or suffer a bad heart attack after diving into the cold Atlantic, with disastrous results to the nation. "Don't worry," he said, "if that happens, the Secret Service has orders to shoot Vice President Quayle."

Early in his presidency, Bush made it his practice after the evening lid to drop by the White House Press Room for an informal chat with his Photo Dogs still on duty. The room was usually empty, with reporters long gone. It was an easy, relaxing way for him to end the Oval Office's official day, just sitting there shooting the breeze without fear of quotes or questions. But reporters got wind of these informal sessions and stuck around to ask questions, thus putting an end to them.

President Bush has a vision of a kinder, gentler nation. Truman had a similar vision, but I believe he would have substituted the word *world*. One of Truman's first acts as president was to install a horseshoe pit on the South Grounds of the White House, and one of President Bush's first acts was to do the same thing. The image of horseshoe playing, the common man's game, is as American as baseball, the Fourth of July, and Mom's apple pie. President Truman played as one born to the game, having had much practice with cast-off shoes when he was a boy. President Bush, on the other hand, plays like the latecomer to the game that he is, somewhat awkwardly but still in a respectable 30-percent-ringer range. Both presidents set up and played in White House horseshoe competitions involving staff, the media, and the

Secret Service. Among the media, invitations to play are a hot prestige item, eagerly sought and lobbied for.

After a year—although that is too short a time in which to predict how his presidency will be judged by history—the broad outline and basic thrust were already there. No doubt Bush's tenure will reflect his low-key temperament, courtesy, competence and common sense, and above all, his belief in compromise, compromise, compromise.

My gut reaction is that he will be a good president for the times and that he has the potential for greatness. With the reduction in cold war tensions comes a rare opportunity to make a lasting impression and a mark for peace. Because he will have to continue to work with a Democratic-controlled Congress, he will have to be as successfully conciliatory as Gerald Ford was if he expects to be included among the great presidents.

The president has not changed much from the young man I used to see visiting his father's senatorial office. Over the years I've seen him fill many government positions and grow in stature and political knowledge. He is always spontaneous and casual, and has a vast circle of friends.

At times the president can be sensitive almost to tears for the feelings of others. He is a man you can laugh with and a genuine war hero who hates war and looks uncomfortable telling war stories. The president is a man who in this day and age lives his religion and is not ashamed to show it.

Will he stand tall and fearless, as Harry S Truman did, when the going really gets rough? Will Bush, like HST, do his "damnedest" and not lose a night's sleep? Two events in his first year—the crackdown on the Chinese students demonstrating for democracy in Beijing who were brutally suppressed by the aging Communist leaders, and the invasion of Panama—provided him the opportunity to answer that question. He failed his first tests. In the China case, while giving lip service to the cause of the students, he actually undermined them by sending a secret delegation to China, giving an entirely different signal to the Chinese leaders. On Panama, the downfall of General Manuel Antonio Noriega was not worth the life of a single American soldier, much less the heavy loss of life suffered by the Panamanians. Will he be another Truman? That will have to be assessed by those who follow me. I still sense that he will.

All his political life President Bush has believed in personal contacts. He has also been an avid and prolific note writer. Whether the road is bumpy or smooth, strewn along the way will be miles of personal notes, none of them reading alike, to hundreds of friends, staff, members of the media, and foreign dignitaries. They are notes that will thank and praise one and all for their help and loyalty. They will be treasured, like the one I received:

> To George Tames,
> With admiration for your professionalism and appreciation for your unfailing courtesy.
>
> Good luck,
> George Bush

More than fifty years has separated Roosevelt's "Dog House" from Bush's "Photo Dogs." For me it has passed like a fiftieth-of-a-second click of my camera's shutter.

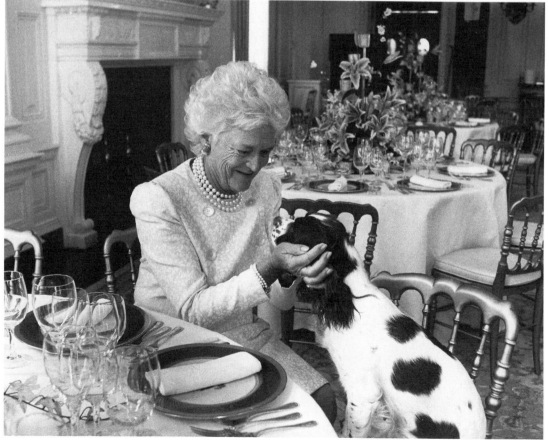

OPPOSITE, TOP

Mrs. Bush reacts to cheers of crowd during the inaugural parade.

OPPOSITE, BOTTOM

Mrs. Bush in the West Dining Room with her dog Millie.

BELOW

Vice President Bush and Secretary of Defense Weinberger practice passing a football before meeting with President Reagan.

TOP RIGHT

Speaker of the House Jim Wright walks away from the House after his resignation.

BOTTOM RIGHT

House Majority Leader Thomas S. Foley in his office with his sixteen-year-old-dog Alice.

TOP LEFT

Egyptian president Hosni Mubarak meets with reporters outside the White House after his meeting with President Bush.

BOTTOM LEFT

Pakistani prime minister Benazir Bhutto addresses a joint session of Congress. At rear are Speaker Tom Foley (left) and Senate President Pro Tempore Robert Byrd. Bhutto is adjusting her veil during the speech.

BELOW

Vice President Bush during a meeting with General Secretary Mikhail Gorbachev at the Soviet Embassy.

OPPOSITE

Bush in the old Senate chamber, U.S. Capitol.

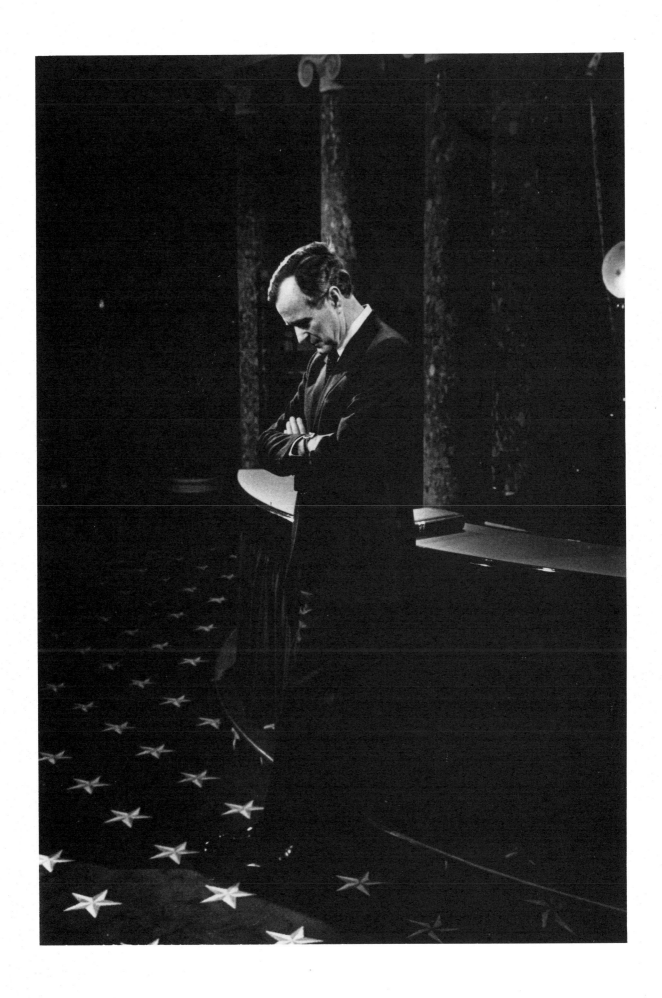

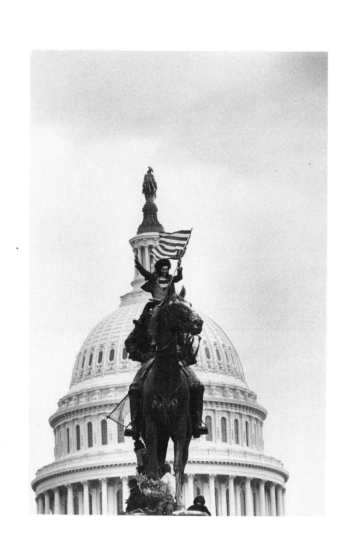

The New York Times Magazine

The New York Times Magazine

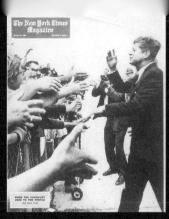

The New York Times Magazine

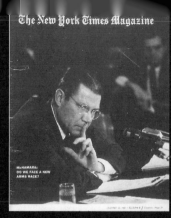

The New York Times Magazine

McNAMARA: DO WE FACE A NEW ARMS RACE?

The New York Times Magazine

The New York Times Magazine

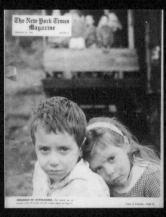

The New York Times Magazine

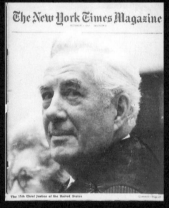

The New York Times Magazine

The 15th Chief Justice of the United States

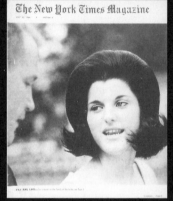

The New York Times Magazine

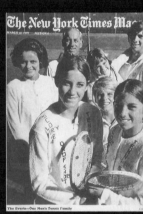

The New York Times Magazine

The Everts—One Man's Tennis Family

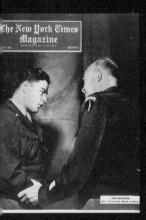

The New York Times Magazine

The New York Times Magazine

The New York Times Magazine

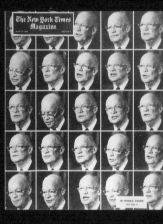

The New York Times Magazine

The New York Times Magazine

The New York Times Magazine

The New York Times Magazine

The New York Times Magazine

The New York Times Magazine

The Emergence Of Senator Kennedy (D. Mass.)

The New York Times Magazine